Southeast Asian Ceramics

Asia House Gallery, New York City
Philadelphia Museum of Art
Honolulu Academy of Arts
The St. Louis Art Museum

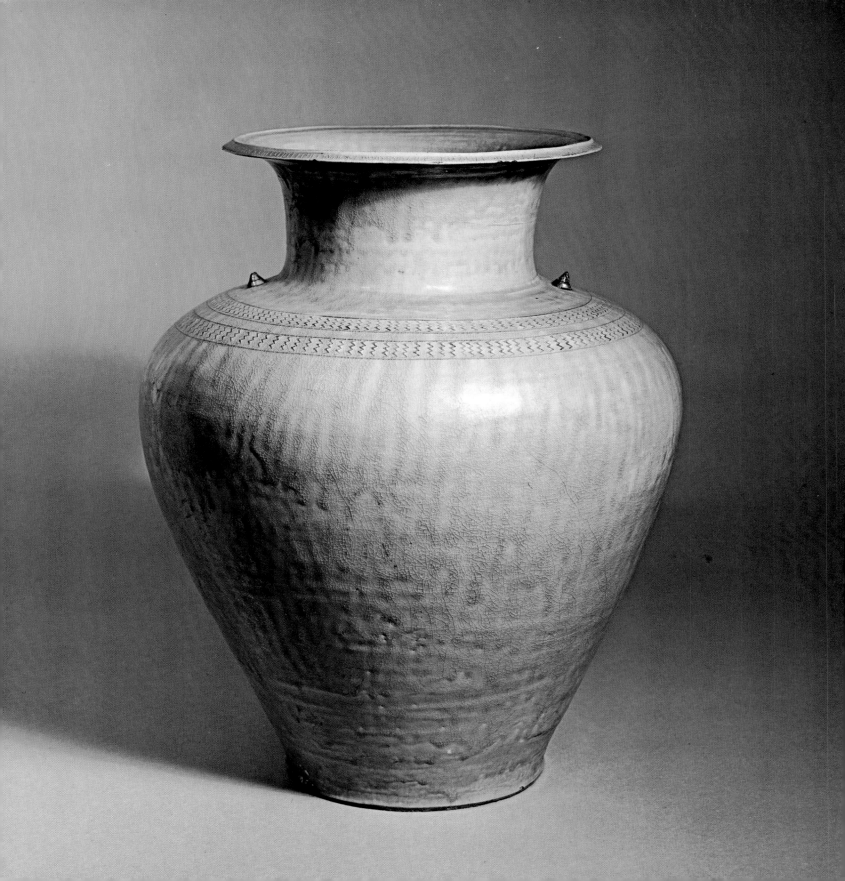

Southeast Asian Ceramics
Ninth Through Seventeenth Centuries

Dean F. Frasché

The Asia Society
In Association with John Weatherhill, Inc.

SOUTHEAST ASIAN CERAMICS is the catalogue of an exhibition
shown in Asia House Gallery in the fall of 1976 as an activity
of The Asia Society, to further greater understanding between
the United States and the peoples of Asia.

An Asia House Gallery Publication

This project is supported by grants from the National Endowment
for the Arts, Washington, D.C., a Federal Agency, and the Andrew W.
Mellon Foundation.

Frontispiece

48. *Storage Jar*. Thai; 14th-16th century
Stoneware; H. 45.2 cm.

Contents

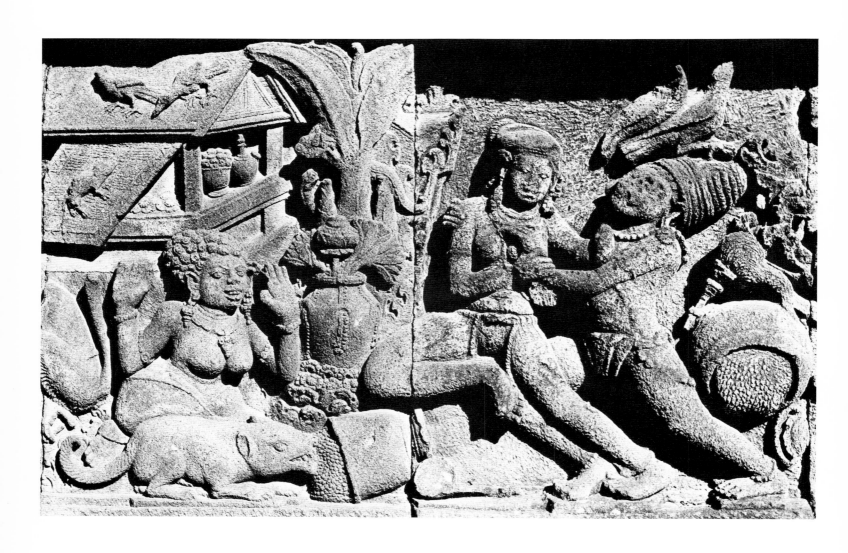

Foreword

Detail of a ninth-century bas-relief on Candi Lara Jongrang, Prambanan, Java, showing the abduction of Sita. In the foreground an animal devours food from an overturned stem bowl whose heavily potted form is very similar to those of Khmer pieces found in Thailand and Cambodia (cf. fig. 4c).

As has been the case with all the exhibitions organized by Asia House Gallery, this one has had a long history. About five years ago my predecessor, Gordon Washburn, recognized the need for an exhibition of the ceramics of Southeast Asia. There had been extensive research and numerous publications and exhibitions dealing with Chinese and Japanese ceramics, but no major exhibition of Southeast Asia's ceramics has ever been held in this country, and, with the exception of William Willetts' catalogue, "Ceramic Art of Southeast Asia," published in Singapore in 1971, there had been no broad study completed on the subject of these ceramic wares. Although the Willetts work is a fine introduction to this complex subject, its scope is limited to those pieces which could be borrowed from collections in Singapore, and only two thousand copies of the catalogue were printed.

In America museum curators and private collectors have recently shown considerable interest in Southeast Asian ceramics and, as can be seen from the extensive bibliography that accompanies this text, there have been numerous articles and studies concerning various types and styles of pottery, but they have appeared in comparatively inaccessible journals. There was a distinct need to pull all of this material together and to report on new discoveries and developments that have been made over the past several years. It was therefore decided that the Gallery should mount an exhibition of the finest objects that could be borrowed from collections throughout the world.

From the beginning it was clear that it would be difficult to find an individual in America who knew the field well enough to gather this considerable and varied data together and who also had the taste and knowledge to choose objects of the quality that one expects to see in an Asia House exhibition. In the past all of the guest directors who have organized exhibitions for the Gallery have been associated with museums or universities, but in this case the recognized authority turned out to be a mining executive who had spent much of his life in Southeast Asia and had made the study of these ceramics his passionate hobby.

Dean F. Frasché was first exposed to the fascination of Asian ceramics in 1937 when he was taken to a burial cave on the island of Minaloa in the Philippines which was filled with shards of Ming dynasty blue-and-white porcelain. From that moment, the acquisition and deep study of "pots," as he affectionately calls them, became a permanent and consuming part of his life. While he was associated with the Union Carbide Corporation, from 1944 to 1971, he used his free time to collect and classify the ceramics of Thailand, Cambodia, and Viet Nam. During visits to various mining operations and his subsequent residence in Bangkok, he had access to ceramics as they came on the market. He was also able to make numerous forays to investigate rumors of new kiln sites or to revisit the known centers of ceramic manufacture.

As is so evident here, the fact that Mr. Frasché has had no formal training in art has

not been the slightest hindrance. Indeed it may even have been to his advantage. From his profession in the mining industry, he has brought a new point of view to this field of study. Expertise in the behavior and properties of materials is usually lacking in the experience of the curator or art historian, but Mr. Frasché is readily able both to spot such details as variances in the composition of pastes, evidence of manufacturing techniques, and subtle differences in glazes, and to describe them with great accuracy.

Mr. Frasché is well known to The Asia Society through his long association with the Thailand Council and his enthusiastic interest in every exhibition organized by the Gallery that has included ceramics. His generosity is also renowned, and he has given a large part of the collections of Southeast Asian ceramics in several American museums, including the Philadelphia Museum of Art, the Honolulu Academy of Arts, and the museums of Cornell University, Indiana University, and the University of Michigan. This project is the culmination of an intense and consuming interest of almost forty years.

For myself, the exhibition represents a unique experience. In 1974, shortly before I assumed my position as Director of the Gallery, Mr. Washburn and Phillips Talbot, President of The Asia Society, were able to obtain a generous grant from the Ralph E. Ogden Foundation which enabled Mr. Frasché and me to travel to Southeast Asia that summer to study the collections of ceramics in museums and private hands and to visit several sites in Thailand where some of the pottery had been made. One of these kiln sites had actually been discovered by Mr. Frasché only a few months earlier. It was, I confess, my first trip to Asia, a situation which would have made it unforgettable under any circumstances. Traveling with Dean, however, was also the best introduction to Asia one could imagine. My wife was fortunately able to join us and, during the course of our travels, we met many people : collectors, art dealers, museum curators and directors, leading citizens, and businessmen, all of whom greeted us with warmth and hospitality. For six weeks we became totally immersed in the subject of this exhibition. I was able to study the objects in their original settings, discuss their relative merits with Mr. Frasché, and sometimes even play a very minor role in the selection process itself.

Retracing the various stops we made in Asia reminds me of many pleasant and stimulating moments and of all the people who have assisted in this project. Some are mentioned by Mr. Frasché in his acknowledgments, but there were many others as well. In Honolulu we were offered the generous hospitality of Ambassador and Mrs. John M. Allison. Mr. and Mrs. Robert P. Griffing, Jr. were also most hospitable and gave freely of their time in allowing us to examine their extensive, magnificent collection of Vietnamese pottery. When we arrived in Tokyo, we found the storerooms and resources of the National Museum at our disposal thanks to the interest of Seizo Hayashiya and Gokuji Hasebe. Ikutaro Itoh, the head of the art department of Ataka Company, was most helpful in supplying information about their collection and in offering the services of his firm to us.

During this strenuous and constantly stimulating introduction to Southeast Asia, there was one experience that I remember with particular vividness. A few short months before the fall of Cambodia, we visited the city of Phnom Penh to study the Khmer ceramics that were in the National Museum. With the help of Dr. Pan Sothi, then Minister of Education, and his wife, we were introduced to Duong Sarin, Minister of Culture, Ly Von Ong, the curator of the museum, and Men-Makoth, professor at the Université des Beaux-Arts. All of them were generous

with their time and extremely cooperative despite the events which were threatening them. I do not know where any of them are today, but I deeply hope that our paths shall cross again, and that I can thank them in person and share with them the results of our visit.

In Thailand, we are indebted to Rangsrit Chaosiri, Director, The Fine Arts Department, for approving our requests, and to Chira Chongkol, Head, Division of National Museums, for her assistance in seeing through details of the loans from her country. Elizabeth Lyons of The Ford Foundation in Bangkok also contributed advice and guidance. In Indonesia we were aided by the Minister of Education and Culture, Dr. Sjarif Thajeh, Amir Sutaarga, Director, Directorate of Museums, and by Abu Ridho of the Museum Pusat, Jakarta.

On the return journey from Asia, Adrian Joseph extended the courtesy of showing me collections of Vietnamese wares at Hugh Moss Ltd. in London. During his trip to the Netherlands and Belgium, Mr. Frasché renewed old friendships and he has thanked these friends in his own acknowledgments.

We were also aided by many American colleagues. Dr. Jean Gordon Lee of the Philadelphia Museum of Art was able to supply us with photographs and information about objects in that museum's collections despite the reconstruction work that was underway. Martie Young and Emoretta Yang of the Herbert F. Johnson Museum of Art, Cornell University, gave us invaluable assistance in obtaining the proper photographs of the ceramics in their care. As usual, Otto Nelson was on hand to supply us with his clear and carefully made photographs.

I wish also to thank my staff for their work on this project. Terry Tegarden, Cecelia Levin, Kay Bergl, Lilly Ryterski, and volunteer Carol Lew have performed their duties with efficiency and care. From other offices, we called on Sarah Bradley for editorial assistance and research and Linda Merchant for endless typing. Although these words are written in advance of the event, I am certain that Cleo Nichols will produce an installation up to his fine standards.

This project has been supported by a generous grant from the National Endowment for the Arts, a Federal Agency, and an education grant from the National Endowment for the Humanities which will enable a number of supplementary activities to take place at the time of the exhibition. The Andrew W. Mellon Foundation has underwritten part of the costs of producing the catalogue with the first of six grants directed towards maintaining the excellence of the Gallery's publications.

Lastly, there is one sad fact which must be noted here. This is the last catalogue that will be completed under the guidance of Virginia Field, Associate Director of Asia House Gallery. Miss Field has been a hard working member of the Gallery staff since October 1963. From the moment she came to the Society, she took many important administrative matters in hand. Her efficiency and careful attention to detail have been mainstays in the day-to-day operations of the Gallery and her assistance to me has been invaluable. Perhaps the most amazing single fact about her extraordinary record is that during her thirteen years here, she has produced thirty catalogues. They have become models of their kind in quality of printing, design, clarity, and accuracy. She has set the standards which will continue to be followed by Asia House Gallery. In this way her always strong influence will make itself felt long after she has left us. We will constantly be reminded of what she has done and will miss her greatly.

Allen Wardwell, Director, Asia House Gallery

Lenders to the Exhibition

Mr. and Mrs. Alphonse Cohen
The Denver Art Museum
Mr. and Mrs. Dean F. Frasché
Mr. James W. Frasché
Mr. and Mrs. J. R. Galloway
Mr. and Mrs. Robert P. Griffing, Jr.
Mr. Kimiyuki Hasegawa
Herbert F. Johnson Museum of Art, Cornell University
Honolulu Academy of Arts
Idemitsu Art Gallery, Tokyo
Mr. and Mrs. Dale Keller
Mr. and Mrs. Leandro V. Locsin
Los Angeles County Museum of Art
Ambassador and Mrs. Jack W. Lydman
Mr. and Mrs. Severance A. Millikin
Musées Royaux d'Art et d'Histoire, Brussels
Museum of Asiatic Art, Rijksmuseum, Amsterdam
Museum Pusat, Jakarta
National Museum, Bangkok
Philadelphia Museum of Art
Rijksmuseum voor Volkenkunde, Leiden
Mr. and Mrs. John D. Rockefeller 3rd
Mrs. Lauriston Sharp
Wat Srikomkan, Payao, Thailand
Mr. and Mrs. T. C. White
Mr. and Mrs. Floyd L. Whittington
Dr. Kyozo Yuasa
Mr. and Mrs. Adrian Zecha

Acknowledgments

The writer is particularly grateful to the museums and collectors who have generously lent their ceramics to this exhibition. While preparing the exhibition and the catalogue he has also received outstanding assistance from many people in Asia, the Netherlands, Belgium, and the United States. In Japan, Junkichi and Yasuhiko Mayuyama arranged for loans from private collections, and Professor Tsugio Mikami gave his support to the requests for loans from museums. Mr. and Mrs. Leandro V. Locsin of Manila, in addition to their generous hospitality, made it possible to visit several outstanding collections. In Thailand, Kraisri Nimmanahaeminda, eminent authority on Thai ceramics, supplied valuable information on new ceramic discoveries; J. R. Galloway, Supha Limmanont, and Intong Suwanyuan made it possible to visit several ancient kiln sites; and Mr. and Mrs. Graham A. Nelson contributed extensive archaeological information on recently excavated ceramic centers. Mr. and Mrs. Donald Sinclair of Singapore were most hospitable and, in addition, arranged interviews with numerous collectors. In Jakarta, Cheng Lammers graciously acted as liaison with the Museum Pusat. In the Netherlands, J. van Lier rendered invaluable assistance when visiting numerous collections found throughout his country. Madame J. P. Schotsmans, of the Musées Royaux d'Art et d'Histoire in Brussels, gave valuable help in identifying collections of Vietnamese ceramics in Belgium.

In the United States, the staff at Asia House Gallery, especially Allen Wardwell, Virginia Field, and Sarah Bradley, gave their full cooperation and made invaluable contributions during the preparation of the exhibition and the catalogue. The writer is grateful to Angela Anderson for her secretarial assistance and to Kay H. Kim and Francis W. Paar of The New York Public Library and Giok Po Oey of the Cornell University Libraries for their valuable cooperation.

Dean F. Frasché

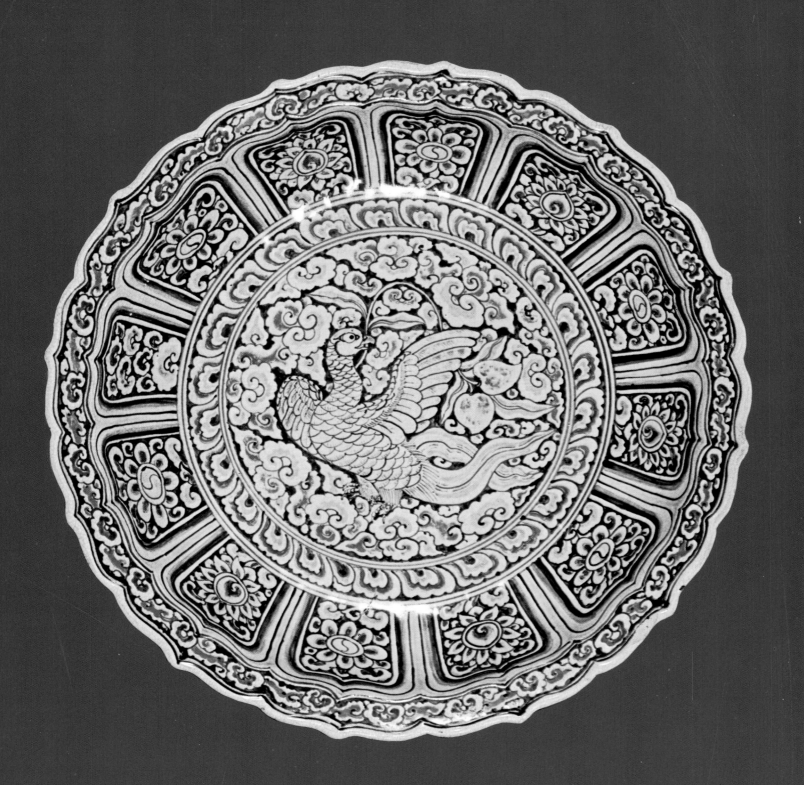

Southeast Asia: Its Land and Its People

93. *Dish*. Vietnamese; 15th-16th century
Stoneware; Diam. 25 cm.

The part of the world we know collectively as Southeast Asia, on the rim of the earth's largest landmass but separated from it by mountains, trails into a long peninsula whose farthest reaches are scattered about as islands in the sea. Burma, Thailand, Cambodia, Laos, Viet Nam, Malaysia, Indonesia, and the Philippines are dwarfed by their neighbors, China and India, and they serve, in part, as buffers between the two giants of Asia, as did their predecessors—Funan, Champa, the Khmer Empire, and a host of smaller states.

The area, never a center of political or economic power, is a microcosm, compressed in space and time, as we with our occidental scales reckon them. Its history, as we of the West define history—a continuous, systematic, written record of past events, in chronological order—occurs late, within the Christian era. Here space does not permit treatment of prehistory: the Neolithic or pre-Neolithic eras. This account will confine itself to the last twenty centuries, focusing on the ninth to the mid-seventeenth, on what was occurring in the lands of Southeast Asia at a time contemporaneous with Europe's Middle Ages, Renaissance, Reformation, and the era of world exploration. The period begins when the West was experiencing the Carolingian renaissance and spans the interval to about 1648, when the Thirty Years' War ended, a hundred and fifty years after European explorers first made contact with the cultures treated here.

Until our recent involvement in Southeast Asia, we were perhaps more familiar with the names of some of its cities and islands—Mandalay, Moulmein, Singapore, Java, and Sumatra—than with the countries themselves. All were ''somewhere east of Suez'' but vague in location—the antipodes, remote and exotic. A diverse array of lands and islands, broken up into small pockets by mountains as are the Balkan countries, Southeast Asia has never achieved an integrated culture to the degree, for example, of classic Greece. There is no common language, religion, or race. The area remains a congeries of separate ethnic stocks, language groups, and levels of cultural and religious development from the very primitive to the exalted and the decadent.

Before examining the dissimilarities of the nations of Southeast Asia, however, the effect of a common factor should be considered. All of these countries, situated in the lower latitudes, are burdened with an oppressive and debilitating tropical climate that saps the strength and health of the people living within them.

With the possible exception of the Khmer Empire, no great civilization has arisen in the tropic zone, not because of any deficiency in the inhabitants but because conditions that permit the development of high civilization were lacking: soil of a quality suitable for supporting a staple food crop, materials that can be fashioned into adequate tools to clear land, substances to shape into more than ephemeral architectural and art forms—creations that will not rot away in the rank, stultifying climate. Any achievement beyond simple survival in the extreme heat and humidity of the tropics requires an extraordinary effort. Yet that gratuitous, non-utilitarian dimension of man's enigmatic spirit, the drive to create and enjoy things of beauty, has always been a powerfully motivating force in Southeast Asia.

Into this area the ancestors of the Thais, Burmese, Cambodians, and Vietnamese pushed southward through the mountains that would divide them. In search of a warmer climate and richer soil, they traveled the great river valleys to the deltas that would support them as settled farmers after they had learned to cooperate with, and to challenge successfully, this grudging, ungracious corner of the Asian continent. The great variety of ethnic groups who drove or drifted into the region— most of them by the end of the Neolithic period—included the Tibeto-Burmans, the Austro-Asiatic Mons and Khmers, the Malayo-Polynesians of Funan, the Vietnamese, and the Chams who were also affiliated with the Malayo-Polynesians. Earlier arrivals were the Veddas, the Indonesians, and a people called the Pyus who soon disappeared as a separate group. Latecomers were the true Mongoloids and the warlike Thai tribesmen.

These varied peoples contributed an assortment of languages to Southeast Asia, and the confusion of the linguistic picture is increased by the variety of foreign scripts employed: Sanskrit, Pali, Chinese ideographs, Arabic, and the alphabets and languages of Western colonizers. Each tried to approximate phonetic values, syntax, words, and concepts which had no counterparts in the original languages and scripts.

Of major importance in any consideration of the countries of Southeast Asia is the influence of India and China. The strength and independence of the countries of Southeast Asia have varied in inverse proportion to the strength of their mightier neighbors, changing as China and India fluctuated between weak, feudal, and strong, central forms of government. It is instructive to observe the ways in which the people flanked by these vast, ancient powers have been affected by them, to note what they have adopted, adapted, and assimilated while maintaining the integrity of their indigenous cultures. To examine this it is necessary to divide the lands of Southeast Asia into three areas: the largest, including much of Burma, Thailand, Cambodia, southern Viet Nam, Malaysia, and Indonesia, where the preponderance of influence is Indian; another, primarily northern Viet Nam, where Chinese influence prevails; and thirdly, the Philippines, which have hardly been touched by either (see map, p. 20).

Despite the difficulties presented by formidable mountain ranges that made east-west communications extremely difficult, more than two thousand years ago travelers from India began to arrive in Southeast Asia from the west and south, and to influence the people who had come to inhabit the valleys of the Irrawaddy, the Salween, the Chao Phraya, and the Mekong rivers. While the influence of India was primarily cultural and religious, it contained some political elements in the benign form of offering models of government. This led to the establishment of a number of Southeast Asian states structured along Indian lines. The principal ones were Srikshetra in the lower valley of the Irrawaddy, Dvaravati in the southern part of the Chao Phraya River valley, Champa on the east coast of the peninsula, between the Hoanh Son mountain spur and the Mekong delta, and Funan in the Mekong delta, which was later absorbed by the Khmer Empire.

Proximity, naturally, is the primary determinant which allows one country to exert influence over another, but other factors are involved. Two of the major religious philosophies of Asia, Hinduism and Buddhism, were engendered on the subcontinent, and both were carried to Southeast Asia by Indian emigrants. In our time Hinduism is practiced chiefly within the borders of India. Buddhism, which came into conflict with Hinduism in about the sixth century A.D., has not survived in India to any great extent. It was, however, successfully exported by traders and proselytizing monks who migrated to Burma, Thailand, Cambodia, Malaysia, and Indonesia when their faith met resistance in their native land. In its Theravada form, Buddhism has had a much greater impact on the peoples of Southeast Asia, particularly in Burma, Thailand, Laos, and Cambodia, than did either Hinduism or Islam, the faith that now prevails in much of Indonesia and Malaysia.

When religion or the supersensory is posited as the ultimate or underlying reality by a culture, it finds expression not only in the formal profession and practice of the faith itself but is often reflected in other aspects of life: customs, government, law, economics, family structure, and the arts—music, literature, and particularly the visual arts. This was the case during the Middle Ages of Western Europe, and it is also true of Indian culture and the cultures of Southeast Asia that came under Indian influence. India has never brought Burma, Thailand, Cambodia, or their predecessors into its political domain, but the profound effect of Hinduism and Buddhism can be observed in the architecture, sculpture, carvings, paintings, ceramics, and decorative motifs found everywhere in those lands.

By contrast the influence exerted by China, limited almost exclusively to Viet Nam, was military, political, technological, cultural—of almost every type but religious. It is the Chinese with their annals and chronicles who provide the records that enable us to reconstruct the early history of Viet Nam.

Little of that history is known before 221 B.C., the end of the chaotic interval known as the period of the Warring States, when the Ch'in emerged vic-

torious among the contenders and unified China under a strong centralized government. The Ch'in had planned to annex the kingdom known first as Van Lang, then as Au Lac, and later as Nam Viet ("Southern Country of the Viet," or "Yüeh," in Chinese), which included Kwangtung province and northern Viet Nam. But Chinese generals who defected from the Ch'in took over the area and ruled it for a period as feudal lords. Conquered by China in 111 B.C., during the Han dynasty, Viet Nam was administered first as part of a group of commanderies and then as an imperial province. Under the T'ang dynasty (618-907 A.D.) the area received the humiliating name of Annam, "Pacified South." The incidence of rebellion, however, bears witness that the Vietnamese did not settle down to a pacified condition.

During the next thousand years the area remained a part of China, and in that millennium its Chinese masters exercised a calculated policy of sinicization of the Vietnamese. This policy stemmed from the mentality of the rulers of China and their perception of the "Middle Kingdom," a translation of the Chinese name for China which clearly conveys their sense that their country was the center of civilization. China, enormous and isolated, almost a closed system, had minimal contact with her neighbors. She knew, however, of the existence of far-off Rome, with which she carried on commerce by overland routes in silks and other luxury items, exchanging them for gold and silver, the only commodities Rome could barter since it produced nothing else of interest to the Chinese. The peoples around the periphery of China were thought of as "barbarians" to be fought off or, if brought within the boundaries of the Middle Kingdom, to have the benefits of Chinese culture conferred upon them.

Individuals and families who fell out of favor with China's central government often found it convenient to put distance between it and themselves by moving to Viet Nam. Among them were teachers and scholars who made a substantial contribution to the region's cultural development. Chinese was the only written language in Viet Nam, the only language of learning and education, and it was from the Chinese that the Vietnamese obtained such technical aids as the metal plow and more sophisticated methods of terracing and rice cultivation. The Chinese administrators insisted that the people adopt Chinese dress, and follow Chinese marriage customs, perhaps to facilitate the keeping of records for census or tax purposes. Yet somehow, throughout these ten centuries, the Vietnamese maintained a distinct and separate identity. They resisted assimilation and, following the fall of the T'ang dynasty, in the middle of the tenth century rebelled successfully against their Chinese masters.

Having thrown off the thousand-year-old yoke of China, the people of Viet Nam turned upon the kingdom of Champa to the south, where the spheres of Chinese and Indian influence met. As its Sanskrit name suggests, Champa was an Indianized state. This kingdom was inhabited by brigands given to Viking-like raids on

their neighbors and its population was concentrated along the coast for access to ships that were the terror of the area. Preferring to prey upon what others had produced, the Chams failed to bring their own lands under cultivation, and slowly the agricultural Vietnamese encroached upon the deltas of Champa, putting them to the plough. By about 1100 Viet Nam extended southward nearly to present-day Hué. By the end of the fifteenth century it included the Champa capital, Indrapura, and had spread along three hundred miles of coastline that had previously provided harbors for Cham fleets. In the south a diminutive Cham state survived until 1720 when the last king fled into Cambodia.

The decay of the Khmer Empire offers an example which tends to support Arnold Toynbee's view that a society is not defeated by outside forces until it has doomed itself by choosing some false path that leads to internal weakness and vulnerability. The Khmer state was heavily influenced by India; it carried on trade with Indians, its aristocracy intermarried with Indians, and its government was patterned on the Indian concept of kingship. The Khmer rulers, who viewed themselves as gods on earth, built their capital at Angkor. A city where symbol and reality almost merged, Angkor was the center for the hydraulic works which irrigated the land— as if the resident king were the source of the life-giving water. But the rulers of the Khmers, having faced the physical challenge of overcoming nature, met with failure because they chose to divert the wealth and energy of their people from the necessary work of maintaining the irrigation systems to the construction of splendid tombs for themselves. The irrigation canals silted up, crops and population declined drastically, and the weakened Khmer Empire eventually fell to the aggressive Thai tribes. The Khmers were pushed south, where they founded a second capital, Phnom Penh, abandoning Angkor to the jungle.

In the thirteenth century a series of events occurred that affected the Eurasian continent from the boundaries of Hungary to the lands of Southeast Asia, when the Mongols rode out of Central Asia to assemble one of the most extensive empires ever to stretch over the surface of the earth. Though the areas now known as Viet Nam and Burma lay on the periphery of the Mongol conquests, and their people eventually succeeded in beating off the over-extended Mongol horde, they did not escape the impact of this upheaval. Pagan (Burma) in particular was affected. Weakened by a campaign against the Mongols, the kingdom was broken up into a number of smaller fiefs under chieftains from some of the Thai tribes who had penetrated Burma from Nan-chao before the Mongol invasion. Meanwhile, in the upper Chao Phraya River basin Thais had emerged from Khmer domination to found the earliest independent Thai state, which they named Sukhothai. The picture in Southeast Asia shifted further with the political decline of the states shaped by Indian influence, and the consequent strengthening of the suppressed indigenous cultures. Older types of Hinduism and Buddhism gave way to religious reforms, Sanskrit fell out of

use, and new forms of art such as the Siamese style of Sukhothai appeared as manifestations of the profound cultural changes.

The Malay Peninsula and the principal islands of present-day Indonesia—Sumatra, Java, Borneo, and Sulawesi—lie between the Bay of Bengal and the South China Sea, occupying a position of strategic importance in the maritime commerce of Asia. Although we have no continuous history of these areas before the seventh and eighth centuries, archaeological finds, Sanskrit inscriptions, and the Hindu and Buddhist faiths of their people reveal the strong early influence of India, transmitted by merchants whose ships made landfalls on the islands as they traded about the seas of Southeast Asia. Primary historical sources are very limited; there is little more than bits of epigraphy—inscriptions of a religious nature, perhaps mentioning the name of a king who donated a temple. There are Chinese sources from the third century A.D. that refer to Java and Sumatra, but they are few, since Chinese interest in any region diminished with its distance from the Middle Kingdom. The Chinese were not the sailors and traders that the Indians were; their ships, less seaworthy, tended to hug the shore. From the fifth century on, however, Chinese Buddhist monks, traveling to India in search of the scriptures that were the revealed truths of their religion, left accounts of the various rich kingdoms and petty states of the Indonesian islands.

Like that of the lands on the continent, the relative strength of the islands traditionally reflected conditions of the major powers: China, India, and in the thirteenth century, the Mongol Empire. Sometimes united under strong kings and centralized governments, at other times Java and Sumatra disintegrated into as many small units as the islands of the Cyclades.

The renowned European traveler Marco Polo, who passed the islands in 1292, remarked that Islam had reached them. Malaya was converted 150 years later, in the mid-1400's, just before its first contact with the West. The peninsula of Malaya, a long strip extending far out into the sea, was ruled by weak kings, vassals who sent tribute to Funan and, in exchange, implored help against the Thais to the north. It maintained ties with China, and its capital, Malacca, was a flourishing center of commerce.

In the early sixteenth century the Portuguese, from their base in Goa, not only became aware of the presence of Islam in the area, but also realized that Malaya posed an impediment to their commercial ventures. By invading Malacca, which surrendered after a long siege, they disposed of an enemy to their Catholic faith and to their trading interests in a single blow. The Portuguese were followed in the middle of the century by the Spanish, who took over the Philippines, the only part of the region almost untouched by Chinese or Indian influence. After them came the Dutch, the British, and finally the French. The "colonial era" of Southeast Asia, which was to last four and a half centuries, had begun. To many it would offer the

stuff of which financial fortunes are made; to others—anthropologists, historians, archaeologists, linguists—it would provide a wealth of material for their investigations. To collectors and appreciators of art it brought a different kind of treasure.

In this crowded backwater of the world, seemingly overshadowed by China and India, the people of Southeast Asia have maintained the integrity of their own cultural genius. From their highly developed aesthetic sense have come forms and styles to enrich almost every one of the arts: sculpture, architecture, music, puppet and shadow dramas, dance rich in symbolic significance, a kaleidoscope of crafts, and their singular, extraordinary ceramics, which are the subject of this catalogue.

Southeast Asia

- ▲ **Archaeological Sites and Monuments**
- ● **Cities**
- ☐ **Indian Influence**
- ☐ **Chinese Influence**

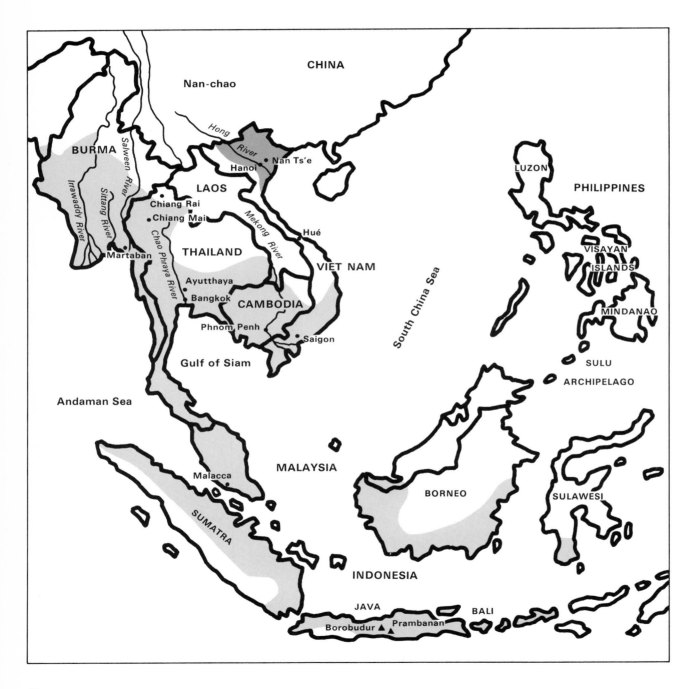

CHINA

Nan-chao

Hong

BURMA

Salween River

Irrawaddy River

Sittang River

LAOS

River

● Nan Ts'e

● Hanoi

● Chiang Rai

● Chiang Mai

Chao Phraya River

Mekong River

Hué

● Martaban

THAILAND

VIET NAM

● Ayutthaya

● Bangkok

CAMBODIA

Phnom Penh

● Saigon

Gulf of Siam

Andaman Sea

LUZON

PHILIPPINES

VISAYAN ISLANDS

MINDANAO

South China Sea

SULU ARCHIPELAGO

MALAYSIA

Malacca

BORNEO

SULAWESI

SUMATRA

INDONESIA

JAVA

BALI

Borobudur ▲ ▲ Prambanan

Kiln Sites and Monuments

▲ **Archaeological Sites and Monuments**
■ **Kiln Sites**

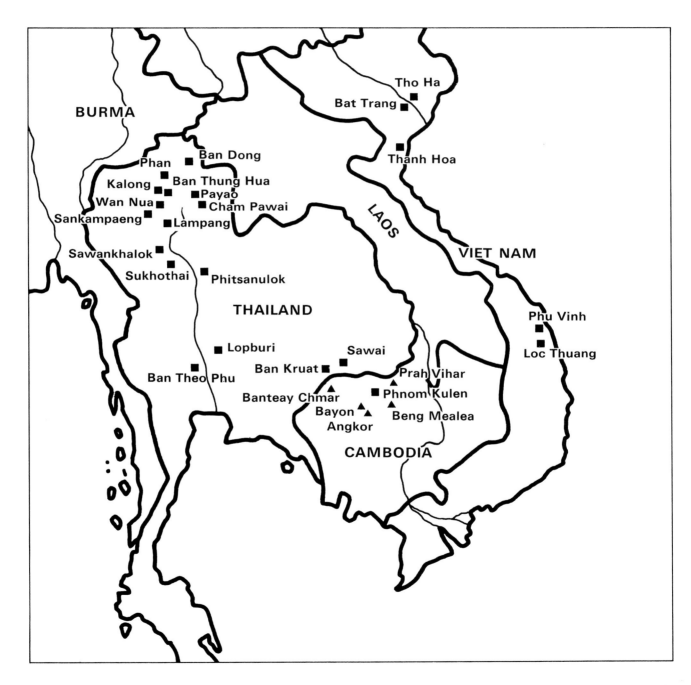

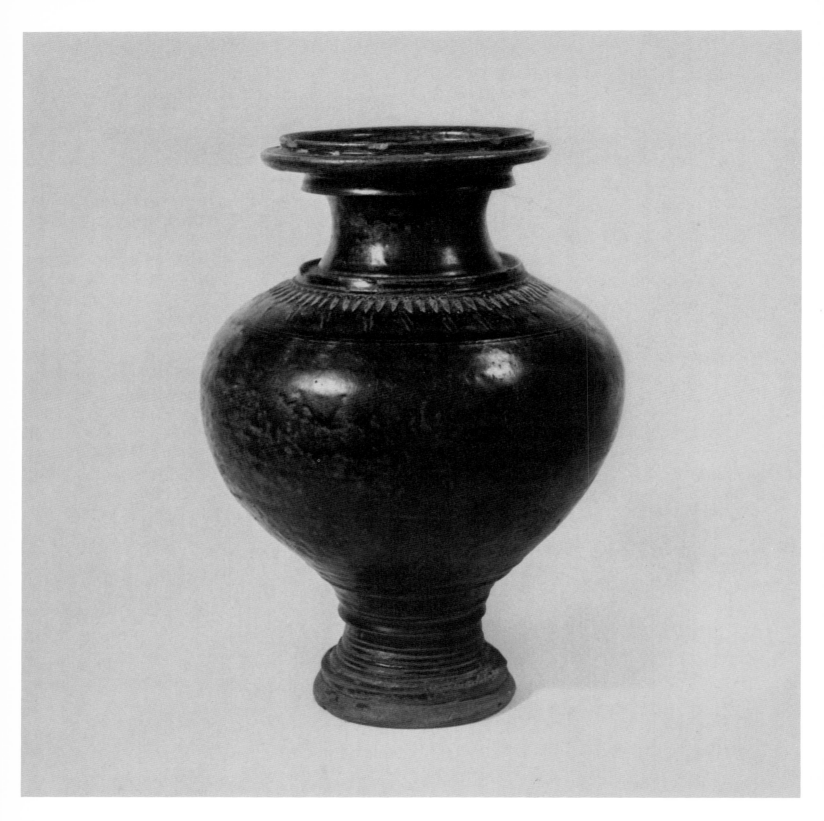

1. *Jar*. Khmer; 10th-12th century
Stoneware; H. 36.8 cm.

Before recorded history the ancient Khmers, ancestors of the modern Cambodians, settled in the heartland of the wide Mekong River basin. This region of rich natural resources afforded a unique geographical environment for the political and cultural development of the dynamic Khmer people, whose superior talents in government organization, hydraulic agriculture, architecture, and the other arts created, between the sixth and the fourteenth centuries of the Christian era, a highly developed civilization and the most powerful empire ever known in Southeast Asia.

Our knowledge of the development of these remarkable people, from the early years of the sixth century when they were a vassal state in the ancient Indianized kingdom of Funan, until they became a great empire, is limited principally to information obtained from the early accounts of Chinese historians, from some nine hundred Sanskrit and Khmer inscriptions that relate almost entirely to the projects of their kings and other high dignitaries, and from the numerous bas-reliefs carved on the Khmer monuments and other structures. The history of the Khmer Empire compiled from these basic sources has been divided into three periods: an early

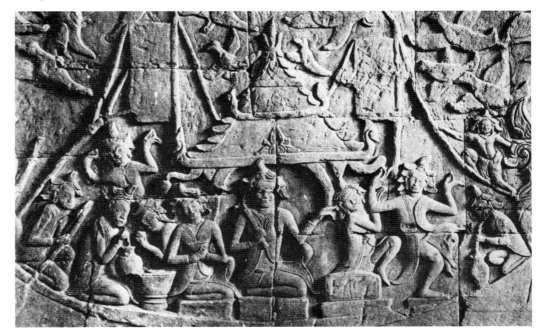

Fig. 1. Detail of a Khmer bas-relief on the Bayon showing a group of merrymakers in a boat using several ceramic vessels. One man is seated in the bow (right) drinking through a straw from a wide-mouthed jar. Near the stern kneels another whose attention has just been diverted from a large wine jar by a friend who holds out his cup suggestively. A large bowl with a flanged foot is on the deck in front of them.

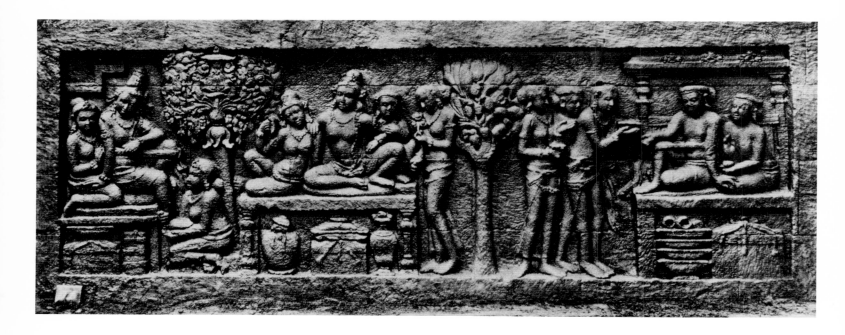

period extending from the first to the mid-sixth century (known only through the accounts of Chinese historians); the pre-Angkorian period, from the sixth to the end of the eighth century; and the Angkorian period, from the ninth to the fifteenth century. The Angkorian period was the classical era of Cambodian history, an era that witnessed the rise (and decline) of the Khmer Empire, with its centralized government, highly organized agriculture, state religions, and controlled social structure. The most remarkable achievement, however, and the Khmers' greatest contribution to civilization, is the vast series of magnificent monuments, architectural structures, stone sculptures, and works in bronze that have been found within the past century in what are now Cambodia, Laos, Thailand, and southern Viet Nam.[1]

At the same time the Khmer artisan potters were developing highly sophisticated ceramics whose individuality in form and decoration clearly sets them apart from those of other countries in Asia. The development of Khmer ceramic art, beginning in the Angkorian period, is set forth pictorially in the carved stone bas-reliefs found on the walls and pediments of such edifices as Prah Vihar (dating from the eleventh century), Angkor Wat (first half of the twelfth century), the Bayon (twelfth century), Beng Mealea (twelfth-thirteenth century), and Banteay Chmar (c. 1200). The carvings on these ruins show many ceramic and metal vessels and their decorations, and their provenance and dates are, of course, established by their host structures.[2] In many cases the utilitarian purposes of the pots can be easily discerned; for example, in a Bayon relief men aboard a junk are depicted drinking through reeds from large jars (fig. 1). At Angkor Wat a woman is shown carrying

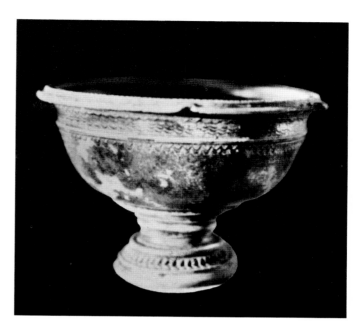

Fig. 4. Khmer and Javanese ceramic shapes: a. Javanese baluster jar similar to Khmer types (from a bas-relief on Candi Lara Jongrang, Prambanan, Java; b. Khmer oviform baluster jar glazed in two colors (private collection, Bangkok); c. Khmer brown-glazed stem bowl (T. C. White Collection, Cambridge, England).

a fine carafe with recessed oblong panels; while a water bottle on a tripod, two jars, and a man drinking through a reed from another jar can be seen at Banteay Chmar.[3] In a bas-relief on the second *gopura* (temple gateway) of Prah Vihar, depicting the churning of the sea of milk, a jar on the back of Kurma the tortoise is used as a pivot to hold a vertical pillar that represents the central mountain of the world. The jar has been said to resemble some Martaban jars, a name used for the large vessels that were exported in quantity from the port of Martaban in southern Burma.[4] Because such carved representations exist in considerable number and variety they can be used as a basis for comparison with and identification of numerous ceramic specimens discovered during modern times that are considered to be indigenous to the Khmer civilization.

Our other sources of information on Khmer ceramics are limited to reports of extensive deposits of potsherds and intact pieces found in close proximity to the Khmer ruins of Prasat Anlong Thom on Phnom (Mount) Kulen,[5] to comparatively recent discoveries by farmers of impressive deposits of ceramic debris and undamaged pieces near the remote small villages of Ban Kruat[6] and Sawai,[7] to numerous minor deposits found scattered over a considerable distance along the southern periphery of the Khorat Plateau,[8] and to chance discoveries of pottery within the confines of some of the ancient architectural ruins.[9] In addition, numerous pieces are uncovered periodically during the routine tilling of agricultural lands within the former, widespread frontiers of the Khmer Empire.

Even though these ceramics reveal an individuality that sets them apart from the major groups of Oriental ceramics that show Chinese affinities, some scholars

are of the opinion that Chinese tradition and technology played a dominant role in their development and production.[10] This opinion appears to be based on the fact that large numbers of ceramic fragments of Chinese origin, dating from the Sung dynasty on, and many examples of Thai pottery of the fourteenth and fifteenth centuries that show unquestionable Chinese influence have been found within the confines of some of the Khmer ruins in Cambodia and in other areas that were formerly within the Khmer Empire. The presence of pottery fragments of Chinese origin is not surprising; Chou Ta-kuan, a Chinese envoy from the Yüan court, who visited Angkor at the height of its splendor in 1296-97, reported the use of Chinese ceramics by the Khmers. He wrote, " . . . most in demand are Chinese gold and silver; next come figured silk fabrics woven with light or double thread. After these tin ware from Chen-chou, lacquered trays from Wen-chou, green porcelains [celadon] from Ch'uan-chou, mercury, vermillion, . . ." Under another caption, "Utensils," he noted, "For serving rice, they make use of pottery dishes from China, or copperware."[11]

Unfortunately, no written records concerning later imports into Cambodia from the Sukhothai and Sawankhalok kilns situated in present-day Thailand have been found. In any case, although Chinese and Thai pottery that has been unearthed

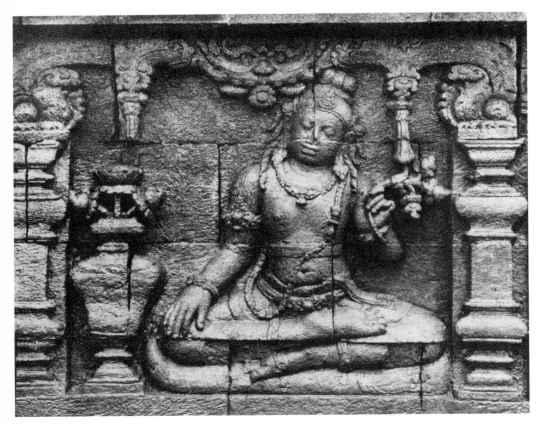

Fig. 5. In a bas-relief on Borobudur, Java, to the right of the goddess Hariti, three lotus blossoms are arranged in a large baluster jar. This type of vase is frequently seen holding the sacred flower in reliefs on Borobudur and may have been especially designed for use in religious ceremonies and temples. Khmer jars of like form (cf. No. 1) may have been used for similar purposes.

in Cambodia and elsewhere during modern times has often been confused with Khmer ceramics, on comparison the Khmer pieces appear to show no evidence of either Chinese or Thai influence.

As the theory of Chinese influence remains in serious doubt, the question might be asked: Are the Khmer ceramic types Khmer creations, and did their potters develop their own technology? At present there is no definitive answer, but monuments in Java suggest the possible origin of the early Khmer pottery forms and their decorations as portrayed in the Khmer bas-reliefs. Numerous ceramics are also illustrated in central Javanese carvings on the eighth-ninth century Buddhist stupa of Borobudur (fig. 2) and on ninth-century temples of Indian architectural tradition at Prambanan (figs. 3, p. 6, and 4a). These ceramic forms support the contention that Javanese art exerted a strong influence on the Khmers.[12]

The similarity of many of the ceramic and metal vessels shown on Khmer temples to those seen on Javanese structures of an earlier date should come as no surprise. Historical sources suggest that during at least part of the eighth century Cambodia (Chen La) was a feudatory of the Javanese Sailendras, and that about 790 a young Khmer (?) prince returned to Cambodia from exile in Java. By 802 he had consolidated his power sufficiently to liberate Cambodia from Sailendra suzerainty and to establish himself as Jayavarman II, the Devaraja, or "god-king."[13] When the young prince was in exile, we may assume he was familiar with Borobudur, and that on his return to his homeland its architectural and decorative influence was extended to Cambodia, perhaps through the work of artisans and craftsmen who accompanied him. It also seems likely that Javanese artistic taste represents an intervening step between India and the Khmers in the evolutionary development of ceramic art.

The carvings on the Khmer bas-reliefs assist us in determining the provenance and the age of numerous ceramic forms; the actual potsherds, wasters, and intact pieces discovered in recent years, along with those previously acquired by private collectors and museums in Asia and the Western world, offer us voluminous additional data on shapes and dimensions, the nature of the clay, the types of glaze, and the style of decoration which characterize the Khmer wares. From this evidence it soon becomes apparent that Khmer ceramics are, with limited exceptions, fully formed, heavily potted, and carefully executed stonewares.

The ceramics include large, ovoid, cylindrical, or spindle-bodied baluster jars of classical form, usually modeled in low or moderate relief and decorated with simple, incised designs under the glaze. The mouths of these jars have a circular, flared shape, with either wide or narrow openings, and their pedestal bases are usually hollow (No. 1).[14] Baluster jars of similar form, usually holding the sacred lotus, are frequently represented in reliefs on Borobudur (see figs. 2 and 5). They undoubtedly were used in Buddhist ceremonies and as fixtures in the temples. The hollow bases found on the large Khmer jars are also found on vases and bottles of all

sizes and seem to be a common characteristic of certain types of Khmer ceramics. Also typical are the paucity of handles and the occasional presence of non-pouring spouts on jars and bottles. Other jars of Khmer form and incised decoration but with unusual, splayed, high foot rings and slightly concave bases have been recovered from the riverbed of Thale Sap.[15] There are numerous bowls (No. 5) of various shapes and sizes, some of which are potted in a very individual manner with one or more deep wheel cuts above the base (No. 6). This decorative device can also be found on many other forms of Khmer ceramics including vases (No. 7), the large, wide, flat-bottomed water jars (No. 4) and the ceramics found on Phnom Kulen (No. 2). Examples of the same shapes and decorative treatments can also be found in the carvings on Borobudur, such as the large jars shown in fig. 6, the tall baluster jar (fig. 7; cf. fig. 4b), and the bulbous jar decorated with a series of wheel cuts in its lower section (fig. 7). In addition, there are bowls with hollow or solid pedestal bases (fig. 4c) that can be identified in the bas-reliefs on the Bayon, in the reliefs on Borobudur (fig. 8), and in those on Candi Lara Jongrang at Prambanan (fig. 3, p. 6). Among the remaining ceramic shapes are decorated, compressed globular vessels (No. 8), some with pouring spouts and stylized animal and bird handles (No. 9), boxes, cups, flasks, jugs, urns, conch-shells, and a wide variety of semi-zoomorphic (No. 12) and zoomorphic forms (Nos. 10, 11, 13).

The bases of these pieces are usually flat, but may be slightly concave, and are often covered with a thin glaze. It is not uncommon to find one of a variety of marks on the base such as sets of shallow, incised, double or triple lines crossing each other, or a simple cross, or, occasionally, a star. Sometimes rough, concentric lines are found on the bases of large jars, indicating that they were cut from a potter's wheel with a cord.

The clays in these jars and in the other forms vary in color from off-white, to ivory, ochre, shades of brown, and black and their texture also shows a wide variation. The dark clays found in the large jars are usually coarse, sometimes contain small, rounded, quartz pebbles, and appear to be composed of fused iron compounds. Light shades of clay are often fine in texture and appear to have been levigated.

For the most part, glazes on the Khmer wares are thin and flake easily. They are limited in color to various shades of brown, almond green, yellowish green, cream white, and black, the color of the glaze having been determined in most cases by its iron content and the firing conditions in the kilns. Ceramics glazed in two colors are not uncommon, but some two-color wares have actually been made with two different pastes, covered with a monochrome glaze. As an example, on the high-necked bottle (No. 12) a light paste has been appliquéd on both the interior and exterior of the neck and on details of the molded elephant's head. The glaze, which looks greenish over the light paste, looks dark brown on the body of the bottle. The glazes are usually unevenly applied, whether on the interiors or exteriors

Fig. 6. Detail of a bas-relief at Borobudur showing two large water jars with slightly curved sides, low necks, and wide mouths. Khmer jars of this shape are frequently found in Cambodia, Thailand, and Laos (cf. No. 4).

Fig. 7. Detail of a bas-relief at Borobudur showing a large, pedestal-footed, oviform vase, with a high neck and a lotus petal pattern in relief around the shoulder, that is similar to the Khmer piece represented in fig. 4b. The small globular jar to the left of the vase's mid-section is decorated with a series of parallel wheel cuts above its base, a common characteristic of Khmer ceramics (cf. Nos. 2, 3, 6, 7, 12).

Fig. 8. Detail of a bas-relief at Borobudur. The large, baluster-footed bowl with a thick, everted, beveled rim closely resembles a common Khmer ceramic shape (cf. fig. 4c).

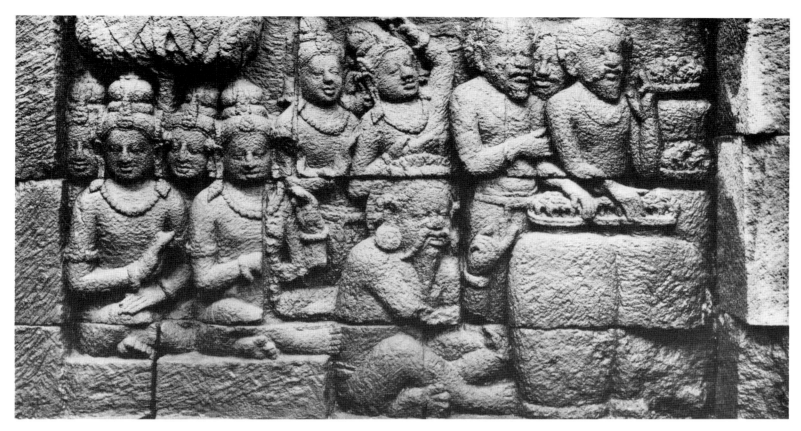

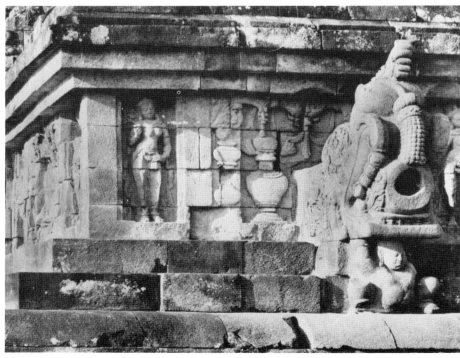

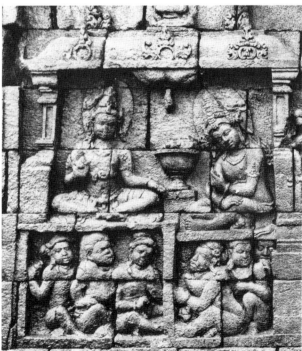

of the pots; they are sometimes finely crazed and often run short of the foot. In addition to their decorative function, such glazes were undoubtedly intended to reduce the permeability of vessels used for the storage of water and other liquids.

As a general rule decorations, shallowly incised under the glaze, are simple designs of single or multiple bands of chevrons, wavy lines, cross-hatching, concentric loops, vertical lines, horizontal parallel lines, and stylized lotus petals.

In addition to the incised designs, one frequently finds molded heads of animals (elephants being the most common), birds, and reptiles attached to jars of all sizes. There are also anthropomorphic cinerary urns, bottles, and jars with pointed knob handles, sometimes in the shape of stylized lotus buds, on the lids. Delicately designed pericarps and petals of the lotus modeled in relief were frequently used to decorate lids of small jars (No. 3) and the collars on the shoulders of the spindle-shaped baluster jars (No. 1). The lotus motif is often found on potsherds that show off-white clay appliquéd on a dark brown body.

The type of kiln and the firing methods used by the Khmer potters remain a matter of conjecture because the few suspected ancient production centers have not been systematically investigated. There is, however, evidence at an extensive kiln center near Ban Kruat that kiln fixtures in the form of small clay wads were used for separating bowls when they were stacked in the kilns before firing (fig. 9). The fired wads are found in great profusion with numerous potsherds and other ceramic debris representing a wide range of different ceramic forms, clays, and glazes. Very often large, irregularly shaped, flat slabs of high-fired clay are found with the potsherds and other kiln debris, suggesting that these slabs had been used for kiln construction in lieu of bricks. Laterite, a common construction material used by the Khmers, could also have been used for building kilns.

Up to the present time, attempts to classify Khmer ceramics have not met with much success. Sufficient data for dating the wide range of ceramic types is lacking, as is positive proof of the locations of their centers of manufacture.

The question of whether Khmer ceramics were items of early international trade remains to be investigated. They have been found in considerable numbers in Thailand and they have appeared in Malaysia but, because much of this area was once part of the Khmer Empire, perhaps these finds were not, in the strict sense, export wares. As far as is known, Khmer ceramics have not been excavated in the Philippines, but they have been reported in Indonesia by E. W. van Orsoy de Flines, who wrote that Cambodian jars are found frequently, practically always buried and containing remains of cremations, and that the distribution of Cambodian ceramics is ''limited to Lampung (south Sumatra), Java, Bali, and the central and southern Celebes.''[16]

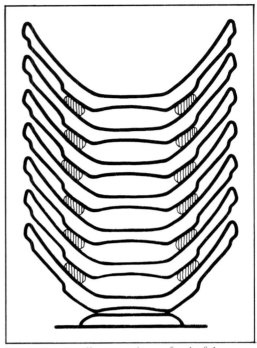

Fig. 9. Drawing illustrating the use of wads of clay to separate stacked bowls during firing. This technique was used at Ban Kruat.

(See Selected Bibliography for complete information on publications referred to here in abbreviated form.)

1. For the history of Cambodia see L. P. Briggs, ''The Ancient Khmer Empire,'' and G. Coedès, *The Indianized States of Southeast Asia.*

2. See H. Dufour and G. Carpeaux, *Le Bayon d'Angkor Thom.* In their two-volume photographic record of the Bayon, eighteen plates reveal some thirty-eight depictions of different Khmer ceramic and metal vessels carved in the bas-reliefs. See also G. Groslier, ''Objets anciens trouvés au Cambodge,'' pp. 129-139. During an archaeological mission to Cambodia in 1913 Groslier collected nineteen ancient ceramics from the houses of Cambodians and compared them with those that he had observed in the bas-reliefs on the temples of Banteay Chmar, Angkor Wat, and the Bayon. Finding them to be of the same apparent type of workmanship, form, and decoration, he assigned them to the period of Angkor Thom and Angkor Wat.

3. For drawings of these and other ceramic shapes found on the bas-reliefs see G. Groslier, *Recherches sur les Cambodgiens,* pp. 119-120, fig. 77.

4. See C. N. Spinks, ''Siam and the Pottery Trade of Asia,'' p. 85.

5. See E. Aymonier, *Le Cambodge,* vol. 2, pp. 414-415. See also W. Willetts, *Ceramic Art of Southeast Asia,* pp. 7-8, and Louis-Frédéric, *Art of Southeast Asia,* p. 355.

6. It is not clear when Khmer ceramics were discovered in the Ban Kruat area, but it probably coincided with the unusual influx of pieces into the Bangkok antique market during early 1969. The name and the location of the area where these pots originated did not become generally known to collectors until 1972. Although there have been no controlled systematic archaeological excavations, the numerous mounds containing an abundance of potsherds and wasters found in the area are undoubtedly the remains of an extensive ceramic manufacturing center that probably dates from the eleventh century. J. R. Galloway visited Ban Kruat on many occasions and examined several of the large mounds where he found hundreds of pieces of pottery rejects, both on the mounds' surfaces and scattered over wide areas contiguous to them. A great many of the brown-glazed pieces were bases, shoulder fragments, necks, and flat, circular tops of classical baluster-type jars, but these were mixed with numerous large fragments of high-fired bowls of cream colored paste covered with thin, almond green glaze, a large number of fragments appliquèd with off-white clay decorations on a dark paste, and unusual jar sections covered with a heavy black glaze and decorated with light, chocolate brown glaze in parallel bands and mottled spots, showing that the Khmer potters were masters of their material and possessed a sophisticated knowledge of ceramic technology. (J. R. Galloway and S. Limmanont, ''The Ban Kruat Kiln Site,'' unpublished report, 1973-74.) S. Vallibhotama (''The Khmer Ceramic Kilns of Ban Kruat and Their Preservation,'' pp. 30-33) reported that more than one hundred ''kilns,'' some up to four meters high, are found scattered over about 150,000 *rai* (approximately 243 square kilometers), and that the largest part of the area lies within the vicinity of the Ban Kruat Self-Help Land Settlement. Unfortunately, many of the mounds were leveled to the ground by villagers and officials of the land settlement program when the land was cleared for agricultural development. In spite of the obliteration of some of the mounds, however, a large number of misfired pieces and fragments covered with black, brown, ivory, and green glazes were collected for study. Included in these are jars and bottles covered with two-color glazes, ceremonial vessels, toys, glazed tiles and finials, zoomorphic, semi-zoomorphic, and anthropomorphic forms, and glazed and unglazed large jars, vases, bowls, plates, cups, and boxes. Within a thirty-one-kilometer radius of the Ban Kruat site are a mid-eleventh century Khmer temple, Prasat Phnom Rung, and Prasat Muang Tham, Prasat Huay Thamor, Prasat Lalom Thom, Ban Prasat, Prasat Beibaek, and Kok Prasat. Vallibhotama points out that in the vicinity of these sanctuaries, ''. . . are ancient towns, large water reservoirs, irrigation dams and ancient roads which mark the living settlements of the well organized society of that time. At these archaeological sites, the relationship that the Ban Kruat pottery has with them is more obvious, as one is likely to come across its ceramic sherds of black, brown or green glaze on the ground. Therefore, the ceramic kilns of Ban Kruat is, so to speak, a pottery manufacturing area for the Phnom Rung community at a certain period of time and it reflects a high level of specialization, as well as technological advancement of the society to which it belongs.'' (Ibid., p. 33)

7. In a personal communication to the author, Nikom Musigakama of the National Museum, Bangkok, affirmed his discovery of ''a new kiln'' in 1972 near the village of Sawai about eleven kilometers south of Surin. He reported that he found a wide variety of Khmer potsherds and kiln rejects. In R. Brown, V. Childress, and M. Gluckman, ''A Khmer Kiln Site—Surin Province,'' the authors mention visiting seven sites being exploited by local villagers in the Sawai area. The different types of Khmer ceramics taken from these digs and from others near Sawai are almost identical to those found in abundance in the Ban Kruat area. Although there have been no officially controlled excavations in the area to establish that it was an ancient manufacturing center, the presence of large pieces of high-fired clay lead the authors to believe that they are structural remains of kilns which probably date between the mid-eleventh and the thirteenth century.

8. In 1901 Aymonier reported finding countless small pieces of glazed pottery on a hill named Preah Ei Sei, ''The Holy Hermit,'' six kilometers southeast of Bak Dai village, which is south of Surin (*Le Cambodge,* vol. 2, p. 189). Unfortunately he tells us nothing more. In an unpublished report (''Note on Khmer Ceramics in Southern Isan, Thailand''), Lauriston and Ruth Sharp stated that many examples of glazed, imperfect ceramics of Khmer style were observed while conducting an ethnographic survey during 1966 in Surin, Buriram, and Sisaket provinces in northeastern Thailand. Many of these pieces were in Buddhist monasteries, village ancestral shrines, and district government offices. A search of some areas failed to reveal positive evidence of an ancient Khmer kiln site.

9. In ''Objets anciens trouvés au Cambodge,'' G. Groslier lists nineteen pieces found in different areas in Cambodia. H. Marchal catalogues thirty Khmer pieces with detailed descriptions in ''La collection khmère, Musée Louis Finot.'' B. P. Groslier, *Indochina,* pl. 143, shows two pots in an eleventh-century Khmer burial at Sras Srang.

10. See Aymonier, *Le Cambodge,* vol. 2, pp. 413-418; Groslier, *Recherches sur les Cambodgiens,* pp. 129-133; and A. Silice and G. Groslier, ''La céramique dans l'ancien Cambodge.'' These scholars credit Chinese technology for the development of Khmer ceramic art, beginning in the Angkorian period, without offering specific supporting evidence to show how such technology might be identified in the numerous existing ceramics which have been accepted as being indigenous to the Khmer civilization. Willetts brought the subject of Chinese tradition into proper perspective when he wrote: ''In view of the established strength of Chinese ceramic tradition, it is difficult to believe that an overt Chinese influence would not be evident in classical Khmer pottery had the potters been Chinese ''(*Ceramic Art of Southeast Asia,* p. 9).

11. Chou Ta-kuan, *Notes on the Customs of Cambodia,* pp. 34, 35.

12. See N. J. Krom and T. van Erp, *Beschrijving van Barabudur.* These two volumes give a complete photographic record of the bas-reliefs on Borobudur where perhaps more than one thousand ceramic and metal containers ranging from small vessels to large water(?) jars can be easily identified. C. Sivaramamurti contends that most of these forms are still used in India, especially the spouted ewers and the bowls, and he therefore implies that the forms in the reliefs are of Indian origin (*Le stupa de Barabudur,* pp. 7-8). However, the Javanese sculptors undoubtedly altered some of these to suit their own artistic taste.

13. Coedès, *The Indianized States of Southeast Asia,* pp. 97-103.

14. These hollow bases were formerly reported as a characteristic of Khmer baluster jars that were thought to have been made in Thailand and not in Cambodia. As several large jars in the National Museum, Phnom Penh, and numerous jars of all sizes found elsewhere have this characteristic it cannot be assigned only to Thailand. See Willetts, *Ceramic Art of Southeast Asia,* p. 8.

15. See J. Stargardt, ''Southern Thai Waterways; Archaeological Evidence on Agriculture, Shipping and Trade in the Srivijayan Period,'' *Man* 8 (March 1973), pp. 18-20.

16. E. W. van Orsoy de Flines, *Guide to th Ceramic Collection (Foreign Ceramics),* p. 63.

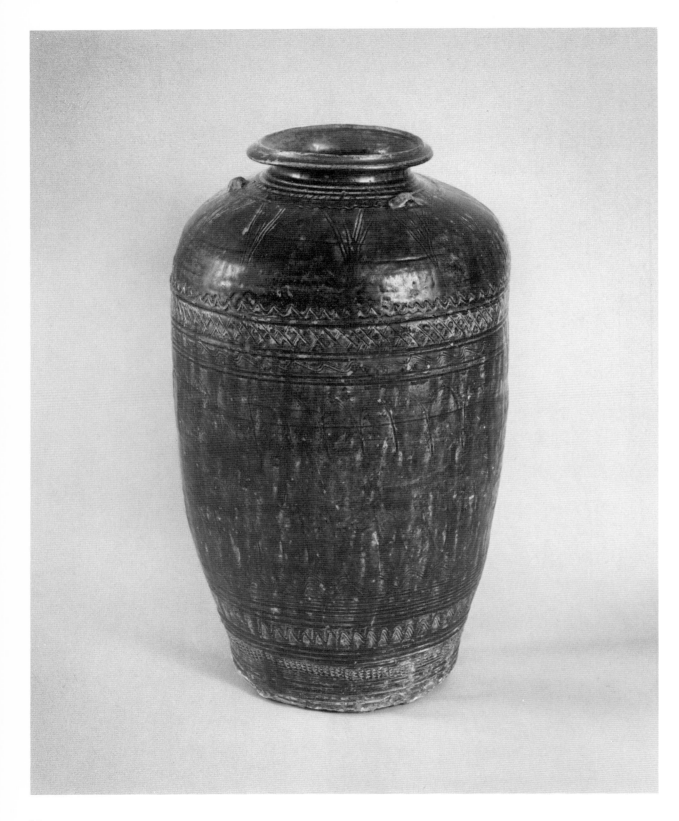

2. *Cosmetic Box*. Khmer; 10th–12th century
Stoneware; Diam. 7.5 cm. (*below*)

3. *Covered Jar*. Khmer; 10th–12th century
Stoneware; H. 8.5 cm. (*upper right*)

4. *Storage Jar*. Khmer; 11th–13th century
Stoneware; H. 65 cm. (*opposite*)

5. *Bowl*. Khmer; 11th–13th century
Stoneware; Diam. 26.2 cm. (*lower right*)

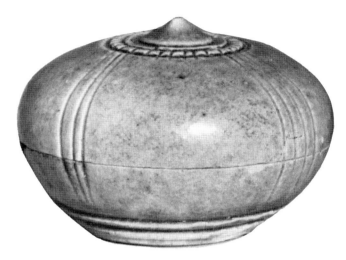

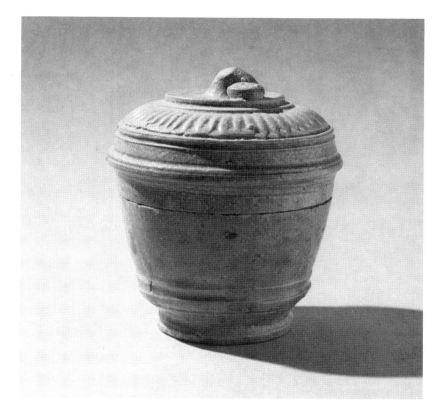

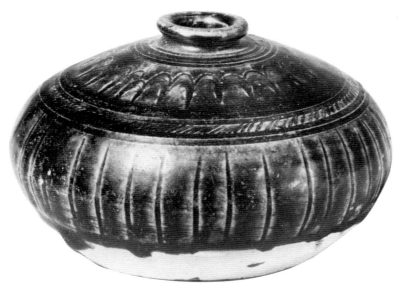

6. *Bowl.* Khmer; 11th-13th century
Stoneware; Diam. 19.5 cm. (*below left*)

7. *Vase.* Khmer; 11th-13th century
Stoneware; H. 28.3 cm. (*opposite*)

8. *Oil Jar.* Khmer; 11th-13th century
Stoneware; H. 8.7 cm. (*left*)

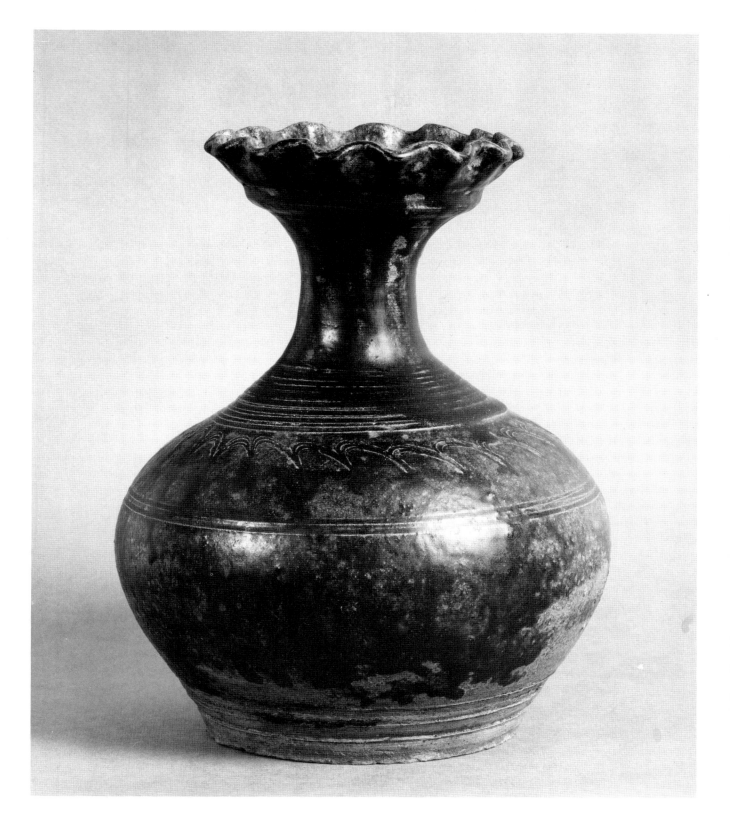

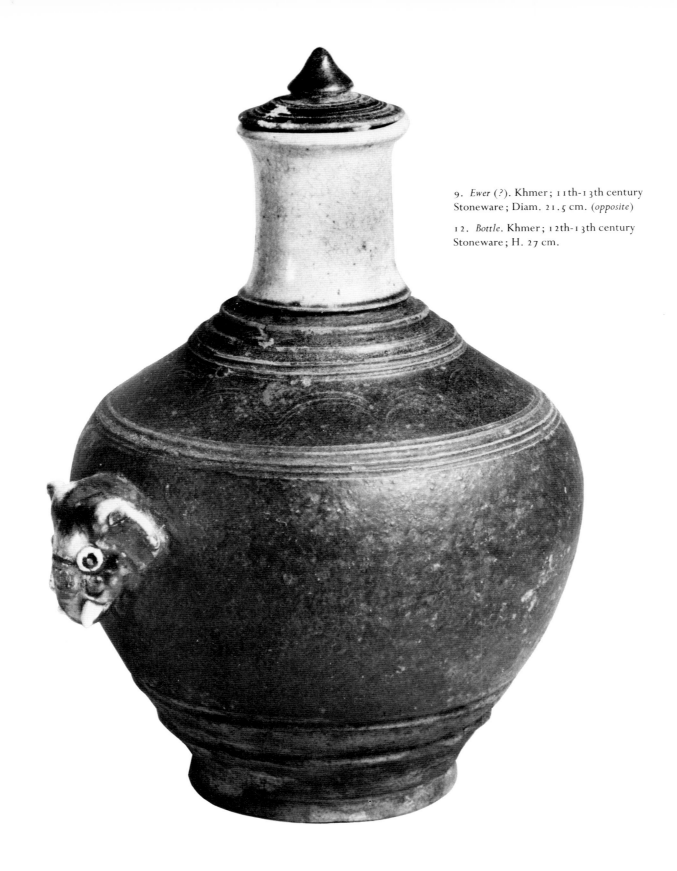

9. *Ewer* (*?*). Khmer; 11th-13th century
Stoneware; Diam. 21.5 cm. (*opposite*)

12. *Bottle*. Khmer; 12th-13th century
Stoneware; H. 27 cm.

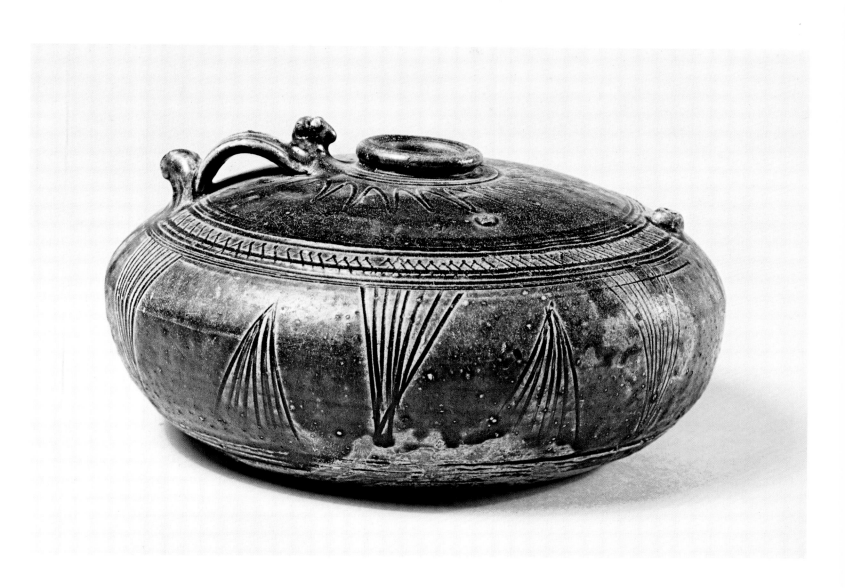

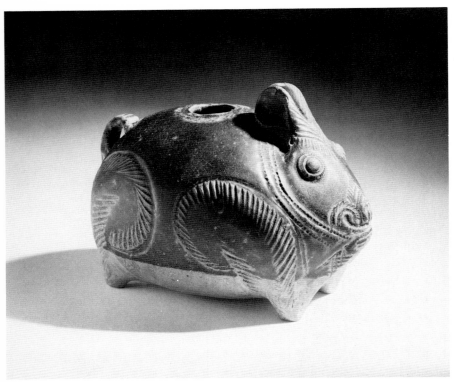

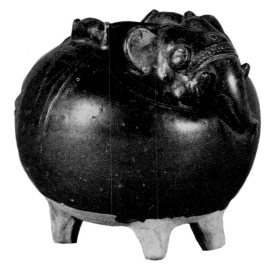

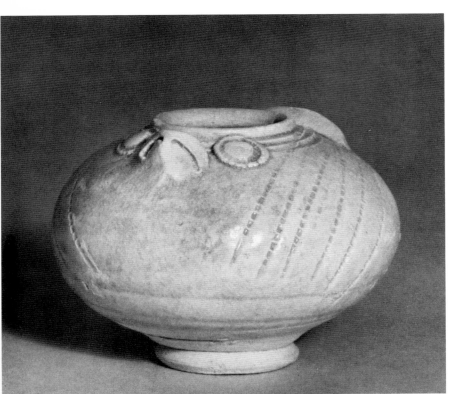

10. *Jar in the Form of an Elephant*. Khmer;
 12th-13th century
Stoneware; H. 12.5 cm. (*above right*)

11. *Jar in the Form of a Rabbit*. Khmer;
 12th-13th century
Stoneware; H. 11.7 cm. (*above left*)

13. *Jar in the Form of an Owl*. Khmer;
 12th-13th century
Stoneware; H. 8 cm. (*left*)

Khmer Ceramic Art

1. *Jar*. Khmer; 10th-12th century
Stoneware; H. 36.8 cm.
Lent by the National Museum, Bangkok

A bulbous baluster jar with a high neck and a wide, flanged mouth rim is decorated with a band of molded, off-white, stylized lotus petals and incised, concentric loops around the shoulder. A crackled brown glaze covers the gray paste. (*p. 22*)

2. *Cosmetic Box With Cover*. Khmer; 10th-12th century
From Phnom Kulen
Stoneware; Diam. 7.5 cm.
Lent by Mr. and Mrs. T. C. White

A compressed globular box has a circular design in relief around a conical knob on the cover, incised, vertical stripings on the body, and wheel-cut flanges above the flat base. The box is fashioned of pale gray paste with an even, pale green glaze over the exterior; the lower section of the interior is glazed in chocolate brown.

3. *Covered Jar*. Khmer; 10th-12th century
From Phnom Kulen
Stoneware; H. 8.5 cm.
Lent anonymously

A molded lotus pericarp and stem on the raised center, surrounded by a band of lotus petals in relief, decorates the cover of the jar. It has straight sides and a high foot, and the gray beige paste is coated in beige glaze.

4. *Storage Jar*. Khmer; 11th-13th century
From Buriram or Surin province
Stoneware; H. 65 cm.
Lent anonymously

The shoulder of this jar, with its flaring, flanged rim on a short neck, is decorated with four low knobs and incised bands of chevrons. Parallel lines of waves, cross-hatching, and vertical loops encircle the upper part of the vessel, and above the flat base there are similar designs. A thin, uneven, dark brown glaze covers the beige paste. (Cf. jars in fig. 6.)

5. *Bowl*. Khmer; 11th-13th century
From Ban Kruat
Stoneware; Diam. 26.2 cm.
Lent anonymously

The deep bowl has a beveled rim and steep, rounded sides. Its pale beige paste is covered with a thin, transparent, crackled, pale green glaze that ends in an uneven line above the foot ring. The base is flat. Seven wad scars are visible in the bottom of the bowl (see fig. 9).

6. *Bowl*. Khmer; 11th-13th century
From Ban Kruat
Stoneware; Diam. 19.5 cm.
Lent anonymously

This undecorated, almond green glazed bowl has an exterior, extruding, thin flange above a low foot ring. Below the flange and around the bottom of the interior are several firing scars.

7. *Vase*. Khmer; 11th-13th century
From Ban Kruat or Sawai
Stoneware; H. 28.3 cm.
Lent by Mr. and Mrs. Severance A. Millikin

The bulbous vase has a high neck ending in a flaring, rippled rim. Incised horizontal bands and a loop design around the shoulder, under the thin brown glaze, decorate the body, which is of brown paste.

8. *Oil Jar*. Khmer; 11th-13th century
From Surin province
Stoneware; H. 8.7 cm.
Lent by James W. Frasché

Incised, concentric circles, loops, and vertical lines decorate this compressed globular jar with a concave base. The uneven, thin, green brown glaze forms thick drops above the base, where the pale gray paste is exposed.

9. *Ewer* (?). Khmer; 11th-13th century
From Ban Kruat
Stoneware; Diam. 21.5 cm.
Lent by the Philadelphia Museum of Art

A stylized, zoomorphic, strap handle and unusually small spout distinguish this compressed globular pouring vessel. Decorations are incised under a thin, uneven, dark brown glaze that covers the gray paste.

10. *Jar in the Form of an Elephant*. Khmer; 12th-13th century
From Sawai
Stoneware; H. 12.5 cm.
Lent by the Herbert F. Johnson Museum of Art, Cornell University

A sculptured elephant's head and tail embellish this jar for lime paste. Two loop handles on the back flank the circular opening, and four short legs support the globular form. The gray paste is coated in brownish black glaze.

11. *Jar in the Form of a Rabbit*. Khmer; 12th-13th century
From Surin province
Stoneware; H. 11.7 cm.
Lent by the Philadelphia Museum of Art

This incised, zoomorphic jar, used as a container for lime paste, is covered with a thin, crackled brown glaze.

12. *Bottle*. Khmer; 12th-13th century
From Ban Kruat
Stoneware; H. 27 cm.
Lent by the Herbert F. Johnson Museum of Art, Cornell University

This high-necked bottle has a rounded mouth rim and a conical top. A light cream-colored paste has been appliquéd on the inside and outside of the neck and used to shape details of the elephant's head molded on the side of the bottle. Because of the use of two clays, the crackled glaze which looks greenish over the light paste appears brown on the lower part of the vessel. (*p. 36*)

13. *Jar in the Form of an Owl*. Khmer; 12th-13th century
From Ban Kruat
Stoneware; H. 8 cm.
Lent by Mr. and Mrs. J. R. Galloway

An owl's beak and eyes in relief on the shoulder of this globular jar, the suggestion of a tail, and incised outlines of wings create an illusory image. The transparent glaze is crazed. The jar has a low, narrow lip rim and a high foot.

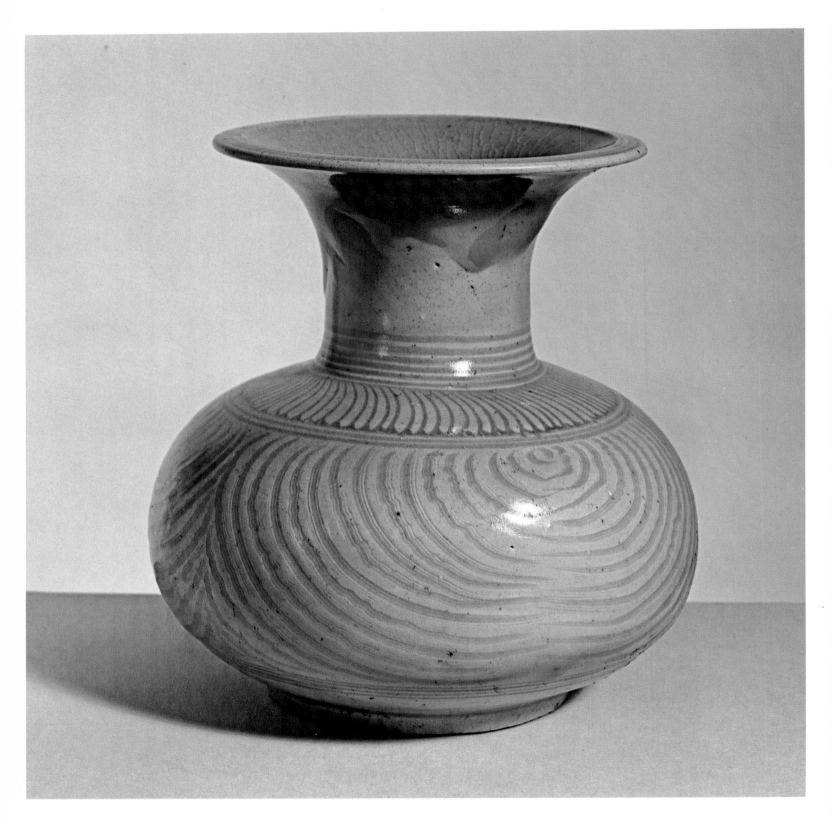

23. *Vase*. Thai; 14th-15th century
Celadon; H. 20.8 cm.

According to early Chinese historical sources the Thai, Shan, Lao, and other racially related tribal groups made their first appearance in southwest and south China long before the beginning of the Christian era. For centuries these "barbarians" south of the Yangtze River had been driven back by the Chinese, until early Christian times when they came under Chinese suzerainty.

The founding of the T'ang dynasty in 618 A.D., which brought a new era to China, was paralleled by the resurgence of large-scale political power of the Thai clans and other tribal people in southwest China. In 628 Chao Mo, clan chief of the Nan-chao-man, yielded his allegiance to the T'ang court, and in 647 he became the governor of his territory, which had been reorganized as a department under the T'ang. Some time later, when Chief P'i-lo-ku of Nan-chao came to power, with the imperial sanction and the prestige of imperial backing he overpowered the other chiefdoms in the southwest. Out of these conquests emerged the war-like kingdom of Nan-chao with its base on the Tali Plain in northwest Yunnan. Nan-chao had a Thai population, but its rulers were of a different race. During the period of about six hundred years between the kingdom's formation and its conquest by the Mongols in 1253, the elite of Nan-chao, as a result of innumerable wars of conquest, intermarriage with the Chinese, acceptance of imperial gifts, and educational privileges exercised under imperial T'ang and Sung tutelage, served as a medium for the uninterrupted sinicization of the peoples in southwest China.

It was during the first millennium A.D. that the Thai tribal groups, who seemed to be ever on the move, slowly pressed their way southward through the great river valleys into the areas that are now Burma, northern Thailand, and Laos. These gradual infiltrations brought them into contact with the Mon people, who probably converted them to Theravada Buddhism, and with the Khmers, in whose armies they served as mercenaries. As far as can be determined the Thais did not remain in isolated groups, but intermarried with the Mons, Khmers, Burmans, and other peoples encountered in the southern regions and adopted many of their customs. As Coedès has pointed out, " . . . the Thai have always been remarkable assimilators: they never hesitated to appropriate for themselves whatever in the civilization of their neighbors and masters might place them in a position to fight victoriously against them."[1]

In the eleventh century, the Thais began to form small principalities under

their chieftains, perhaps the earliest being at Payao in the northern tributary system of the Chao Phraya River basin. Early in the thirteenth century, following a strong southward movement of the tribes and weakening Khmer control of that empire's northern frontier, they founded Mogaung and Muong Nai and, in 1229, conquered Assam. About the same time it is thought that they founded Luang Prabang and in 1238 they were sufficiently strong to wrest the city of Sukhothai from their Khmer overlords. Somewhat later they established it as the capital of the first Thai kingdom, and eventually substituted their government for the Khmer administration in the Chao Phraya River basin and on the upper Mekong.

Before the new rulers of Sukhothai had fully consolidated their power, however, the Mongols conquered Nan-chao in 1253 and pacified Yunnan in 1257. These martial activities exerted greater pressure on the southward migrations of Thai tribesmen, who eventually joined their predecessors in the valleys of present-day Burma and Thailand. There they seized power in established principalities or formed new ones. The conquest of Pagan by the Mongols in 1287 meant the temporary disappearance of the Burmese kingdom and the division of the country, with tacit Mongol approval, into principalities governed by Thai chieftains. Following the Mongol incursions into Burma, the Thai chief of Chiang Rai, Mangrai, conquered the old Mon state of Haripunjaya and founded the kingdom of Chiang Mai. Many of these far-reaching political events seem to have resulted not from a sudden change in the composition of the population in the northwestern areas of Southeast Asia, but from the seizure of power by a governing elite of Thai origin.[2]

The new, independent Thai kingdom of Sukhothai reached the height of its power during the late thirteenth and early fourteenth centuries under its most celebrated ruler, Rama Khamhaeng (1283-c. 1317), a formidable warrior, statesman, builder, lawgiver, and scholar. Among his other achievements, Rama Khamhaeng adopted the Khmer script for writing the Thai language. It has also been recorded that during his reign the kingdom of Sukhothai entered into diplomatic relations with China, and Thai tradition asserts that Rama Khamhaeng visited the Middle Kingdom in person. But the data that have been used to support this assertion and several other folk-legends connected with his reign have recently been challenged.[3]

The kingdom of Sukhothai is often referred to as the "cradle of Siamese civilization." With their sinicized political, military, and cultural background as a base and their later assimilation of civilizing influences from their Mon, Khmer, and Burmese neighbors, the Thais developed their own unique civilization, institutions, and art.[4] The architectural ruins at the capital city of Sukhothai and further north at Sawankhalok attest to the Khmer influence, clearly discernible in these early Thai structures that probably date from the thirteenth century. The Thai artistic genius is also revealed in their early development of bronze sculpture and ceramics. The Sukhothai school of sculpture was active from the thirteenth to the sixteenth cen-

tury, and it is probable that the ceramic industries at Sukhothai and Sawankhalok flourished during at least part of that time. The periods of their productivity, however, remain a matter of conjecture, as do those of the other ten indigenous ceramic sites that have been reported in Thailand during the past sixty years.

The ancient ruins of these twelve ceramic centers are concentrated in the upper reaches of the Chao Phraya River basin among the fertile valleys of its northern tributaries, which undoubtedly served in very early times as access routes and places for settlement by the Thai tribes during their southward migrations. Of these sites, ten are located within a comparatively narrow area extending about 370 kilometers northward from the city of Sukhothai, between the Yom River on the east and the Ping River on the west.[5]

In this area are located the ceramic centers of Sawankhalok (reported in 1885),[6] Sukhothai (1907), Phitsanulok (1917),[7] Kalong (1933), Sankampaeng (1952), Cham Pawai (1959?), Phan (1962), Ban Dong (1962?),[8] Ban Theo Phu (1966),[9] Wan Nua (1967?), Lampang (1972), and Ban Thung Hua (1974). The concentration of these sites within rather restricted geographical limits, and the considerable variation from site to site in ceramic technology and in the forms, decorations, and quality of the wares strongly support the contention that the area had a substantially changing population over a period of several centuries. Successive groups of artisan potters who accompanied the migrating Thais, and perhaps itinerant potters from outside the area as well, must have made their various contributions to the ceramic arts.

Throughout the literature on Thai ceramics one encounters the ever-present argument that Chinese potters were responsible for the technological and artistic development of the various indigenous potteries found in Thailand. Although these ceramics often show some Chinese influence, it does not necessarily follow that they could have been created only by Chinese craftsmen. Chinese ceramic designs and methods of fabrication were probably introduced into Thailand during the tribal infiltrations by skilled, migrant Thai artisans. No doubt these potters had obtained their knowledge of the techniques from their predecessors, who had learned the art during the long periods of sinicization of their ancestral homelands of Nan-chao and Yunnan.

As an introduction to the following discussion of the different ceramic centers in Thailand, it should be mentioned that the absence of adequate supporting archaeological and historical data on the ceramic sites precludes their being assigned accurate dates for the periods of their activities. Therefore, in the pages that follow the sites will be considered in the sequence of their reported dates of discovery. Unfortunately, some of these sites have received only superficial archaeological attention, and all of them have been immeasurably damaged, either through pilfering or as a result of official and unofficial land reclamation for agriculture.

The Ceramics from Sawankhalok

In 1901 and 1903 Thomas Lyle of the British Consular Service in Thailand wrote what are probably the first reports published in the English language on ancient indigenous ceramics of Thailand.[10] These describe his two visits to an abandoned ceramic center or kiln site near ruins of the city known to the Khmers as Sri Satchanalai (old Sawankhalok), on the west bank of the Yom River about nineteen kilometers north of the modern city of Sawankhalok. From his reconnaissance of the area, Lyle concluded that there were two distinct groups of kilns, the more northerly group of "not less than fifty" kiln structures commencing some six and a half kilometers above the old city, and the second group of "thirty-two in various stages of ruin" much nearer to its north wall.

The northern kiln ruins were situated more or less in one extended line, but in some sections the line apparently widened to include several kilns arranged parallel to each other.[11] They were originally of brick construction, roughly uniform in size, the largest being about ten meters in length, and each was divided into three vaulted sections: a hearth, a firing room, and a chimney. Most of the ceramic debris found around these kilns consisted of artistically decorated celadon shards.

In the southern kilns, which were better protected from invaders or the curious by heavy vegetation, Lyle found that a different type of ware had been made. Fragments of white-glazed tiles, sections of temple guardians, or *yakshas*, of ferocious appearance, and shards of other architectural ceramics were discovered among the kiln ruins. Lyle was impressed by the voluminous debris of bricks, ceramic "pipes," and wasters, as well as the great masses of shards found near the kiln mounds and in the riverbed as far removed as the modern city of Sawankhalok, some thirty-two kilometers by river south of Sri Satchanalai. Special attention was given to the large number of "pipes," described as being of various sizes and "built like a gun barrel," which were used as stands to support vessels in the kilns.

These cylindrical ceramic tubes or "pipes," sometimes referred to as pontils (as they are called in the glass industry), vary in length and diameter. They are made of fireclays which have a wide range of colors, and are fired at high temperatures before they are used as stands for ceramics placed in the kilns. The dark circles, or sections of circles, found on the bases of Thai ceramics are marks left after breaking the tubes from the bottoms of the fired pots. The color of the marks is due to the presence of black carbonaceous matter and an excess of fused iron silicate minerals in the fireclays. These ceramic tubes are found in the debris of several Thai kiln sites and some kilns fired only "pipes."

Following Lyle, the French archaeologist E. Lunet de Lajonquière examined the kilns in 1904 and published his observations two years later. From the architectural ceramic debris found at the kilns he judged that they were contemporary

with the old city of Sri Satchanalai and probably dated from the thirteenth century.[12]

In 1908, seventeen years after he had visited Sawankhalok, Lucien Fournereau published an important paper on Thai ceramics in which he emphasized the role they played in Thai architecture, pointing out that ". . . ceramics take the place held by sculpture in sandstone among the Khmers." He also described in detail the Sawankhalok kiln ruins, one having been found intact so that its shape and dimensions could be determined. As the kiln area was in such a damaged state, he formed the opinion that it had been sacked and "destroyed by barbarians from the north."[13]

Fournereau's conclusion regarding the sudden abandonment and destruction by invaders of the Sawankhalok kilns is supported by events that took place between the early fourteenth and middle sixteenth centuries. This period witnessed the rapid decline of the Sukhothai kingdom after the death of Rama Khamhaeng in about 1317 and the equally rapid rise of a new, powerful, Thai kingdom founded in 1350 at Ayutthaya, on an island in the Chao Phraya River. This kingdom not only gained control over the middle and lower Chao Phraya River basin, much of the Malay Peninsula, and parts of present day Burma; it exercised an uneasy suzerainty over Sukhothai, waged periodic wars with Cambodia, and carried on a relentless war for decades with the kingdom of Chiang Mai, its northern enemy. In these northern wars Sukhothai and Sawankhalok could not avoid becoming involved, and thus suffered destruction.

After Fournereau's publication almost a quarter of a century elapsed before new information about Thai ceramics appeared. This unexpectedly came from Manila when, in 1930, H. Otley Beyer privately circulated an unpublished report on his excavations of Filipino burial sites said to predate the Spanish period. He revealed the discovery of some 2,200 intact or near-intact pieces of Chinese and Thai ceramics that had been used in many cases as grave furniture. In the same year Walter Robb published a summary of Beyer's field and laboratory data.[14] These studies contributed abundant original data on the shapes, sizes, pastes, and the general nature of the Thai ceramics, all of which were identified as having come from the Sawankhalok kilns in northern Thailand.[15] Heretofore, complete or intact examples of the Sawankhalok wares were virtually unknown, except in Indonesia where van Orsoy de Flines had started to amass his famous collection of Southeast Asian ceramics during the late 1920's.[16]

Of all Thai ceramics, those from the Sawankhalok kilns have been found in the greatest numbers throughout Southeast Asia. This should not be surprising, because there is considerable evidence to support the view that the wares were made for the export trade. Judging from the many hundreds of pieces that have been found in Indonesia and the Philippines, these countries were the most important markets, but there were others, such as the Middle East.

The remarkably fine quality and wide variety of Thai ceramics found in

Indonesia and the Philippines set them apart from those discovered in other countries, including Thailand itself. The outstanding examples of Thai ceramics now in Asian and Western private collections and museums came, with few exceptions, from the Indonesian and Philippine archipelagoes, which suggests that the Thais selected their best wares for these important markets.

The ceramic center at Sawankhalok produced an astonishingly wide variety of wares, ranging from large water jars and architectural ornaments to Buddhist religious figures, tiles, bowls in various sizes, ewers, kendis, vases, bottles, dishes, jarlets, water droppers, and covered bowls, as well as miniature figures of people, birds, animals, and amphibians, and large figures of mythical demons. These, like the wares found at the other ceramic centers in Thailand, are classified as stonewares.

The paste forming the bodies of these wares shows a wide variation in texture, color, and chemical composition. Some bodies are coarse and yellowish; another group was formed from a hard, fine-grained paste that fires to a red brown, but shows a smooth gray surface when fractured. Others are gray, some almost pure white, while still others are dark brown, all having retained their colors during firing.

The glazes also vary widely in color, as well as in quality. Perhaps the earliest are the thin, brown glazes which flake easily, in contrast to the later thick glazes, chocolate brown to brown black. Both stop high above the foot ring or base of the pot.[17] The thin glazes are usually found on cup-mouthed, pear-shaped bottles, small jars of various shapes, and well-modeled miniature figures of horses, dogs, monkeys, elephants, tigers, fish, and amphibians. The heavy brown glazes are found on ovoid bottles (No. 14), on deep bowls, and on the fine globular jars of various sizes that have round-rimmed, narrow mouths on short necks and are decorated with two, three, or four miniature loop handles (No. 15). Such bottles and jars are usually decorated on their shoulders with incised, horizontal, wheel-cut grooves. These brown-glazed ceramics were produced, probably in the thirteenth and early fourteenth centuries, at the kiln site in the area now known as Ban Ko Noi, about ten kilometers north of the old city of Sawankhalok.

Although the brown-glazed wares are quite common, they are completely overshadowed in quality and in number by the fine green, bluish green, blue gray, and gray green celadons that were produced contemporaneously in the Ban Ko Noi area. The translucent celadon glazes, often thick, glassy, and usually crazed, have a tendency to form pools in the bottoms of the large, heavily potted dishes and bowls. Nos. 21 and 22 are classic examples. Occasionally, the heavy concentration of glaze takes on a bluish opalescent effect, which is due to unanticipated firing conditions that affected the glaze.[18] The forms include admirable vases (No. 23), globular bottles of distinctive shape with small loop handles on the shoulder (No. 24), unusual, well-potted stem dishes (No. 25), and beautifully formed bowls with a

watery bluish-green crackled glaze such as is seen in No. 26. The glaze on the rarer underglaze painted celadons is usually dark green and thick, often coagulating into large drops above the foot ring as in the fine water dropper, No. 27. Incised decorations of fishes, formalized flowers, especially the sacred lotus, petal patterns, and cross-hatching are sometimes found.

A pitted, thick, opaque, grayish white glaze is found on jars and boxes of various sizes (Nos. 28, 29), molded tiles (No. 30), roof finials (No. 31), rare Buddhist images (No. 32), and grotesque temple guardians and demons. Some of the kilns in the Ban Pa Ying area near the north wall of old Sawankhalok specialized in architectural ceramics.

Quite different from the celadons and the brown and off-white glazed ceramics are the Sawankhalok painted wares. Many of these, such as No. 33, are similar in shape to the brown wares, but the fine covered boxes like Nos. 34 and 35, the simple decorated bowl with the high foot ring (No. 36), the small painted cup (No. 37), the rare wine pot (No. 38), and other painted gray wares seem to have been made at different kilns from those that produced the celadons and the brown and off-white glazed ceramics. The painted boxes are usually circular, but some are faceted, with domed or near-flat lids surmounted with conical knobs, miniature birds, figures of monkeys and elephants, stylized stems and petals of the mangosteen and pomegranate, or modeled lotus petals and other flowers. They are of high-fired, coarse gray paste, usually thin-walled and glazed on the interior of their lower sections to insure impermeability. Their glazes, like those on the other painted ceramics, range from colorless to pale, watery green. The underglaze painting on slip is in black and brown black that sometimes turns to a rust brown. The painted motifs range from simple foliage patterns of feathery brush strokes to more elaborate panels of intertwining foliage as seen on the kendis (Nos. 39, 40) and the ornate plumage on the bird ewer (No. 41). Indian motifs such as conch shells, multiple-pointed rosettes, stylized birds reminiscent of those found on early Indian pottery, and bold lotus flowers occur, but there are also more sophisticated designs of mandarin ducks swimming among aquatic plants that are almost identical with those found on fourteenth-century Chinese blue-and-white trade wares (fig. 10).[19]

Incised decorations of foliage with small, rounded and pointed leaves on gracefully curved branches, encircled by borders of short, pointed, triangular leaves are found on covered boxes like Nos. 16, 17, and 18. The designs are painted in brown against an off-white or gray slip background and covered with a very thin, transparent, pale green or beige glaze. Other incised designs representing Buddhas, kinnaras, flowers, jungle fowl and other birds appear on covered jars, kendis, bottles, and ewers. Occasionally the colors are reversed, the background becoming brown, the decoration white. There are also incised, two-colored, miniature figurines of people (No. 19), animals, and birds (No. 20).

Fig. 10. *Shard of a Sawankhalok dish decorated in underglaze gray after a fourteenth-century Chinese pattern. From the collection of Mr. and Mrs. Prok Amranand, Bangkok.*

Dated specimens of Sawankhalok wares are unknown, and their conjectured dating depends upon technological and stylistic comparisons with Chinese ceramics, confirmed to a limited extent by the evidence supplied by Beyer from grave excavations in the Philippines. The thinly glazed brown pots probably date from the early thirteenth century or earlier, the well-formed, heavy, dark brown glazed wares, probably of the thirteenth to fifteenth centuries, were contemporaneous with the celadons, and the underglaze painted boxes and other shapes probably belong to the fourteenth, fifteenth, and sixteenth centuries. The shapes of all of these ceramics appear to be more Thai and Indian than Chinese, but the evidence of Chinese artistic influence is unquestionably present.

The Sukhothai Wares

The Sukhothai kilns, which are situated about one kilometer north of the walls of the old capital of the Sukhothai kingdom, probably date from the late thirteenth or early fourteenth century. Though they were known to a few Thai scholars in the early part of the present century,[20] they were not brought to the attention of the Western world until 1933, when Reginald Le May published his article, "The Ceramic Wares of North Central Siam," in *Burlington Magazine* (vol. 63 [1933], pp. 156 ff.). Since Le May's time some fifty kilns have been identified and the remains of a few have been found sufficiently intact to establish their original structural pattern.[21]

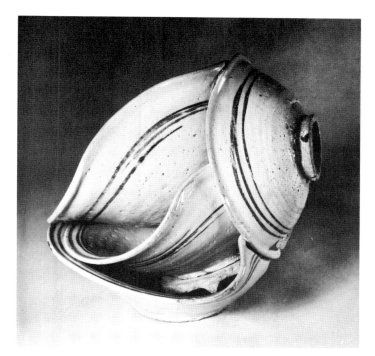
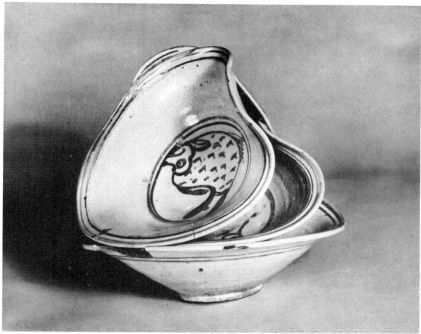

Fig. 11a, b. Sukhothai kiln waster showing one of the spurred disks used in stacking vessels for firing. From the collection of the Herbert F. Johnson Museum of Art, Cornell University.

The highly developed kiln furniture used during the firing of the Sukhothai wares was an interesting feature associated with the operation of the kilns. These accessories consisted of high-fired, flat, stoneware disks, with five short conical spurs on the underside, and tapering ceramic tubes or pipes similar to those found at Sawankhalok, Kalong, and other early ceramic centers in Thailand. Both disks and pipes vary in size, and they occur in large numbers in the debris associated with the kiln ruins. Le May described the use of the disks: "The bowls were placed on small flat round earthen discs with five pointed projections on the bottom, and stood inside one another in the kiln so that on the bottom of the interior of each bowl except the [highest] will be found five spur marks where the pontil [disk] was broken off."[22] The spurred disks can be seen in the large waster from Sukhothai (fig. 11a), and their use in combination with the pipe serving as a tubular stand is illustrated in fig. 12. Thus, after firing, the top dish would not show spur marks like the others below it, and only the bottom dish would have a mark left by the tubular stand.

The Sukhothai kilns produced mostly heavily potted, hard stonewares of coarse, dark gray-brown paste covered with an off-white slip. Over the slip were painted dark brown or black decorations and then the whole was covered with a thin, transparent, or semi-transparent glaze. Accordingly to Le May and Spinks, these features have an unmistakable affinity with the Chinese Tz'u Chou wares and they use this resemblance to support their contention that Tz'u Chou potters or

potters knowledgeable in Tz'u Chou ceramic tradition established the kilns at Sukhothai. These assertions are certainly debatable, as pointed out by Watt.[23]

Often boldly executed, the black or brown painted decorations include stylized flower motifs, geometric patterns, a fish or fishes (No. 42), a *chakra* or solar disk (No. 43), or sometimes a swastika. Designs portraying people, animals, and birds are less common. The bases of these thick stonewares are usually shallow and unglazed, but there are rare exceptions where they are covered with a brown iron oxide wash.

Sukhothai ceramics are usually found in the forms of bowls, wide-shouldered jars with or without covers (Nos. 44, 45), pear-shaped wine bottles with flaring necks, stem bowls (No. 46), and dishes of various sizes.

In addition to the bowls, jars, and dishes, the potters produced skillfully modeled large and small statues of deities and other celestial beings in the Hindu and Buddhist pantheons, as well as large quantities of ceramic architectural materials such as tiles, roof finials, railings, lattices, and water pipes.

Judging from the considerable number of Sukhothai ceramics found in Southeast Asia, especially in Atjeh and in other areas of Sumatra, west and south Borneo, south Sulawesi, and north Java, they were important items in international trade, but they were of far less importance than the exports from the Sawankhalok kilns.

Kalong Ceramics

In 1933 an ancient ceramic manufacturing center was discovered by Praya Nakon Prah Ram at Kalong near the village of Wieng Papo, which is about ninety kilometers by road southwest of Chiang Rai. Surrounded by outlines of an ancient moat and ruins of earthen ramparts, the old town of Kalong is situated on a moderately high, wide ridge on the right bank of the Menam Lao. Along the banks of this stream and at three other locations near the long abandoned town some one hundred kiln ruins were located. Later, others were discovered in the districts of Wieng Ho and Amphoe Ce Hom. Excavations of some of these kiln ruins revealed that they varied in size and were constructed of brick.[24] The Kalong potters fired large jars on flat, fireclay slabs, and many of the other ceramic forms were fired on tubular pipes or stands such as those found at Sawankhalok and Sukhothai, but there is no evidence to show that the spurred disk was used in the Kalong kilns.

The Kalong kilns produced well potted, high-fired stonewares from local clays of good quality which varied, after firing, from off-white and pale beige to various shades of gray and brown. A wide variety of both monochromes and wares with painted decorations were produced in the area. The latter were ornamented with an iron oxide pigment on slip and then covered with vitreous glazes which,

after firing, ranged from colorless to pale green, celadon green, gray, gray green, yellow green, and pale shades of brown. Flower motifs in brown, gray, or black are most usual, but stylized birds and animals, celestial beings, and mythical beasts are also portrayed (No. 47).

The Kalong forms include large and small jars, bowls, thinly potted dishes of various sizes, and pear-shaped bottles. The large jars, which are usually beige, gray, or dark brown monochromes, tend to be of ovoid form with steeply sloping shoulders and a short neck flaring slightly into a heavy, squared-off rim. This potting characteristic appears to be confined to Kalong ceramics.[25] Other jars show wide, flaring, beveled mouth rims (No. 48).[26] The dishes are shallow, thinly potted, sometimes covered with a celadon glaze (No. 49) and usually decorated in brown or black flower patterns. The pear-shaped wine bottles have high, tapering necks with everted rims, and sometimes they have cup finials (No. 50).

There has been some speculation about the origin of the Kalong potters and the dating of their kilns. Nimmanahaeminda and Spinks think that the Kalong potters may have been artisan refugees who were taken prisoner in the Sukhothai-Sawankhalok district during the wars between the kingdoms of Chiang Mai and Ayutthaya in the fifteenth century, and settled in the Kalong area.[27] Historical events lend support to this thesis, but if the prisoner-potters came from the southern kiln centers it is difficult to understand why the Kalong wares do not show obvious Sukhothai-Sawankhalok ceramic affinities. The Kalong wares in many respects stand apart from other Thai ceramics, with the exception of those found near Ban Thung Hua (Nos. 56, 57). Because of its nearby location and the fact that its ceramics are identical in character with those produced in the Kalong area, we may assume that Ban Thung Hua was a Kalong satellite ceramic center.

Sankampaeng Pottery

In 1952, Kraisri Nimmanahaeminda discovered a kiln site in the Sankampaeng district, about twenty-three kilometers east of the old walled city of Chiang Mai. During a subsequent survey of the area, eighty-three kiln mounds were recorded and many of these were found to be surrounded by heaps of shards. It is thought that this location was chosen for its favorable position near an old trade route between Chiang Mai, Lamphun, and Lampang, and because adequate raw materials for a ceramic industry were present.[28]

Some time after his discovery of the kiln complex, Nimmanahaeminda uncovered in the complex, near the ruins of an old monastery named Wat Chiengsen, a four-sided stone column inscribed with the Sukhothai script. The inscription revealed that the monastery was established in 1491. It seems likely that the kilns were founded at some time during the reign of King Tilokarasa of Chiang Mai

(1442-1487), and continued production until the conquest of Chiang Mai by the Burmese in 1558.[29]

The Sankampaeng kilns, which vary considerably in size, are of two types: bank kilns dug into hillsides, or kilns constructed above shallow excavations with walls and domed roofs built of pre-fired, flat slabs of clay that were cemented together and later covered with a thick coating of wet clay.[30] Judging from the abundant shards found at the kiln ruins, and the few undamaged specimens of the wares, the Sankampaeng pottery is inferior in materials and workmanship to the products found at most of the early ceramic sites in Thailand.

Kiln fixtures such as the tubular stands and spurred disks used at Sukhothai have not been found in the kiln debris at Sankampaeng, but the potters evidently used saggers (ceramic containers in which pieces are fired), because several upper and lower sections of the boxes have been found in the kiln refuse.[31] Dishes and bowls with unglazed rims, foot rings, and bases were fired in tiers, rim to rim and base to base, as shown in fig. 13.

A variety of monochrome and painted forms are revealed among the shards, wasters, and undamaged pieces which have been found at Sankampaeng. There are large, deep, monochrome dishes, bowls (No. 51), cups, pear-shaped bottles, heavily potted, conical-topped wine jars with small mouths, and globular and ovoid jars with flaring, wide cup finials. Some of the jars have loop handles inserted through the shoulders, a technique peculiar to Sankampaeng pottery (Nos. 52, 54). The thin, green, greenish gray, pale beige, yellowish green, and brown glazes range from opaque to transparent. Among the painted wares with underglaze designs in brown and black are dishes decorated with flowers, leaves, and vines, or geometric patterns, or with one or more fish as a central design.

Other Thai Kiln Sites

Cham Pawai

A third kiln site in north Thailand was discovered some time in 1959 or early 1960 by Vipat Chutima on a stream named Mae Tom in Cham Pawai township, about ten kilometers south of Payao. The shards from the area are reported to be very similar in raw materials and potting to those found at the kilns in the Kalong and Sankampaeng areas and the pottery is thought to be of the same antiquity as that of the other kiln sites in north Thailand.[32]

Phan

In 1962, ten years after his discovery of the Sankampaeng kilns, Kraisri Nimmanahaeminda found another kiln site in the Phan district of Chiang Rai, but it was not until 1973 that the area was given serious attention by the Fine Arts Department. A survey revealed thirty-eight kilns at two sites approximately six kilometers

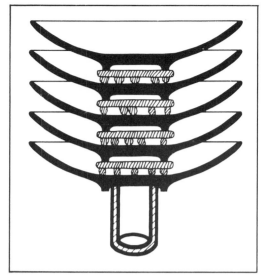

Fig. 12. *Drawing illustrating the spurred disks and tubular support used in firing bowls at the Sukhothai kilns.*

Fig. 13. *Drawing illustrating method of firing bowls, stacked base to base and rim to rim, used at Sankampaeng and in Viet Nam.*

apart that have been designated as Pong Dang and Chumplu. Fifteen of the kilns have been excavated. They are of brick construction and are similar to those at Sawankhalok, usually having a length of between eight and ten meters. The kilns that have been excavated appear to have been arranged in a radial pattern. Kiln fixtures were apparently confined to tubular stands which are found in various sizes and in considerable number among the widely scattered kiln debris.[33]

Phan ceramics have been found in many forms, but undamaged pieces are extremely rare. The paste is of good quality, the potting skillfully done, and the incised, underglaze, floral and animal decorations are well executed. The wares are covered with a crackled, pale green or yellowish green glaze. Covered jars, dishes, lamps, footed platters, large basins, and miniature pouring vessels have been found but the most outstanding forms are the small bowls (No. 57).

Wan Nua

This site, discovered in the late 1960's, is situated approximately ninety kilometers north of Lampang. During a survey of the area the Fine Arts Department located twenty-five kilns, of which eleven were excavated in 1972. The kilns are of similar construction to those found at Sankampaeng, and the pottery is thin, glazed celadon of mediocre quality. The kiln complex probably dates from the early sixteenth century.

Ban Thung Hua

In 1974 a complex of eight kiln mounds was discovered by J. R. Galloway, S. Limmanont, and the writer, on the east bank of the Menam Mae Liap, some six kilometers west of the village of Ban Thung Hua. From the well-formed bricks observed in some of the mounds, it is assumed that the kilns were of brick construction. A great number of shards litter the area, and among these are numerous tubular firing-supports of various sizes, but other types of kiln fixtures were not found. The high-fired shards are, for the most part, thinly potted of well prepared, pale beige, gray, or brown paste. Fragments of both monochrome and decorated bowls, dishes, bottles and tops, shoulders and bases of large jars, spouted vessels with cup finials, kendis, domed jar covers, and miniature jars and bottles have been found at Ban Thung Hua. The glazes include shades of green, blue green, yellowish beige, gray, and brown. Decorations, primarily floral motifs, are painted in dark gray and black. The oil bottle (No. 55) and the small dish (No. 56) are examples of the beige monochrome wares.

The physical characteristics of the Ban Thung Hua ceramics are identical with those found in the Kalong area, which is about ten kilometers directly west of Ban Thung Hua. The two kiln sites are undoubtedly closely related, and their activities were probably contemporaneous.

1. Coedès, *The Indianized States of Southeast Asia*, pp. 190-191.

2. Ibid., p. 190.

3. For a modern critical commentary on historical data concerning Sukhothai-Mongol relations in the late thirteenth and early fourteenth centuries see the scholarly work of E. T. Flood, "Sukhothai-Mongol Relations: A Note on Relevant Chinese and Thai Sources (With Translations)" *Journal of the Siam Society* 57, 2 (July 1969), pp. 203-257.

4. According to G. Coedès: ". . . the Siamese showed a marked and perhaps deliberate contrast with Khmer civilization in some areas, notably in politics and art. On the other hand, from the beginning of the foundation of Ayuthaya (1350), they borrowed from Cambodia its political organization, material civilization, system of writing, and a considerable number of words. The Siamese artists were beholden to the school of the Khmer artists and transformed Khmer art not only according to their own genius, but also as a result of the strong influences of their contact with their neighbors to the west, the Mons and the Burmese. From the Mons and the Burmese the Siamese received their legal traditions, of Indian origin, and above all their Singhalese Buddhism." (*The Indianized States of Southeast Asia*, pp. 222-223).

5. Other kiln sites have been reported at Lopburi (Louis-Frédéric, *Art of Southeast Asia*, p. 355), Ban Kruat, and at Sawai (R. Brown, V. Childress, and M. Gluckman, "A Khmer Kiln Site—Surin Province") in present-day Thailand, but as these are clearly related to the Khmer civilization they are not considered in the discussion on the indigenous Thai ceramics. See T. Bowie, ed., *The Arts of Thailand*, p. 202, for a classification of Thai ceramics.

6. F. Brinkley, *Japan and China: Their History, Arts and Literature* (London, 1903-04), vol. 9, p. 64.

7. Prince Damrong Rajanubhab, *A History of Porcelain Altar Pieces and Dinnerware*, p. 30. A kiln probably existed at Song Kwae, present-day Phitsanulok, because nearby is an old village with the Thai name of Ban-tau-ha', "village of jar furnace." Damrong reasoned that perhaps the large jars found in the area came from a kiln at or near the village. A search of the area failed to reveal any kiln ruins. W. B. Honey also mentions Phitsanulok as a possible site, "believed to have produced unglazed pieces which were probably Indian in style" (*The Ceramic Art of China and Other Countries of the Far East*, p. 163).

8. In a personal communication to the author, Nimmanahaeminda reported that a kiln site was discovered near the village of Ban Dong, southeast of Chiang Rai, about 1962, but that it has not been investigated. No information was given about the kilns or the nature of the shards found.

9. J. Boisselier, *Manuel d'archéologie d'Extrême-Orient*, vol. 1, p. 44.

10. T. H. Lyle, "Siam: Celadon Ware" and "Notes on the Ancient Pottery Kilns at Sawankhalok, Siam."

11. Since Lyle's visits, one hundred forty-four kilns have been reported in the two areas. On modern maps the northern area is named after the local village of Ban Ko Noi and the southern area is shown as Ban Pa Ying.

12. E. Lunet de Lajonquière, *Le Siam et les Siamois*, p. 335.

13. L. Fournereau, "La céramique des Thais," pp. 132-138. This report, which was related to research on Sawankhalok shards submitted to the technical director of the Sèvres National Factory in France, gives an excellent resume of the raw materials used, their composition and the conditions under which the ceramics were fired, the types of kiln construction, and the different types of ceramics produced. Due credit is given to the skills of the early potters. The types of ceramics examined were terracottas; high-fired, glazed and unglazed, impervious, resonant earthenwares; underglaze painted wares; architectural ceramics; and celadons, the green color of which is attributed to a glaze containing ferric oxide fired under reducing conditions.

14. W. Robb, "New Data on Chinese and Siamese Ceramic Wares of the 14th and 15th Centuries." In a personal memorandum attached to reprints of Robb's article, Beyer listed 390 Sawankhalok pieces in private collections and in the collections of the National Museum, Manila, and of the University of the Philippines.

15. See Robb, "New Data on Chinese and Siamese Ceramic Wares," p. 250. The number of Siamese vs. Chinese pots found in these graves varied greatly from north to south in the Philippine archipelago. From 20% to 40% of the ceramic specimens excavated from the burial grounds in the Visayan Islands were Sawankhalok wares, whereas in the Luzon stratified deposits, which represented old village sites, between 2% and 5% were from Sawankhalok. The date range also varies. The Luzon sites indicate Sawankhalok contact some time in the fifteenth century, while in the Visayan Islands a greater proportion of thirteenth and fourteenth-century types were found. Limited quantities of Sawankhalok shards were found in nearly all early horizons containing glazed ceramic fragments, down to the sixteenth century, ". . . but no fragments were found in any site dating subsequently to the sixteenth century." The low percentage of these wares in the Visayan Islands and their steady increase southward through the Visayan Islands to Mindanao and the Sulu Archipelago seems to indicate that the ceramics entered the Philippines from the south and were carried northward by inter-island trade.

16. E. W. van Orsoy de Flines, *Guide to the Ceramic Collection (Foreign Ceramics)*, pp. 9-10. De Flines started his collection while a planter in Ungaran near Semarang and transferred it in 1932 to the Museum Pusat, Jakarta (then Koninklijk Bataviaasch Genootschaap van Kunsten en Wetenschappen). He remained curator of the collection until he retired and returned to Holland in 1959. See also C. N. Spinks, "Siamese Pottery in Indonesia," for a review of the Siamese collection in the Museum Pusat, Jakarta.

17. The term "Chaliang" is commonly applied to the brown wares, but it is not used here because it has given rise to confusion based on the assumption that it was a distinct kiln site which produced brown monochromes. For a full discussion of the subject see C. N. Spinks, *The Ceramic Wares of Siam*, pp. 27-35, and R. S. Le May, "The Ceramic Wares of North-Central Siam," pp. 156-203.

18. W. B. Honey notes that "The milky-blue opalescence sometimes developed in the Sawankhalok glaze seems to have led to a mistaken belief that a blue pigment was used there" (*The Ceramic Art of China*, p. 63).

19. Cf. J. A. Pope, *Fourteenth-Century Blue-and-White: A Group of Chinese Porcelains in the Topkapu Sarayi Müzesi, Istanbul*, pls. 4, 27; S. E. Lee and W. Ho, *Chinese Art Under the Mongols: The Yüan Dynasty (1279-1368)*, pl. 134; M. Medley, "A Fourteenth-Century Blue and White Chinese Box," fig. 2; and D. Macintosh, "Introduction to Blue and White," p. 38.

20. H. M. King Rama VI mentions his 1907 visit to Sukhothai and Sawankhalok in *Tiaw Muang Phra Ruang*, a cremation ceremony volume for Khun Ratana Woraponsa (Bangkok, 1954). It has not been translated into English. Prince Damrong Rajanubhab also mentions the Sukhothai kilns in *A History of Porcelain Altar Pieces and Dinnerware*. There is an unpublished English translation of the volume in the author's possession. In the late 1920's, Praya Nakon Prah Ram, Lord Lieutenant of the Phitsanulok Circle, had knowledge of Sukhothai kilns (see Le May, "The Ceramic Wares of North-Central Siam," p. 159).

21. Y. Azuma, "Sukotai no Yakimono" [Pottery of Sukhothai], pp. 15, 17-18. His sketch 4, page 15, shows a Chinese type kiln of laterite (?) estimated to be three by fifteen meters in ground plan, including a chamber of eight square meters for ceramics.

22. R. S. Le May, "On Tai Pottery," p. 60.

23. See Le May, "The Ceramic Wares of North-Central Siam," p. 160; Spinks, *The Ceramic Wares of Siam*, p. 21; and J. C. Y. Watt, "Southeast Asian Pottery—Thai in Particular."

24. Praya Nakon Prah Ram, "Thai Pottery," pp. 17-19. This remains the authoritative work on the Kalong ceramic center.

25. There is a beige monochrome jar of this type in the Herbert F. Johnson Museum of Art, Cornell University, and a similar gray monochrome jar in the Seattle Art Museum.

26. Numerous shards of necks, mouth rims, and shoulders of large Kalong jars have been found in the Kalong area and among voluminous kiln debris near Ban Thung Hua.

27. K. Nimmanahaeminda, *Sankampaeng Glazed Pottery*, pp. 15-18; Spinks, *The Ceramic Wares of Siam*, pp. 112-117.

28. Nimmanahaeminda, *Sankampaeng Glazed Pottery*, p. 10.

29. Ibid., p. 5.

30. The Sankampaeng kilns were excavated in 1970 by Pote Kuakul of the Fine Arts Department, Bangkok, but unfortunately his report has not been translated.

31. Nimmanahaeminda, *Sankampaeng Glazed Pottery*, p. 9.

32. Ibid., p. 13.

33. M. Gluckman, "A Visit to the Phan Kilns in Northern Thailand."

21. *Bowl*. Thai; 14th-15th century
Celadon; Diam. 30.3 cm.

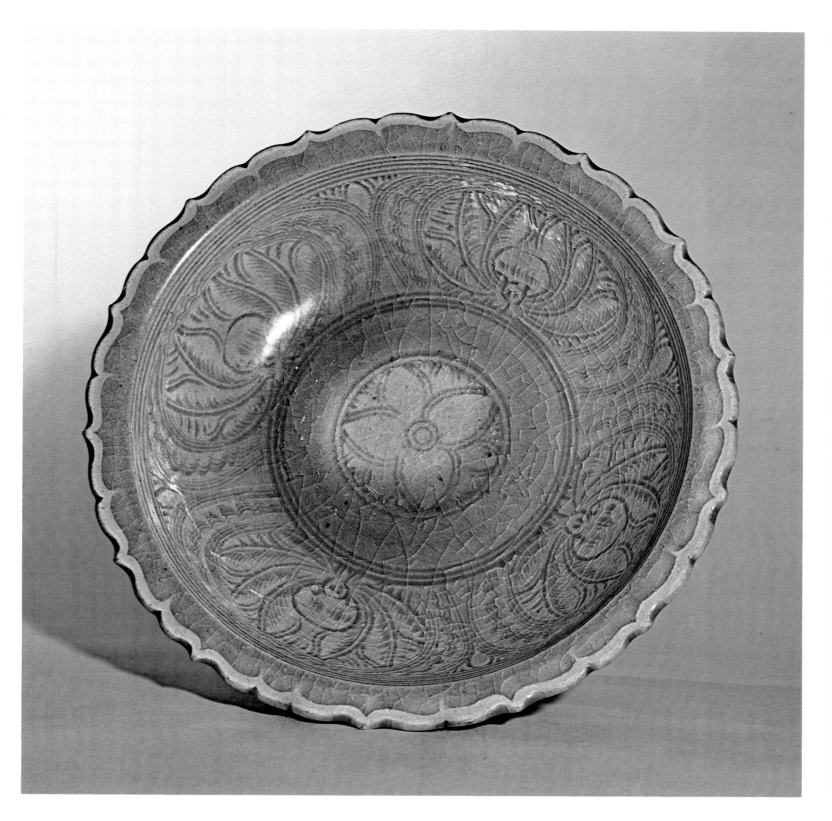

Sawankhalok

14. *Bottle*. Thai; 13th-14th century
Porcelaneous stoneware; H. 14 cm.

15. *Jar*. Thai; 13th-14th century
Porcelaneous stoneware; H. 17.5 cm. (*opposite*)

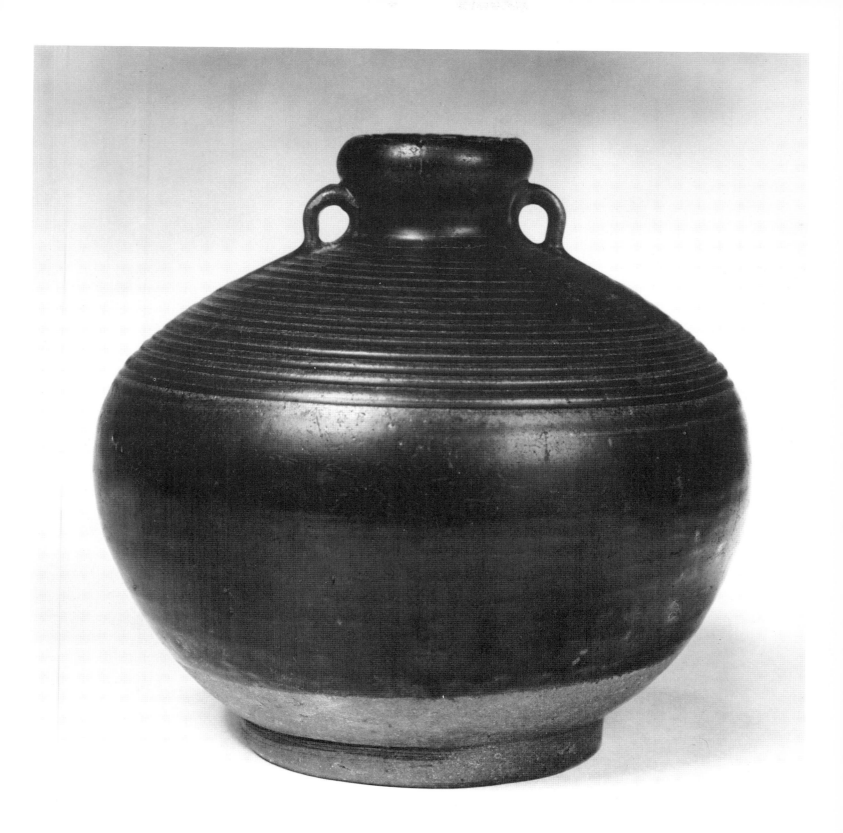

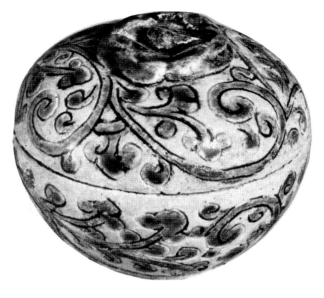

16. *Box With Cover*. Thai; 14th century
Stoneware; Diam. 12.5 cm. (*opposite*)

17. *Box With Cover*. Thai; 14th century
Stoneware; Diam. 12.4 cm. (*below*)

18. *Box With Cover*. Thai; 14th century
Stoneware; Diam. 5.6 cm. (*left*)

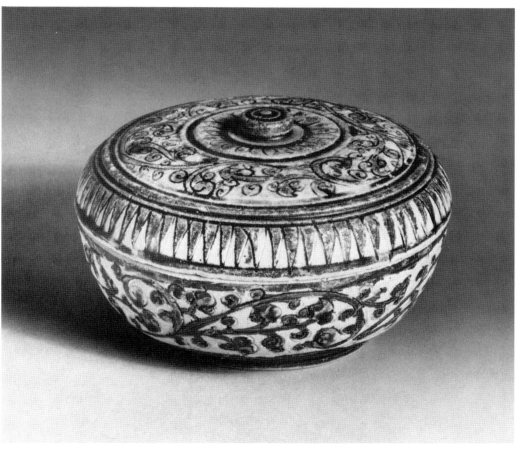

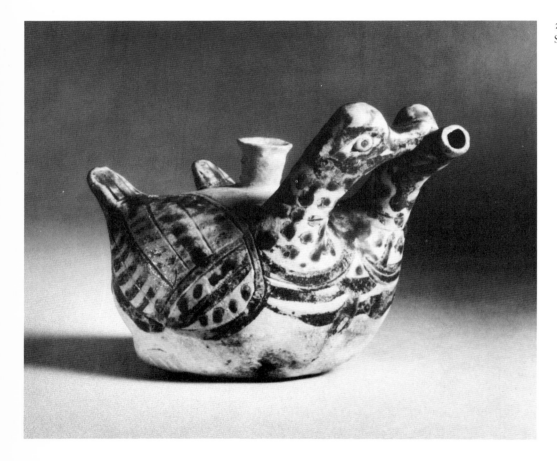

20. *Water Dropper*. Thai; 14th century
Stoneware; H. 7.5 cm.

19. *Female Figure*. Thai; 14th century
Stoneware; H. 8.5 cm.

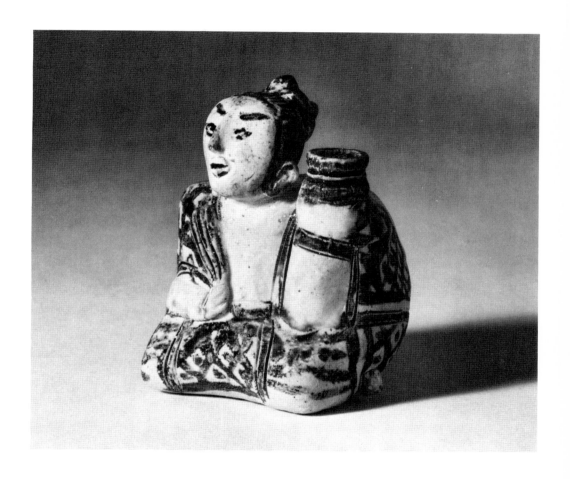

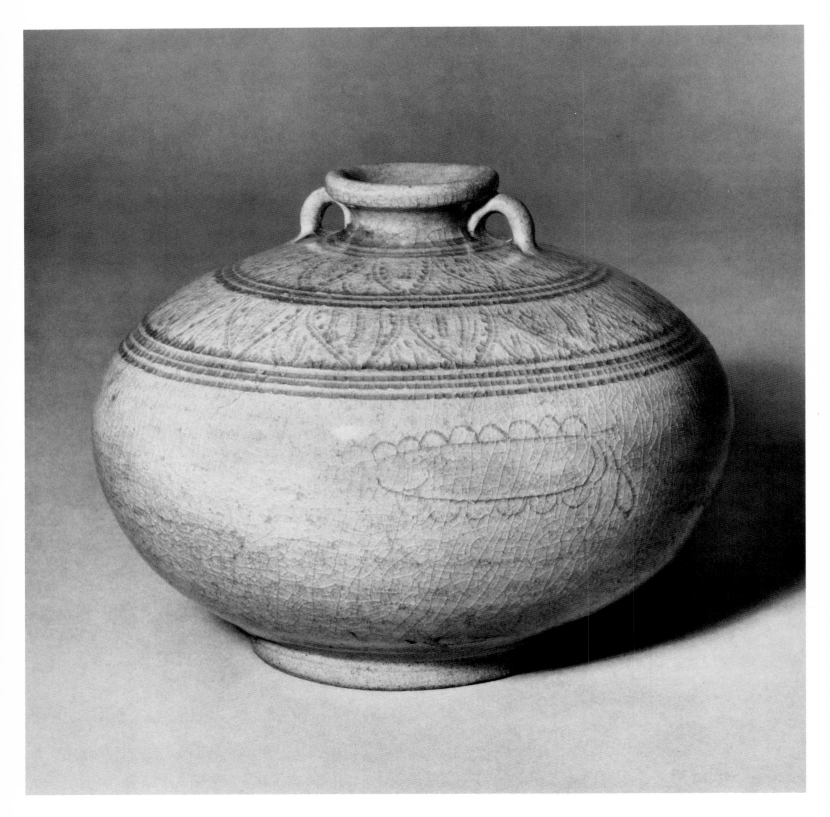

22. *Bowl*. Thai; 14th-15th century
Celadon; Diam. 31.8 cm. (*right*)

24. *Jar*. Thai; 14th-15th century
Celadon; H. 16 cm. (*opposite*)

25. *Stem Bowl*. Thai; 14th-15th century
Celadon; H. 10.5 cm., Diam. 17.6 cm. (*below right*)

26. *Bowl*. Thai; 14th-15th century
Celadon; Diam. 14.8 cm.

27. *Water Dropper*. Thai; 14th-15th century
Celadon; H. 9.6 cm. (*opposite*)

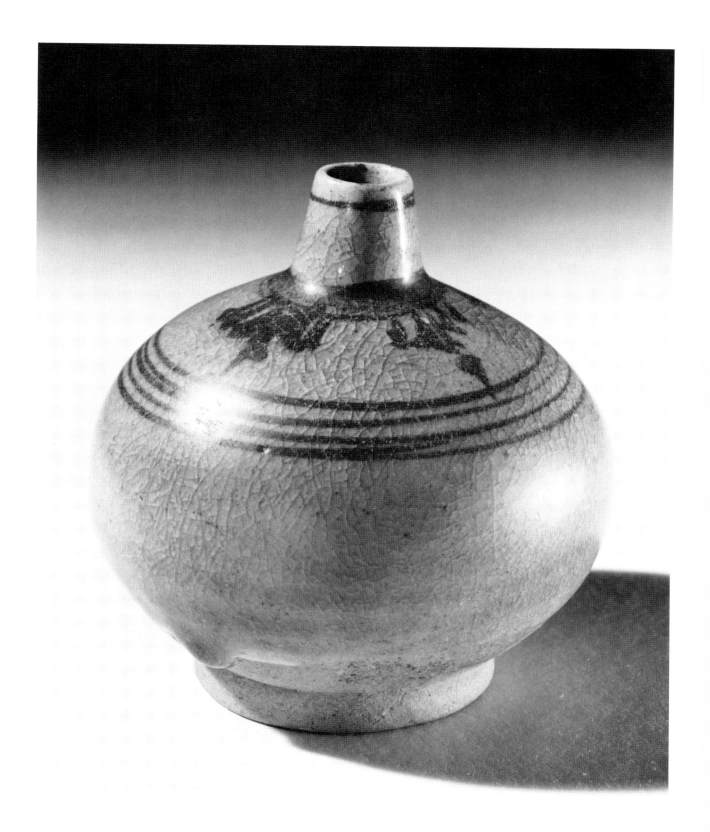

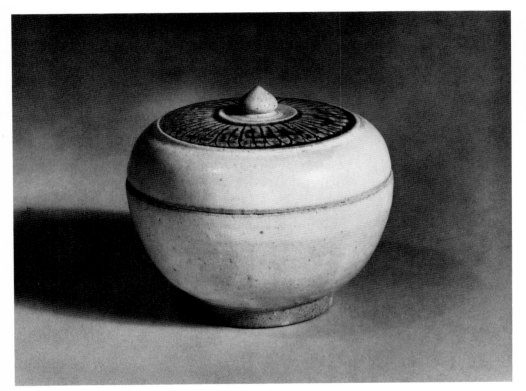

28. *Jar With Cover*. Thai; 14th-15th century
Stoneware; H. 10.5 cm. (*above right*)

29. *Box With Cover*. Thai; 14th-15th century
Stoneware; Diam. 11 cm. (*above left*)

30. *Tile*. Thai; 14th-15th century
Stoneware; L. 32.5 cm. (*opposite*)

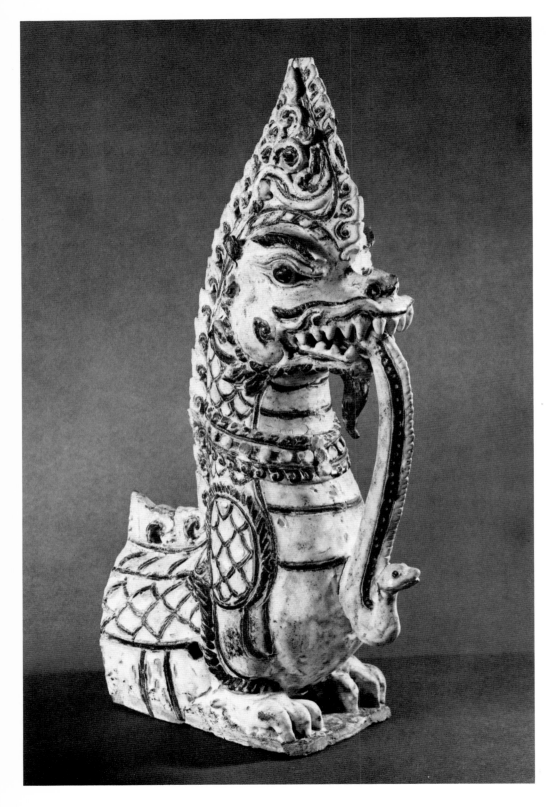

31. *Architectural Finial*. Thai; 14th-15th century
Stoneware; H. 58.7 cm.

32. *Tile Finial*. Thai; 14th-15th century
Stoneware; H. 18 cm. (*opposite*)

34. *Box With Cover*. Thai; 15th century
Stoneware; Diam. 17.8 cm. (*opposite*)

35. *Box With Cover*. Thai; 15th century
Stoneware; Diam. 13.5 cm.

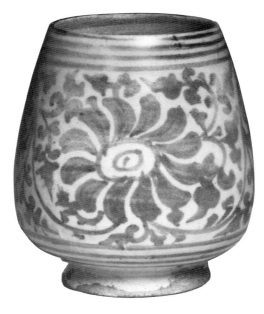

33. *Bowl*. Thai; 15th century
Stoneware; Diam. 14.3 cm. (*below left*)

36. *Bowl*. Thai; 15th century
Porcelaneous stoneware; H. 10 cm. (*opposite*)

37. *Cup*. Thai; 15th century
Stoneware; H. 8 cm. (*above*)

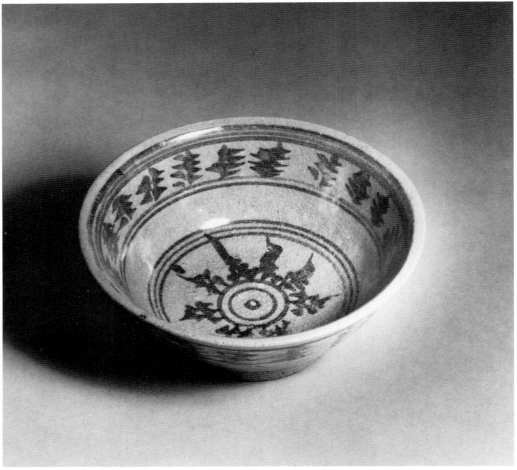

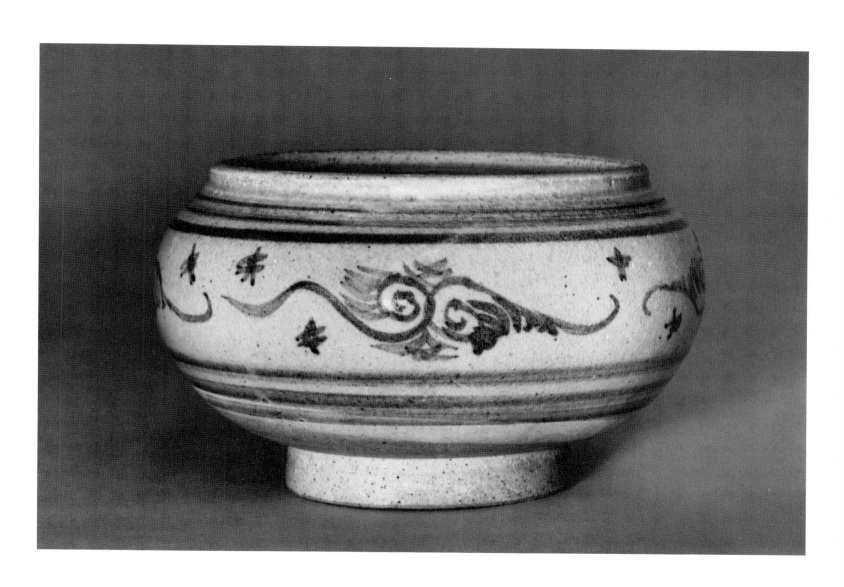

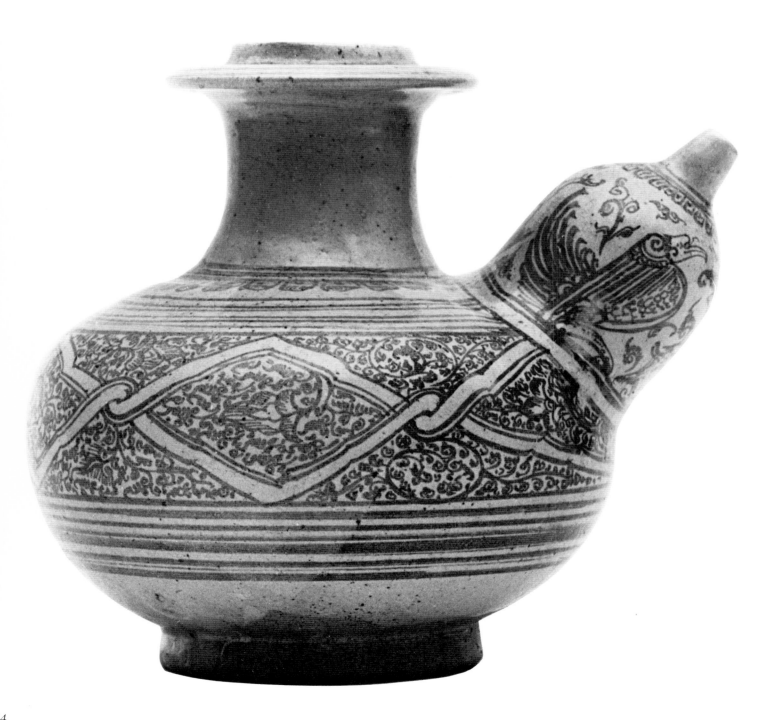

39. *Kendi*. Thai; 15th century
Stoneware; H. 22.4 cm. (*opposite*)

40. *Kendi*. Thai; 15th century
Porcelaneous stoneware; H. 13.7 cm.

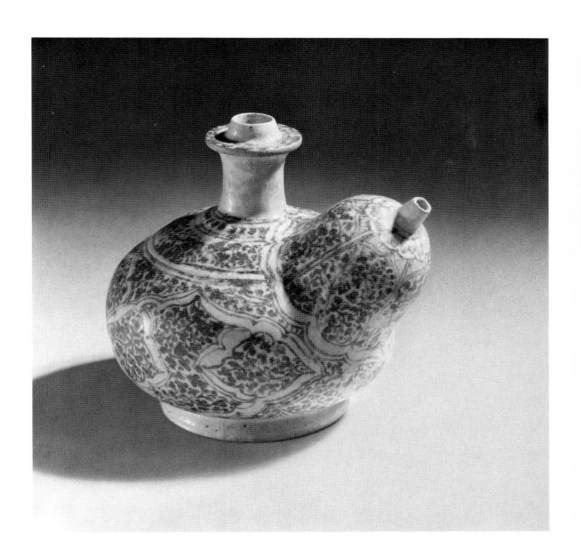

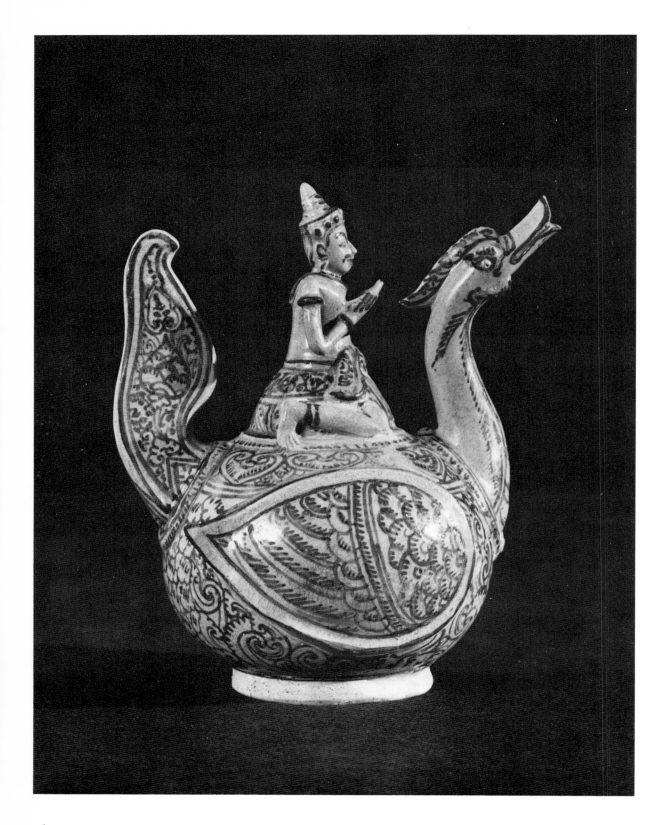

38. *Wine Pot With Cover*. Thai; 15th century
Stoneware; H. 12.4 cm.

41. *Ewer*. Thai; 15th century
Stoneware; H. 21 cm. (*opposite*)

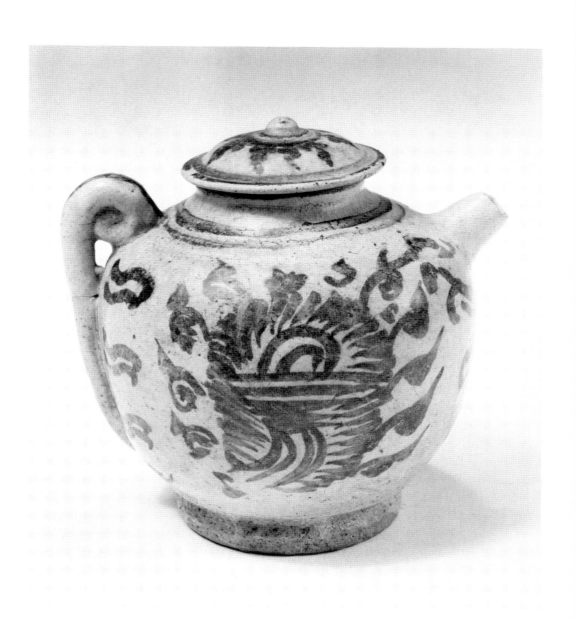

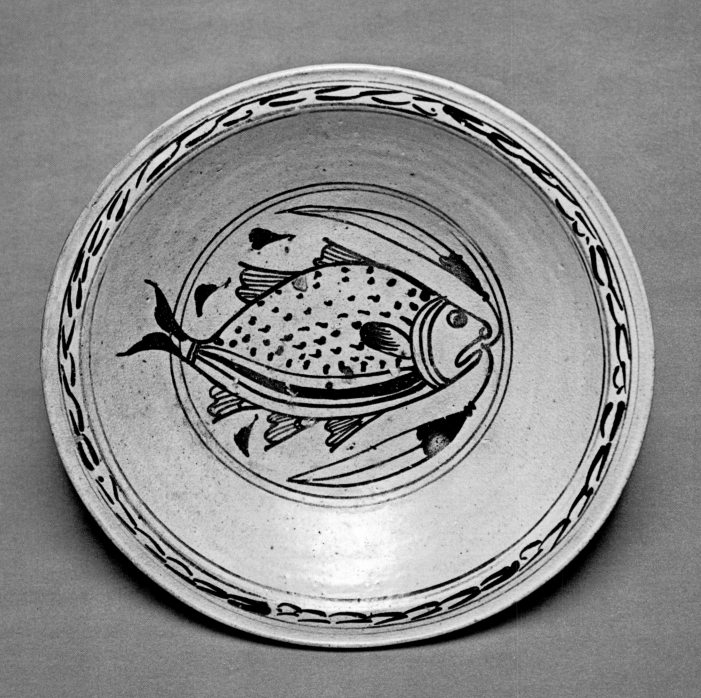

Sukhothai

42. *Dish*. Thai; 13th-14th century
Stoneware; Diam. 25 cm. (*opposite*)

43. *Bowl*. Thai; 13th-14th century
Stoneware; Diam. 11 cm.

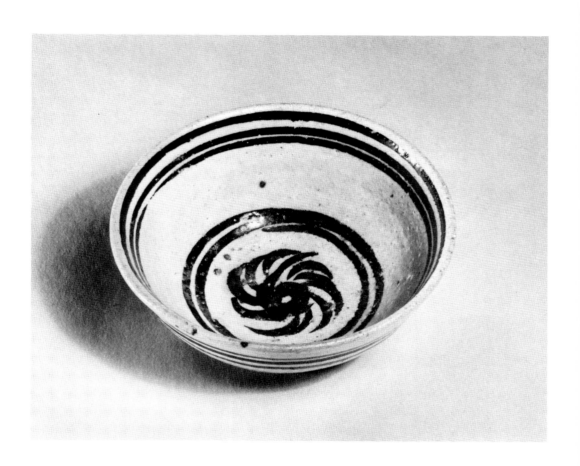

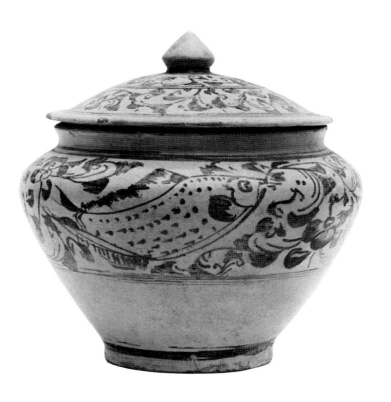

44. *Storage Jar*. Thai; 13th-14th century
Stoneware; H. 18.5 cm. (*below*)

45. *Covered Jar*. Thai; 13th-14th century
Stoneware; H. 21 cm. (*left*)

46. *Stem Bowl*. Thai; 13th-14th century
Stoneware; H. 19.5 cm., Diam. 15.8 cm. (*opposite*)

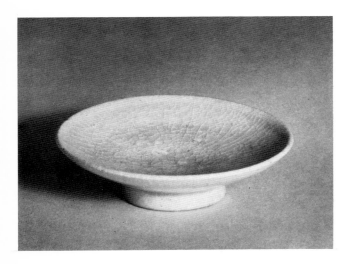

Kalong

47. *Storage Jar*. Thai; 14th-16th century
Stoneware; H. 43 cm. (*right*)

49. *Dish*. Thai; 14th-16th century
Celadon; Diam. 7.5 cm. (*above*)

50. *Wine Bottle*. Thai; 14th-16th century
Stoneware; H. 26 cm. (*opposite*)

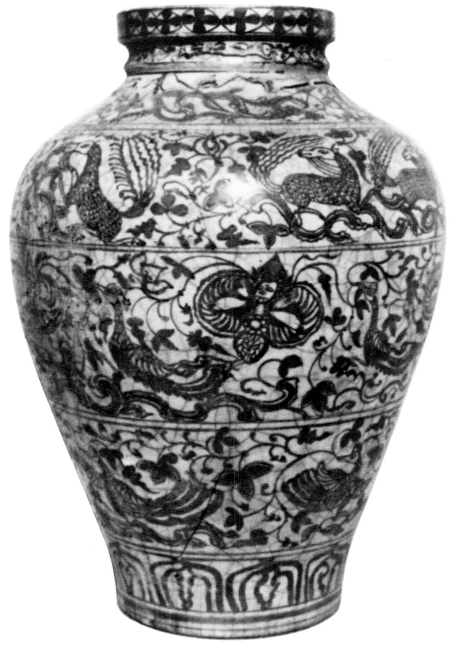

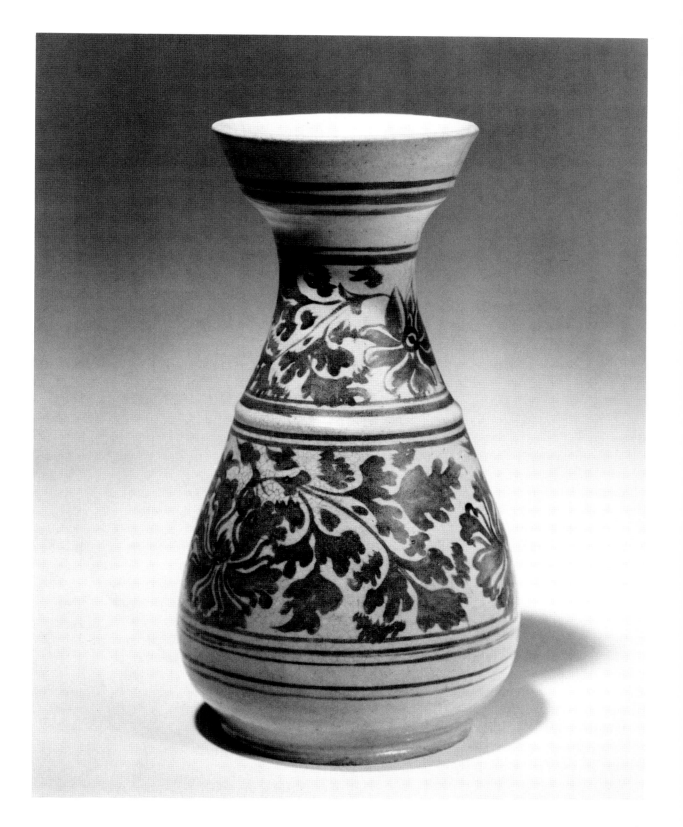

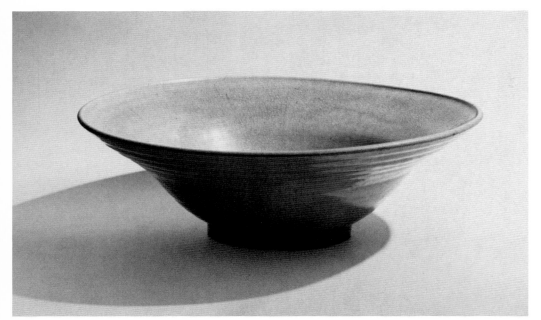

Sankampaeng

51. *Bowl*. Thai; 15th-16th century
Celadon; Diam. 33.5 cm.

52. *Oil Jar With Cover*. Thai; 15th-16th century
Stoneware; H. 14.3 cm. (*opposite*)

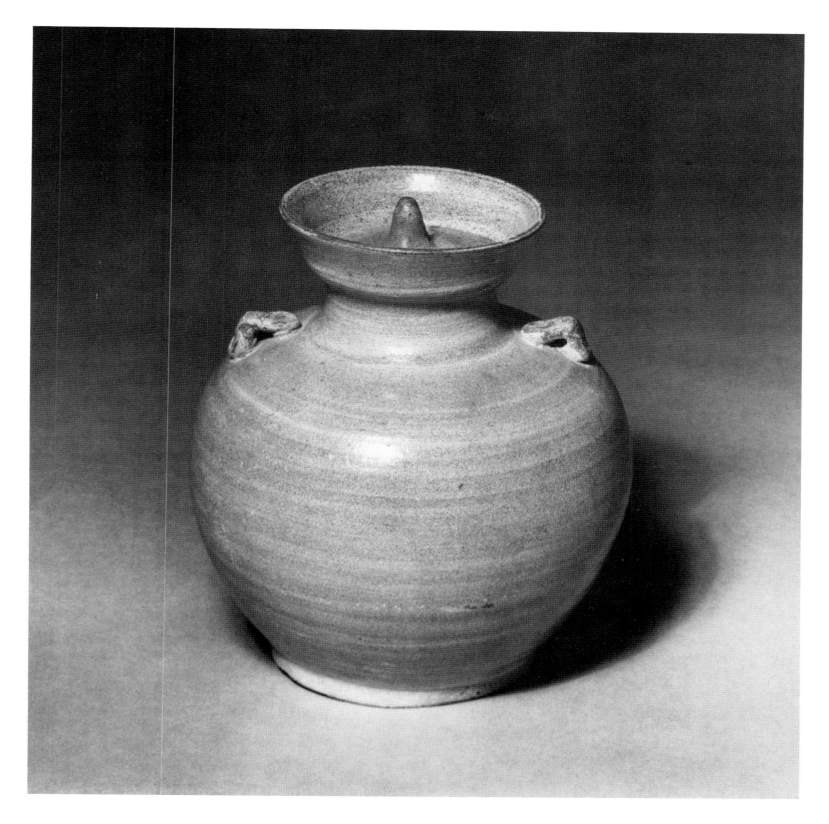

53. *Storage Jar*. Thai; 15th-16th century
Stoneware; H. 26.8 cm.

54. *Oil Jar*. Thai; 15th-16th century
Stoneware; H. 12.5 cm. (*opposite*)

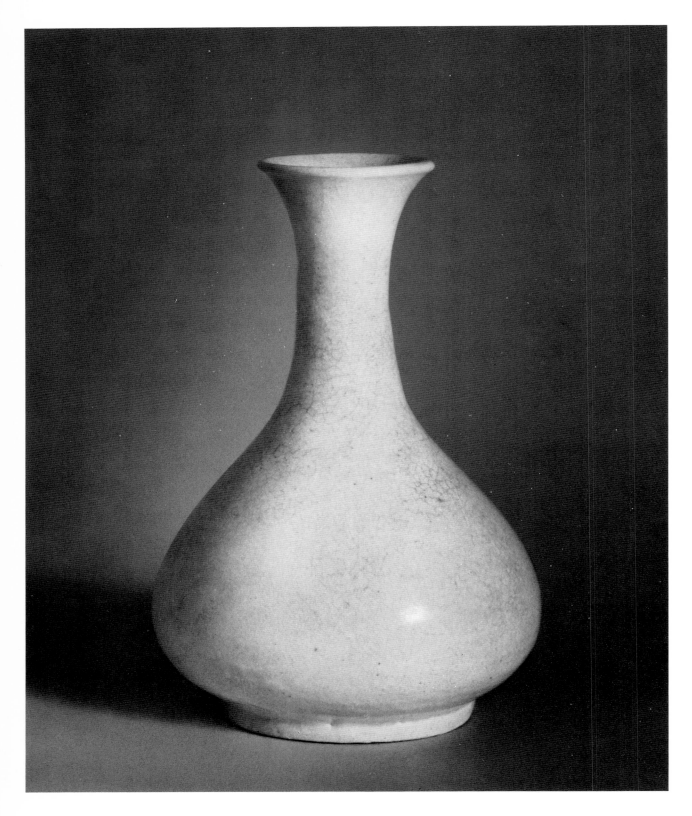

Other Thai Kiln Sites

55. *Oil Bottle*. Thai; 14th-16th century
Stoneware; H. 15.4 cm. (*opposite*)

56. *Dish*. Thai; 14th-16th century
Stoneware; Diam. 7.3 cm.

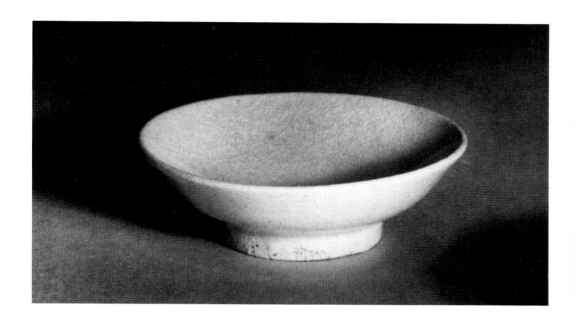

57. *Bowl*. Thai; 15th-16th century
Celadon; Diam. 15.4 cm.

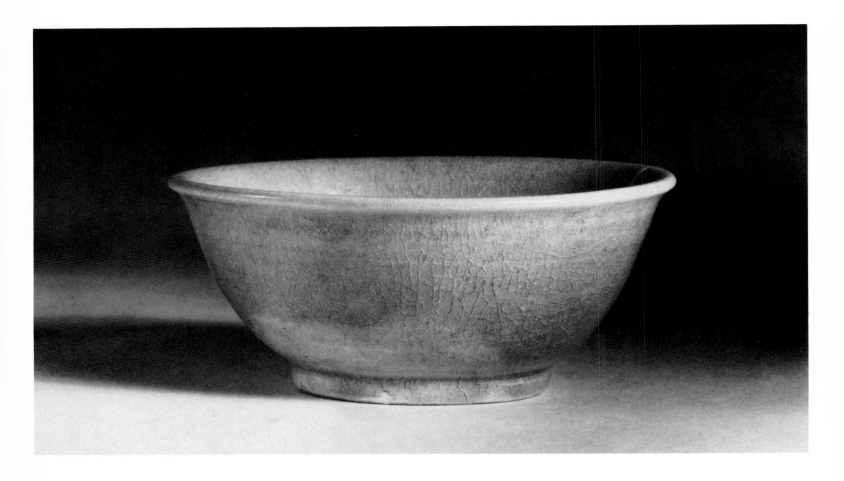

The Ceramics of Thailand

Sawankhalok

14. *Bottle*. Thai; 13th-14th century
From Sawankhalok
Porcelaneous stoneware; H. 14 cm.
Lent by the Philadelphia Museum of Art

This ovoid oil bottle, of brown paste covered with a finely crazed, dark brown glaze, is fitted with two small loops. These served to secure a stopper (now missing) that was tied on with a cord.

15. *Jar*. Thai; 13th-14th century
From Sawankhalok
Porcelaneous stoneware; H. 17.5 cm.
Lent by the Philadelphia Museum of Art

Wheel-cuts around the shoulder decorate this heavily potted, globular jar that was used for oil or wine. The brown paste is covered with a thin brown glaze.

16. *Box With Cover*. Thai; 14th century
From Sawankhalok
Stoneware; Diam. 12.5 cm.
Lent by the Herbert F. Johnson Museum of Art,
 Cornell University

A globular condiment box, decorated with an incised floral pattern in underglaze brown on a pale gray background, has delicately wrought brown petals and a gray stem in relief on its domed cover.

17. *Box With Cover*. Thai; 14th century
From Sawankhalok
Stoneware; Diam. 12.4 cm.
Lent by the Herbert F. Johnson Museum of Art,
 Cornell University

This flattened globular condiment box on a low foot ring has a domed lid with a small knob finial. The decorative patterns are incised and painted in underglaze brown on gray.

18. *Box With Cover*. Thai; 14th century
From Sawankhalok
Stoneware; Diam. 5.6 cm.
Lent by the Herbert F. Johnson Museum of Art,
 Cornell University

At the top of this rounded cosmetic box is a decoration in the form of a mangosteen. Pale brown, incised, floral designs under a beige glaze cover the box.

19. *Female Figure*. Thai; 14th century
From Sawankhalok
Stoneware; H. 8.5 cm.
Lent by the Herbert F. Johnson Museum of Art,
 Cornell University

A seated, female, hunchbacked figure appears to be supporting a vessel whose opening may have held joss sticks. The features and costume are decorated in a brown iron pigment under an off-white glaze. The base is flat and unglazed.

20. *Water Dropper*. Thai; 14th century
From Sawankhalok
Stoneware; H. 7.5 cm.
Lent by Mrs. Lauriston Sharp

A pouring vessel modeled in the form of a pair of ducks has stylized feathers incised and painted in underglaze brown on the gray body.

21. *Bowl*. Thai; 14th-15th century
From Sawankhalok
Celadon; Diam. 30.3 cm.
Lent by Mr. and Mrs. Dean F. Frasché

A heavily potted, porcelaneous stoneware bowl is distinguished by its beveled, foliate rim, which is edged in a pale gray paste that contrasts with the body of the bowl. It is decorated on the cavetto with four incised medallions that frame lotus flowers. A border of three incised concentric rings and a wide band surround the central lotus. The outside of the bowl is fluted. The unglazed base is fired to a reddish buff and marked with a black ring. (p. 55)

22. *Bowl*. Thai; 14th-15th century
From Sawankhalok
Celadon; Diam. 31.8 cm.
Lent by Mr. and Mrs. Adrian Zecha

This unusually large, porcelaneous stoneware bowl is decorated on the cavetto with parallel incised bands and cross-hatching and on the outside with similar bands and fluting.

23. *Vase*. Thai; 14th-15th century
From Sawankhalok
Celadon; H. 20.8 cm.
Lent by Mr. and Mrs. John D. Rockefeller 3rd

This compressed globular stoneware vase has a high, flaring neck with an everted, flat rim. Incised designs consisting of parallel bands at the base of the neck, highly stylized flower petals on the shoulder, and uneven, concentric, wavy lines around the body are emphasized by the concentration of the pale green glaze along the incised lines. (p. 40)

24. *Jar*. Thai; 14th-15th century
From Sawankhalok
Celadon; H. 16 cm.
Lent by Mr. and Mrs. Dean F. Frasché

A compressed globular porcelaneous stoneware wine jar of gray paste is decorated with incised bands of lotus petals on the shoulder and two stylized mud fish on the body. The short neck has a round lip and two small loops between the lip and shoulder. A pipe scar is visible on the base.

25. *Stem Bowl*. Thai; 14th-15th century
From Sawankhalok
Celadon; H. 10.5 cm., Diam. 17.6 cm.
Lent by the Philadelphia Museum of Art

A wide band of incised, criss-crossed lines, bordered by incised circles, decorates the interior of this shallow stoneware bowl. It rests on a stem that rises from a stepped, splayed, hollow base.

26. *Bowl*. Thai; 14th-15th century
From Sawankhalok
Celadon; Diam. 14.8 cm.
Lent by the Philadelphia Museum of Art

The interior of this deep, straight-sided stoneware bowl carries an incised design of curving lines, with three circular lines near the rim and two near the bottom of the bowl. It has an everted lip and a vertical foot ring. The crackled glaze is a pale blue green.

27. *Water Dropper*. Thai; 14th-15th century
From Sawankhalok
Celadon; H. 9.6 cm.
Lent by the Philadelphia Museum of Art

Under a thick, dark green, crackled glaze, bands and stylized leaves are painted in dark gray on the shoulder of this globular stoneware vessel.

28. *Jar With Cover*. Thai; 14th-15th century
From Sawankhalok
Stoneware; H. 10.5 cm.
Lent by the Philadelphia Museum of Art

The everted, stepped top of this ovoid jar is surmounted with a lotus bud in relief. The jar served as a container for lime paste or betel nuts. The crackled, cream colored glaze leaves part of the foot exposed.

29. *Box With Cover*. Thai; 14th-15th century
From Sawankhalok
Stoneware; Diam. 11 cm.
Lent by Mr. and Mrs. Dale Keller

At the center of the domed lid of this white-glazed, porcelaneous stoneware box is a white lotus bud set in a raised circle and surrounded by stylized, loosely drawn petals under a brown glaze.

30. *Tile*. Thai; 14th-15th century
From Sawankhalok
Stoneware; L. 32.5 cm.
Lent by the National Museum, Bangkok

A flat, diamond-shaped tile carries a stylized flower in relief. The surface and sides are covered with a thick, pitted, gray white glaze.

31. *Architectural Finial*. Thai; 14th-15th century
From Sawankhalok
Stoneware; H. 58.7 cm.
Lent by the Los Angeles County Museum of Art;
 gift of Mr. and Mrs. Hans A. Ries

This building ornament is conceived in the form of a mythical lion, *nora singha*, shown here with a serpent between its jaws. The incised decoration is painted in underglaze brown against a background of white glaze.

32. *Tile Finial*. Thai; 14th-15th century
From Sawankhalok
Stoneware; H. 18 cm.
Lent by the Herbert F. Johnson Museum of Art,
 Cornell University

A half figure of a Bodhisattva, resting on a lotus base, is modeled in high relief on this tile. The heavy white glaze is applied over a gray paste.

33. *Bowl*. Thai; 15th century
From Sawankhalok
Stoneware; Diam. 14.3 cm.
Lent by the Herbert F. Johnson Museum of Art,
 Cornell University

Dark gray bands and stylized, angular leaves painted on gray slip, covered with a finely crackled, greenish gray glaze, decorate this bowl. The body is of gray paste and has an everted lip and a high foot ring.
(p. 72)

34. *Box With Cover*. Thai; 15th century
From Sawankhalok
Stoneware; Diam. 17.8 cm.
Lent by the Los Angeles County Museum of Art;
 Far Eastern Art Council Fund, 1972

The cover of this globular box is embellished with a relief of the stem and leaves of a mangosteen. Delicately painted leaves and twining branches are painted in dark gray on the gray paste cover and

body. The transparent glaze does not cover the low foot ring.

35. *Box With Cover*. Thai; 15th century
From Sawankhalok
Stoneware; Diam. 13.5 cm.
Lent anonymously

A bold design of lotus petals and flowers is painted in gray brown on this round box. The cover is surmounted by a lotus bud in relief, encircled with five painted petals. The transparent glaze does not cover the low foot ring, which has a flat base.

36. *Bowl*. Thai; 15th century
From Sawankhalok
Porcelaneous stoneware; H. 10 cm.
Lent by Mr. and Mrs. Dean F. Frasché

The compressed globular body of this bowl has a low, vertical lip and rests on a high foot ring. A freely sketched gray flower design, placed between bands, is painted around the bowl. The transparent glaze which covers the gray paste is finely crackled.

37. *Cup*. Thai; 15th century
From Sawankhalok
Stoneware; H. 8 cm.
Lent anonymously

On a pear-shaped cup a dark gray flower and leaf pattern bordered with bands is painted on gray slip. The lower section of the interior is covered with a thick, green gray glaze over the gray paste. The unglazed areas of the splayed foot ring are iron red.

38. *Wine Pot With Cover*. Thai; 15th century
From Sawankhalok
Stoneware; H. 12.4 cm.
Lent by the Philadelphia Museum of Art

A gray, feathery design on pale gray slip over gray paste decorates this globular wine pot. The domed cover, which rests on a low neck, bears a small knob in relief. The slightly splayed foot ring is unglazed.
(p. 38)

39. *Kendi*. Thai; 15th century
From Sawankhalok
Stoneware; H. 22.4 cm.
Lent by Mr. and Mrs. Adrian Zecha

The globular body of this pouring vessel carries a design of dark gray, scalloped petals around the base of its high neck, concentric bands on the shoulder, and around the body interlocking, lozenge-shaped medallions that frame flowers and leaves. Stylized birds and a floral pattern decorate the mammillary spout. A transparent glaze covers the gray paste.

40. *Kendi*. Thai; 15th century
From Sawankhalok
Porcelaneous stoneware; H. 13.7 cm.
Lent by the Philadelphia Museum of Art

Medallions on the spout and body of this vessel frame clusters of small, pointed leaves and branches, painted in dark gray as are the concentric bands on the shoulder. Foot rim and neck are undecorated, but the upper side of the flanged lip carries a leaf design. The kendi is covered with a transparent, pale green glaze.

41. *Ewer*. Thai; 15th century
From Sawankhalok
Stoneware; H. 21 cm.
Lent by Mr. and Mrs. Leandro V. Locsin

A male figure, perhaps intended to represent Rama, is poised on this ceremonial ewer that takes the form of a bird (*hamsa*?). Stylized designs, painted in a dark gray on gray paste and covered with a transparent glaze, consist of a band of trefoils below the rider, feathers within the outlines of the wings, a lotus bud on the flattened tail, and floral patterns on tail and body.

Sukhothai

42. *Dish*. Thai; 13th-14th century
From Sukhothai
Stoneware; Diam. 25 cm.
Lent by Mr. and Mrs. Adrian Zecha

A narrow band of irregular lines and loops decorates the flattened rim of this dish and two circles surround the central design, a fish with leaves of an aquatic plant. The decoration is in dark gray on an off-white ground. The outside of the bowl is undecorated and the base is unglazed.

43. *Bowl*. Thai; 13th-14th century
From Sukhothai
Stoneware; Diam. 11 cm.
Lent by Mrs. Lauriston Sharp

The central motif in the bottom of this bowl, a symbol of Vishnu's weapon the *chakra*, is encircled by freely drawn bands. Three bands appear inside, near the rim, and are repeated on the exterior of the curving wall. The decoration is painted in brown black on cream slip over a coarse, gray brown paste. Foot ring and base are unglazed.

44. *Storage Jar*. Thai; 13th-14th century
From Sukhothai
Stoneware; H. 18.5 cm.
Lent by the Idemitsu Art Gallery, Tokyo

Leaf designs in iron brown are framed by panels on the shoulder of this jar, and spotted fish circumnavigate the foot. The base is unglazed.

45. *Covered Jar*. Thai; 13th-14th century
From Sukhothai
Stoneware; H. 21 cm.
Lent by Mr. and Mrs. Adrian Zecha

Brown black, speckled fish swim among aquatic plants on the body of this jar, and the cover is decorated with bands of leaf scrolls. A lotus bud finial crowns the dome. The paste is covered with a cream slip.

46. *Stem Bowl*. Thai; 13th-14th century
From Sukhothai
Stoneware; H. 19.5 cm., Diam. 15.8 cm.
Lent by the Honolulu Academy of Arts; gift of
 Donald Bickford, 1957

A deep bowl with rounded sides stands on a hollow, bell-shaped base. The brown black floral motif and bands are painted on cream slip under a crackled transparent glaze.

Kalong

47. *Storage Jar*. Thai; 14th-16th century
From Kalong
Stoneware; H. 43 cm.
Lent by Wat Srikomkan, Payao, Thailand

The ovoid body has a wide, tapering neck terminating in a squared-off collar. The painted, underglaze gray decoration is divided into six horizontal bands. In the three central bands, spotted and striped horses, *kinnaras*, and peacocks appear amid scrolling vines and flowers. Flower patterns encircle the neck and a band of stylized lotus panels is painted above the unglazed base where the gray paste is exposed.

48. *Storage Jar*. Thai; 14th-16th century
From Kalong
Stoneware; H. 45.2 cm.
Lent by Mr. and Mrs. John D. Rockefeller 3rd

This large jar is covered with an uneven, thin, pale greenish yellow crackled glaze. Two bands of incised zigzag lines encircle the shoulder where a pair of small, brown-glazed lotus buds rises at each side. The beveled lip flares from a high neck. The base is flat and unglazed. This jar contained several hundred small, cast metal Buddhas when it was excavated at Kamphaeng Phet, Thailand, in 1961. (*frontispiece*)

49. *Dish*. Thai; 14th-16th century
From Kalong
Celadon; Diam. 7.5 cm.
Lent anonymously

This tiny, shallow condiment dish is covered with crackled, pale gray green glaze.

50. *Wine Bottle*. Thai; 14th-16th century
From Kalong
Stoneware; H. 26 cm.
Lent by the Philadelphia Museum of Art

On the pear-shaped body of this bottle, two wide bands of flowers and leaves, painted in gray on gray paste, are divided by a plain, narrow, raised section. Stripings decorate the cup-like mouth and the lower section of the body. The flat base is unglazed.

Sankampaeng

51. *Bowl*. Thai; 15th-16th century
From Sankampaeng
Celadon; Diam. 33.5 cm.
Lent anonymously

This deep bowl with a round lip and steep, sloping sides rests on a comparatively narrow, unglazed base. Rounded, concentric ridges encircle the upper half of the exterior. The gray paste is covered with a thin, crackled, pale green glaze.

52. *Oil Jar With Cover*. Thai; 15th-16th century
From Sankampaeng
Stoneware; H. 14.3 cm.
Lent by Mr. and Mrs. Floyd L. Whittington

The jar's globular body has two loop handles inserted through the shoulder, a low neck, and a cup finial with a cover. The brown paste is covered outside and inside with a thin, gray green, finely crackled glaze.

53. *Storage Jar*. Thai; 15th-16th century
From Sankampaeng
Stoneware; H. 26.8 cm.
Lent by the Herbert F. Johnson Museum of Art,
 Cornell University

A thin, putty-colored, semi-glossy glaze covers the ovoid body of this jar. Its short neck opens into a wide, cup-shaped mouth. The flat, unglazed base is fired to an iron red.

54. *Oil Jar*. Thai; 15th-16th century
From Sankampaeng
Stoneware; H. 12.5 cm.
Lent by the Herbert F. Johnson Museum of Art,
 Cornell University

A jar with a cup-shaped mouth and low neck has two small loop handles attached through the shoulder. The ovoid body is covered with a finely crackled, thin, green gray glaze.

Other Thai Kiln Sites

55. *Oil Bottle*. Thai; 14th-16th century
From Ban Thung Hua
Stoneware; H. 15.4 cm.
Lent by Mr. and Mrs. J. R. Galloway

The pear-shaped bottle of pale beige paste is covered with cream slip and, except for the low foot ring and base, a transparent glaze. The long neck ends in an everted lip.

56. *Dish*. Thai; 14th-16th century
From Ban Thung Hua
Stoneware; Diam. 7.3 cm.
Lent by Mr. and Mrs. J. R. Galloway

A very small, shallow condiment dish with a concave base is covered with a finely crackled transparent glaze over cream slip.

57. *Bowl*. Thai; 15th-16th century
From Phan
Celadon; Diam. 15.4 cm.
Lent by the Herbert F. Johnson Museum of Art,
 Cornell University

A thick, coarsely crackled green glaze covers this half-spherical stoneware bowl. It stands on a low foot ring, and has a rounded, everted rim and an unglazed, flat base.

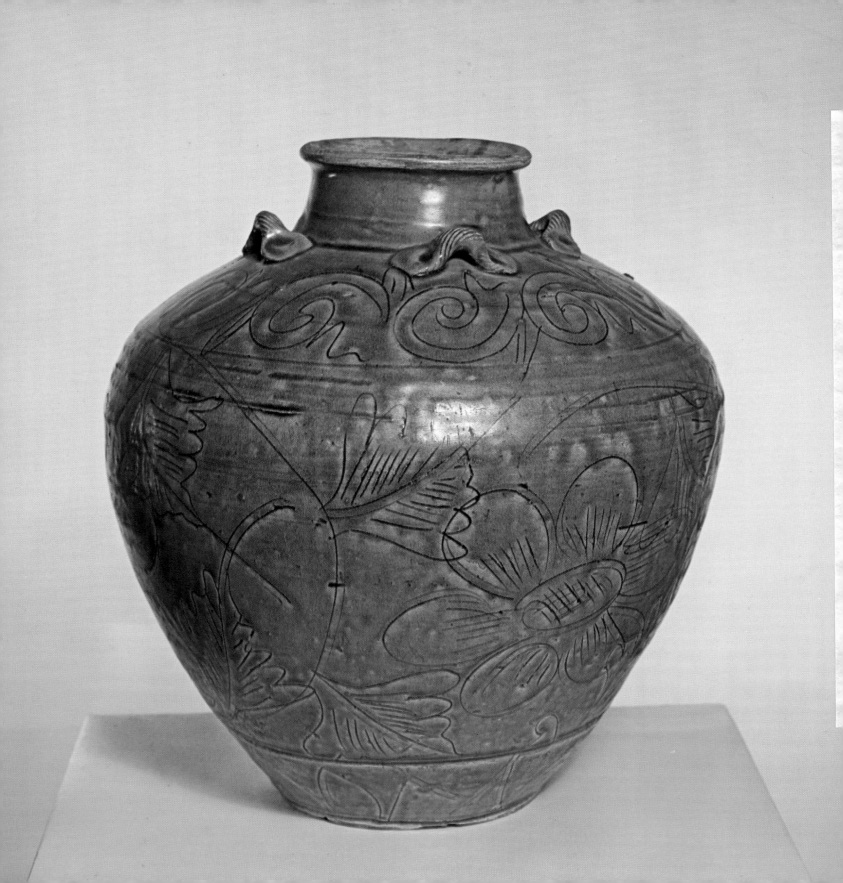

70. *Storage Jar*. Vietnamese; 14th-15th century
Stoneware; H. 33.5 cm.

Since the advent of the twentieth century a large number of widely diverse types of indigenous ceramics dating from the pre-Christian era to modern times have been found in what is now northern Viet Nam.

As noted earlier, this region was dominated by the Han Chinese before and during the early part of Christian times, and in the early T'ang period became the Chinese protectorate known as Annam ("Pacified South"). The dependency embraced an area approximately the same as that designated in modern times as Tonkin, and included the coastal plains as far south as the Hoanh Son mountain spur. Although China had influenced every segment of Vietnamese society and finally had brought it within the political, commercial, and cultural orbit of the Middle Kingdom, the Vietnamese eventually managed to establish their national identity as an independent country. Despite the war of liberation in the tenth century, however, the influence of Chinese customs, language, architecture, and the other arts has remained apparent to the present day.

Among the many cultural benefits derived from China was the art of ceramics, which appears to have flourished, especially in northern Viet Nam, from the tenth century onward. The earliest pottery found in Viet Nam is said to date from the second century B.C. when the Chinese potter Hoang Quang-hung brought the potter's wheel to Viet Nam and settled in Dau Khe, a village in Hai Duong province. This is supposed to have remained the most important provincial pottery center for several centuries.[1] According to Dumoutier, in about 1465 some of the potters migrated from Dau Khe and established a new pottery center at Tho Ha, near the village of Bac Ninh, some thirty kilometers northeast of Hanoi. There they soon surpassed all other ceramic centers in the production of jars of unusually large size and circumference that were used for water and brine.[2] These were made in a single piece and fired successfully without losing their shape, a potting feat unequalled by the Chinese, who made similar jars by luting three sections together.[3] In the sixteenth and seventeenth centuries the kilns at Tho Ha produced ornate, unglazed, red and gray incense burners, vases for joss sticks, and other cult objects intended for the temples.[4] Appropriately, there is a temple in Tho Ha commemorating Hoang Quang-hung as the patron saint of potters.

In addition to the kilns at Tho Ha, ceramic centers were reported in the provinces of Binh Dinh, Phuc Yen, Vinh Yen, Bac Ninh, Ha Dong, Quang Binh, and

Thanh Hoa.[5] Most of the centers in these areas produced terra cottas, faience, and stonewares; other kilns at Loc Thuang and Phu Vinh in Quang Nam province and at the well-known center at Bat Trang in Bac Ninh province produced high-fired, glazed and unglazed stonewares and semiporcelains.[6] Unfortunately there are no historical records of these centers and their dates of origin remain unknown. With the exception of the archaeological investigations in Thanh Hoa province, where Han and Sung kilns have been reported,[7] there have been few systematic investigations of the Viet Nam wares or of the places where they might have been manufactured.

The ceramics of Viet Nam (which have also been identified as Tonkinese, Sino-Annamese, or Annamese wares) show extremely wide variations as to type, form, paste, glaze, and decoration. They can, however, be grouped in a general way as follows: earthen pottery made prior to the eighth century; wares dating from the ninth to the thirteenth century which reveal strong evidence of T'ang and Sung influence; and stonewares and semiporcelains of the fourteenth to the mid-seventeenth century, showing close affinities to some of the ceramics of the Yüan and Ming periods. The latter include pieces decorated in underglaze blue, overglaze enamels (or sometimes with a combination of the two), and green, brown, or cream colored monochromes.

The early earthen wares, which were found during the archaeological investigation in Thanh Hoa province, are probably of Chinese origin.[8] As examples of these wares are not included in the exhibition, they will not receive further comment.

Vietnamese pottery assigned to the ninth to the thirteenth century includes bowls, vases, dishes, wine pots, and jars which show strong Chinese influence of the Sung period. The wares are of hard gray, beige, or cream paste, and their glazes range from celadon green to pale green, blue green, sepia, pale cream, yellowish beige, and dull gray. Bowls made in imitation of China's Northern celadons with incised or stamped decoration (No. 59), molded bowls with fluted sides and scalloped rims (No. 60), and others with painted leaf scrolls under a thin, coarsely crackled green glaze (No. 61) are considered to be typical of the period. Among other ceramics of the same period are storage jars with covers (Nos. 62, 63), deep bowls with incised floral decorations in dark brown (No. 58), globular wine pots of pale cream paste decorated with molded lotus petals and zoomorphic spouts and handles under a honey colored, finely crackled glaze (No. 64), and high-footed bowls (No. 65), cups (No. 66), and small jars (No. 67), all made of fine paste covered with an off-white or cream slip under crackled, transparent glaze. The provenance of these Sung-inspired Vietnamese ceramics is said to be Thanh Hoa province.[9]

The wide range of stonewares and semiporcelains produced in northern Viet Nam between the fourteenth and the mid-seventeenth century includes jars, vases,

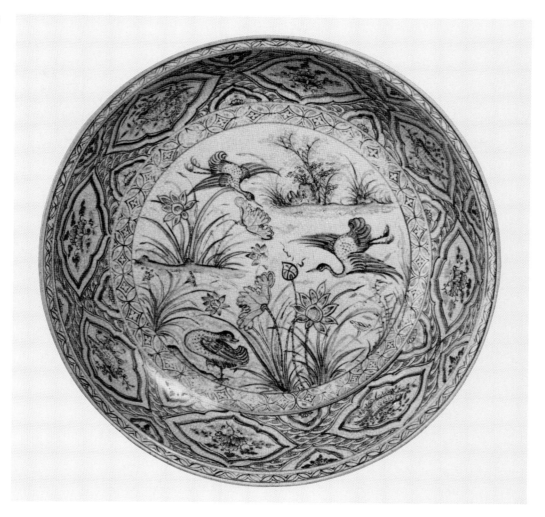

Fig. 14. An outstanding example of Vietnamese overglaze enameled ceramics, this unusually large dish from the Gemeentelijk Museum Het Princessehof, Leeuwarden, is reminiscent of Chinese prototypes both in shape and in the style of decoration. The drawing of various waterfowl among lotus plants in the center and of the birds and flowers on the cavetto has been done with unusual delicacy.

bowls, dishes, bottles, ewers, incense burners, and boxes, varying in size from large temple jars almost a meter in height to miniature animals, fishes, and crabs of a few centimeters. Particularly striking are the pilgrim bottles (No. 84), globular stem bowls (No. 75), slender wine bottles (Nos. 85, 98), vases decorated in underglaze gray (No. 69),[10] wine ewers in forms that are reminiscent of early Persian pottery (No. 86), and kendis (No. 87). Among the wide repertoire of small objects are pouring vessels modeled as birds (No. 99), covered boxes (No. 88), jars (No. 89), and water pots (Nos. 90, 91).

These shapes are almost invariably heavily potted of thick, putty colored, pale beige, or gray paste. Their bases are usually carefully finished, with foot rings varying in height and width, depending on the form and the size of the piece. The foot rings of the large jars and shallow bowls are usually low and wide; on the small jars, vases, and bowls they tend to be high. The bases of the many ceramic forms,

regardless of their size, are often left in plain biscuit or covered with a thin, color-less glaze, but more frequently they are painted with a brown or purplish brown iron oxide wash, which is an outstanding characteristic of the Vietnamese wares of the period.[11]

Another characteristic of many of the wares is the treatment of the edges of rims, lips, and foot rings, which have been left unglazed. This suggests that the large forms were fired on flat fireclay supports, and that smaller dishes, bowls, and other vessels were placed in tiers and fired rim to rim and base to base (fig. 13). Evidence of still another firing technique used by the Vietnamese potters is the wide, un-glazed ring so often found on the interior of their bowls (No. 96) and flat dishes. These ceramics were stacked before firing so that the foot rim of each piece was placed on the unglazed ring inside the piece below it. The spurred disk was also used as a firing accessory in the Vietnamese kilns (fig. 12), as is evidenced by the spur marks found in numerous bowls and dishes (No. 71).

The glazes are usually thin and have a tendency to flake and erode, indicating that they failed to fuse with the paste during firing. The overglaze enamel decora-tions are also thinly applied and, because of their physical and chemical nature, they disintegrate readily if exposed to the elements.

The decorative motifs of the period are primarily floral patterns. Of these one of the most common is the peony, which is depicted in scrolls, as a single flower (No. 102), as a double-petaled flower (No. 78), in pairs or threes, or in combina-tion with the lotus (No. 79) and other flowers. The lotus, too, is an important element in the decorative patterns, appearing as a single flower (No. 80), in ubiqui-tous lotus scrolls, and in combination with other flowers. Other motifs include denizens of the animal world: birds (fig. 14), fishes, which are particularly common (No. 76), also horses, deer and, more rarely, lions (No. 82). The mythical phoenix is a frequent subject (No. 81), but the kylin is rarely found, and the dragon (No. 83) is seldom depicted in underglaze designs. Human figures are said to appear only on pieces made during the late sixteenth century.[12]

The classic example of Vietnamese ceramic art is the celebrated bottle in the Topkapu Sarayi Müzesi in Istanbul which was made at Nan Ts'e-chou and bears a date corresponding to 1450 (fig. 15).[13] The bottle is decorated with an underglaze blue band of boldly drawn peonies between two borders of stylized lotus panels. This dated specimen forms the technical and artistic basis for the assignment to the fifteenth century of a group of undated, highly perfected examples of Vietnamese blue-and-white wares (Nos. 72, 73, 74, 77).

The painted, overglaze red, green, and yellow enamel wares form a special category in Vietnamese ceramic art. Though the place and time of their manufacture remain to be determined, they probably date between the early fifteenth and late sixteenth century. These wares were made in a wide range of forms and sizes. The

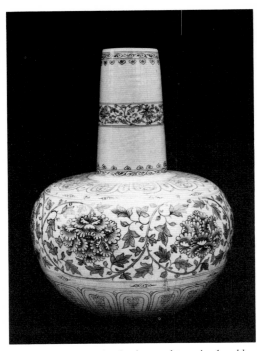

Fig. 15. Vietnamese bottle, decorated in underglaze blue and bearing a date corresponding to 1450, from the Topkapu Sarayi Müzesi, Istanbul. The only known exam-ple of Vietnamese blue-and-white ceramics inscribed with the name of the potter, date, and provenance, this famous piece offers basic stylistic data for establishing the approxi-mate dates for other blue-and-white specimens. The bottle also reveals potting characteristics in vogue during the mid-fifteenth century, such as a low, wide, flat, unglazed foot ring and a shallowly recessed, flat base painted with brown iron oxide pigment.

enamels are painted either on off-white glazed surfaces like those seen in Nos. 76 and 103, or they are used to add ornamental details to designs previously sketched in underglaze blue, as on the stem dish No. 92 and on the dish No. 93.

Finally there are the brown and cream colored monochromes, and the almond green celadons. Among the brown wares are bowls glazed brown on the outside and cream on the inside (No. 94), jars with loop handles decorated with large, incised flowers under a thin brown glaze (No. 70), and flat dishes with unglazed firing rings (No. 106a). The cream colored monochromes include bowls, small, finely potted jars and cups (No. 107), and dishes (No. 106b). The celadons are similar in form and paste to the other Vietnamese wares. Among these are oviform jars with a soft almond green glaze (No. 108), plain beakers (No. 95), small bowls with a dark green glaze over vertical fluting on their exteriors and a cream glaze on their interiors (No. 109), flat dishes molded in the shape of a chrysanthemum with a foliate rim (No. 96), and miniature round boxes (No. 68).

It is evident from the astonishingly large number of Vietnamese ceramics that have been found in other lands that they were important items of international trade throughout Southeast Asia during their long period of manufacture. Like the outstanding examples of Sawankhalok and Sukhothai ceramics, the finest Vietnamese wares in museums and private collections have been found in the Indonesian archipelago and, to a lesser extent, in the Philippines.

1. G. Dumoutier, "Essais sur les Tonkinois," p. 78.

2. Ibid. He cites 1465, but offers no supporting data.

3. P. Huard and M. Durand, *Connaissance du Vietnam*, p. 148.

4. C. Huet, "Les terres cuites de Tho-ha, les brule-parfums de Bat-trang," p. 2.

5. J. Hejzlar, *The Art of Vietnam*, p. 24.

6. H. Barbotin, "La poterie indigène au Tonkin," pp. 659-660; Hejzlar, *The Art of Vietnam*, p. 24.

7. O. Janse, "A Source of Ancient Chinese Pottery Revealed in Indo-China," p. 894.

8. Ibid.

9. Clément Huet donated some 2,900 pieces representing the whole ceramic industry of northern Viet Nam to the Musées Royaux d'Art et d'Histoire in Brussels in 1952. Many of the pieces came from his personal excavations in the Thanh Hoa area.

10. Vietnamese ceramics in all their forms, decorated in underglaze black, gray, blue gray, and blue black, have been found in great numbers in Southeast Asia. The black and gray decorations are derived mostly from natural manganiferous iron oxide pigments, but some of these pigments contain some cobalt which often gives the decorations a smoky blue cast.

11. An extensive, detailed study of the brown bottomed wares of Viet Nam has been made by René-Yvon d'Argencé, "Les céramiques à base chocolatée."

12. E. W. van Orsoy de Flines, *Guide to the Ceramic Collection (Foreign Ceramics)*, p. 67.

13. Referring to the bottle, which is fifty-four centimeters in height and made of coarse porcelain with a base covered with a brown iron oxide wash, R. L. Hobson has written: "On the shoulder is an inscription which reads from left to right, 'Painted for pleasure by Chuang a workman of Nan Ts'e-chou in the 8th year of Ta Ho' (1450). The writing is rather illiterate. There is only one nien hao which will fit this date and that is T'ai Ho, the nien hao of an Annamese ruler (1443-54). Ta for T'ai is a very common variant. And the fact that Nan Ts'e-chou is in Annam makes the interpretation certain. We have then a remarkable specimen of Annamese blue and white, doubtless made by a Chinese workman, and of a date within a few years of the reign of Hsuan Te." ("Chinese Porcelains at Constantinople," p. 13). Nan Ts'e-chou is present day Nan-sash-phu, which is about fifty kilometers east of Hanoi. See van Orsay de Flines, *Guide to the Ceramic Collection*, p. 67. This bottle is the only known dated blue-and-white specimen from Viet Nam, but there are two other dated pieces which are decorated partly in underglaze blue. One is a ritual vase almost a meter in height with two unglazed dragons in relief facing each other, dated "the 3rd year of Dien-thanh" (1575). The other is an incense burner with a legible date: "15th day of 8th month of the 2nd year of Canh-tri" (1665). See G. Dumoutier, "Letter to the Director," pp. 365-366.

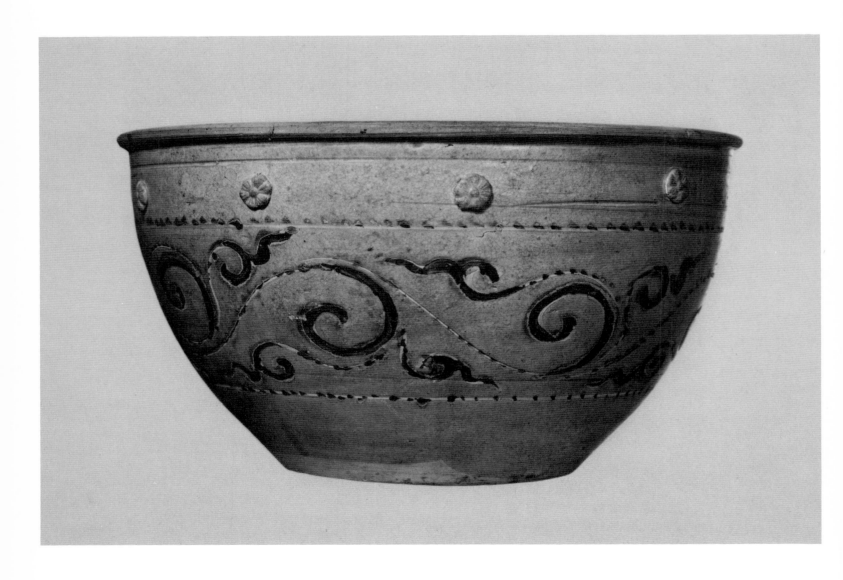

58. *Bowl*. Vietnamese; 10th-12th century
Stoneware; Diam. 35.8 cm. (*opposite*)

59. *Bowl*. Vietnamese; 11th-12th century
Celadon; Diam. 15.3 cm.

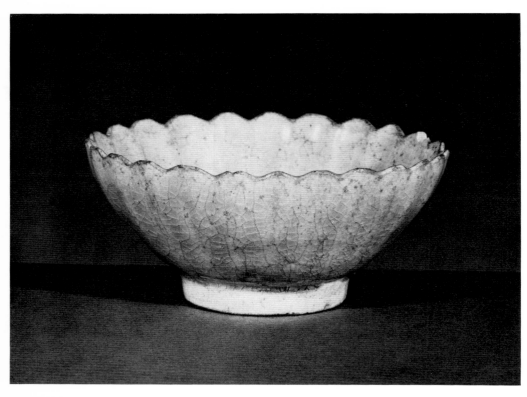

60. *Bowl*. Vietnamese; 11th-12th century
Stoneware; Diam. 10.5 cm. (*left*)

61. *Bowl*. Vietnamese; 11th-12th century
Painted celadon; Diam. 13.5 cm. (*below left*)

62. *Grain Jar*. Vietnamese; 11th-12th century
Porcelaneous stoneware; H. 27.3 cm. (*opposite*)

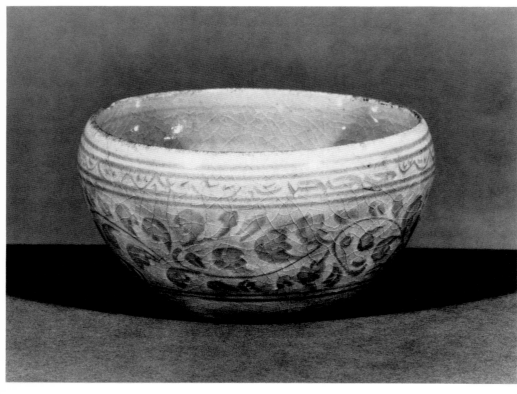

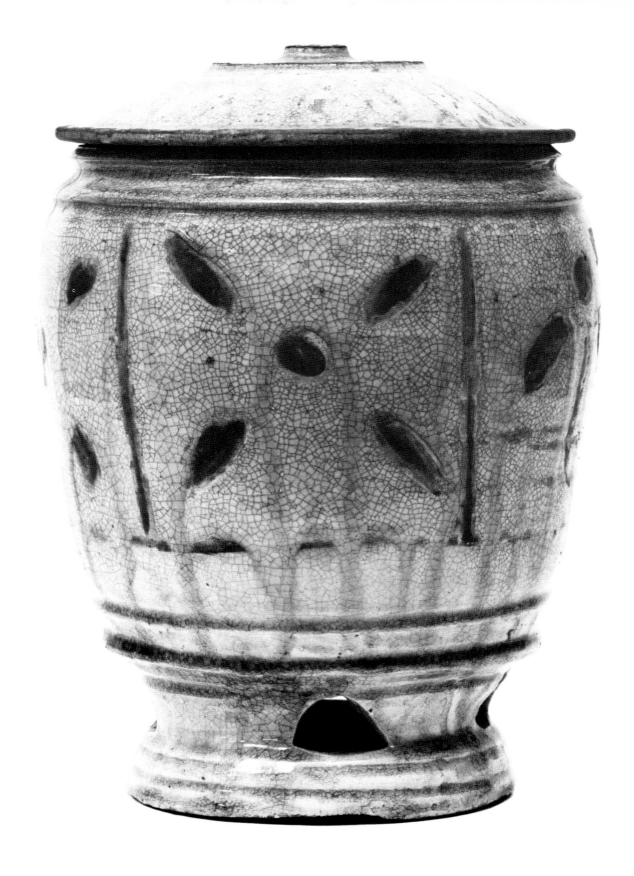

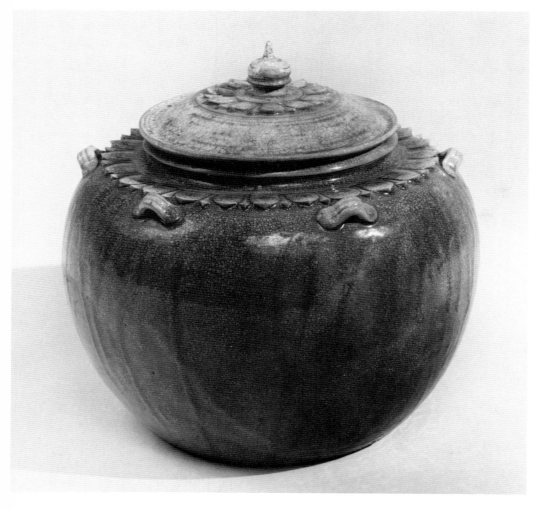

63. *Storage Jar*. Vietnamese; 11th-12th century
Stoneware; H. 21.5 cm.

64. *Wine Pot*. Vietnamese; 11th-12th century
Stoneware; H. 19 cm. *(opposite)*

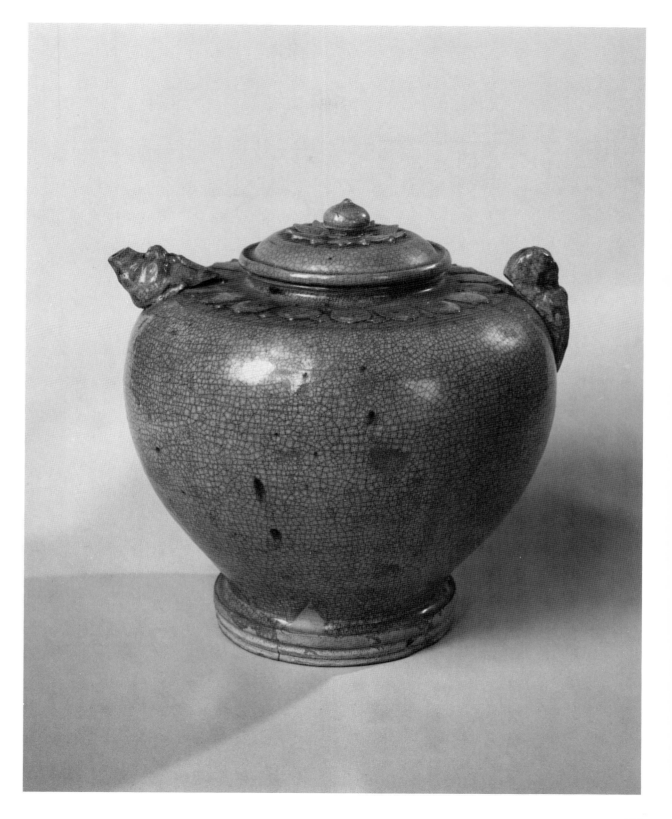

65. *Bowl*. Vietnamese; 11th-12th century
Stoneware; Diam. 14.4 cm. (*right*)

66. *Cup*. Vietnamese; 11th-12th century
Stoneware; Diam. 11.1 cm. (*opposite*)

67. *Water Pot*. Vietnamese; 11th-12th century
Stoneware; H. 7 cm. (*above left*)

68. *Miniature Box With Cover*. Vietnamese;
11th-12th century
Stoneware; Diam. 5.5 cm. (*above right*)

69. *Vase*. Vietnamese; 14th century
Stoneware; H. 18.5 cm. (*opposite*)

71. *Dish*. Vietnamese; 15th century
Stoneware; Diam. 28.8 cm.

72. *Storage Jar*. Vietnamese; 15th century
Stoneware; H. 28.5 cm.

74. *Wine Jar*. Vietnamese; 15th century
Stoneware; H. 46 cm. (*opposite*)

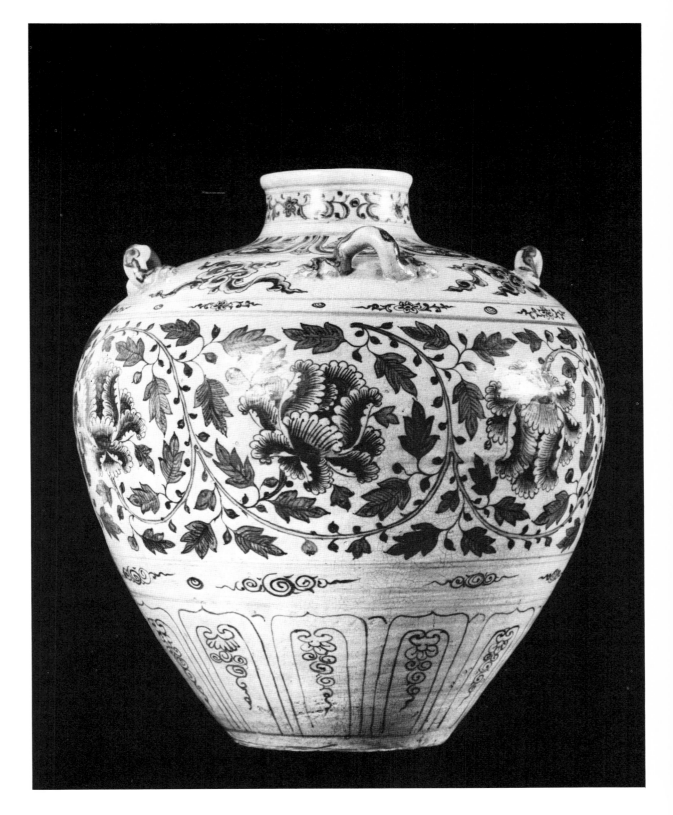

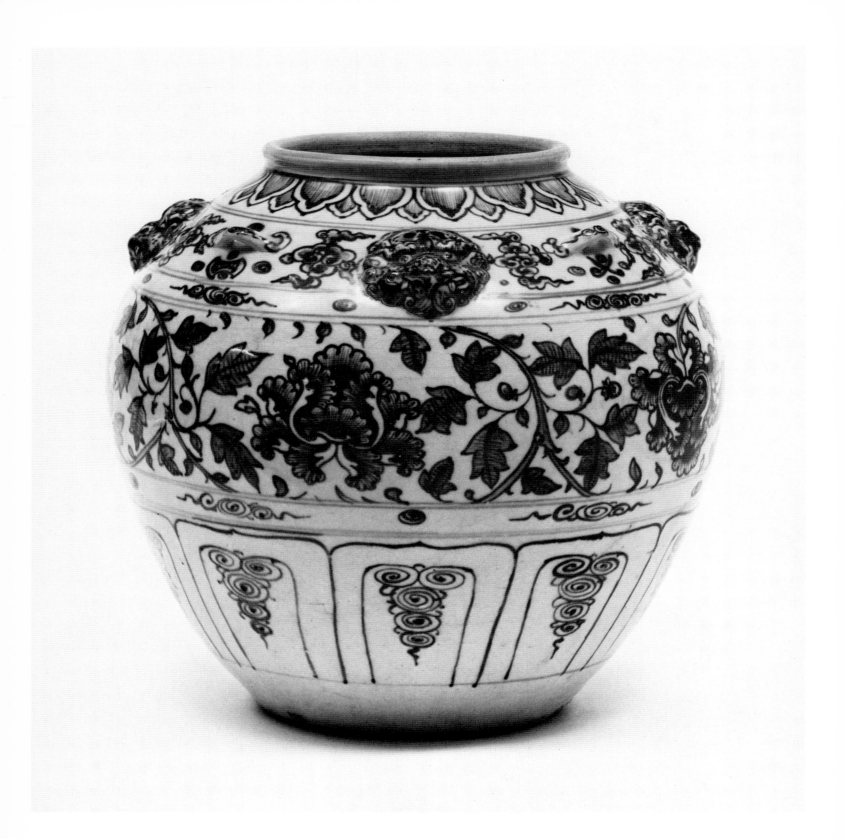

73. *Jar*. Vietnamese; 15th century
Stoneware; H. 25.4 cm. (*opposite*)

75. *Stem Bowl*. Vietnamese; 15th century
Stoneware; H. 16.5 cm.

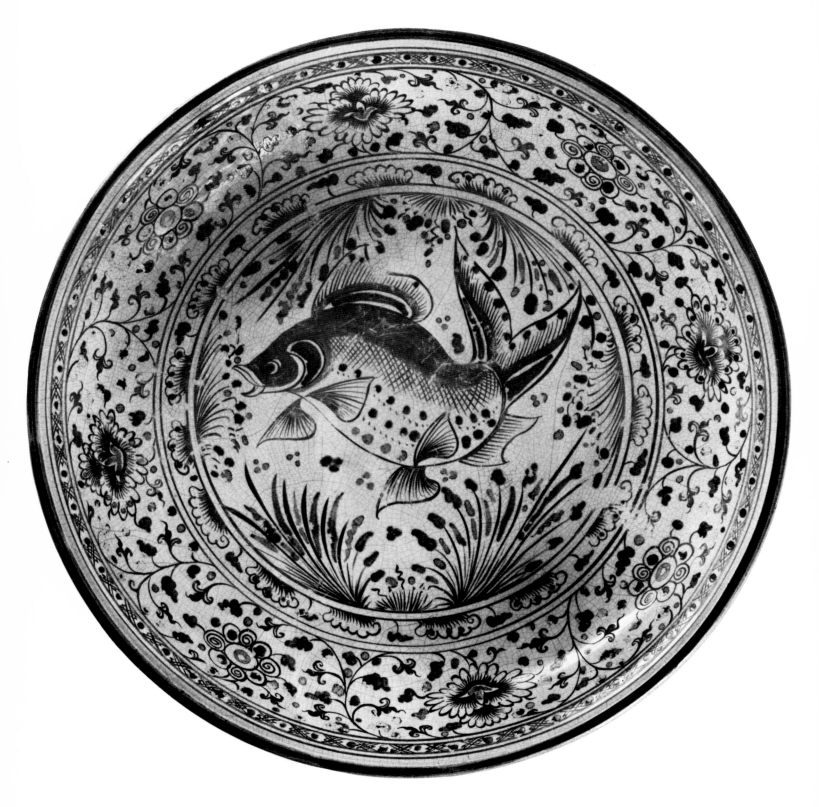

76. *Dish.* Vietnamese; 15th century
Stoneware; Diam. 45.5 cm. (*opposite*)

77. *Dish.* Vietnamese; 15th century
Stoneware; Diam. 36.5 cm. (*right*)

79. *Storage Jar.* Vietnamese; 15th-16th century
Stoneware; H. 16.5 cm. (*below right*)

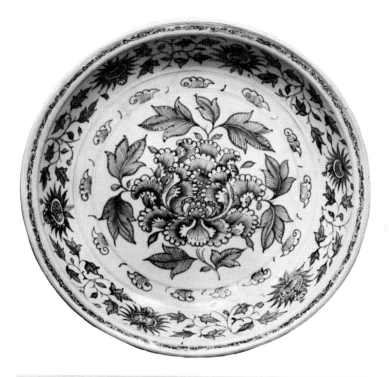

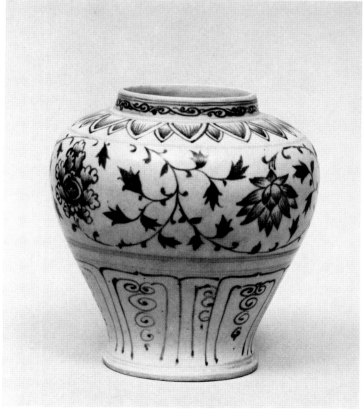

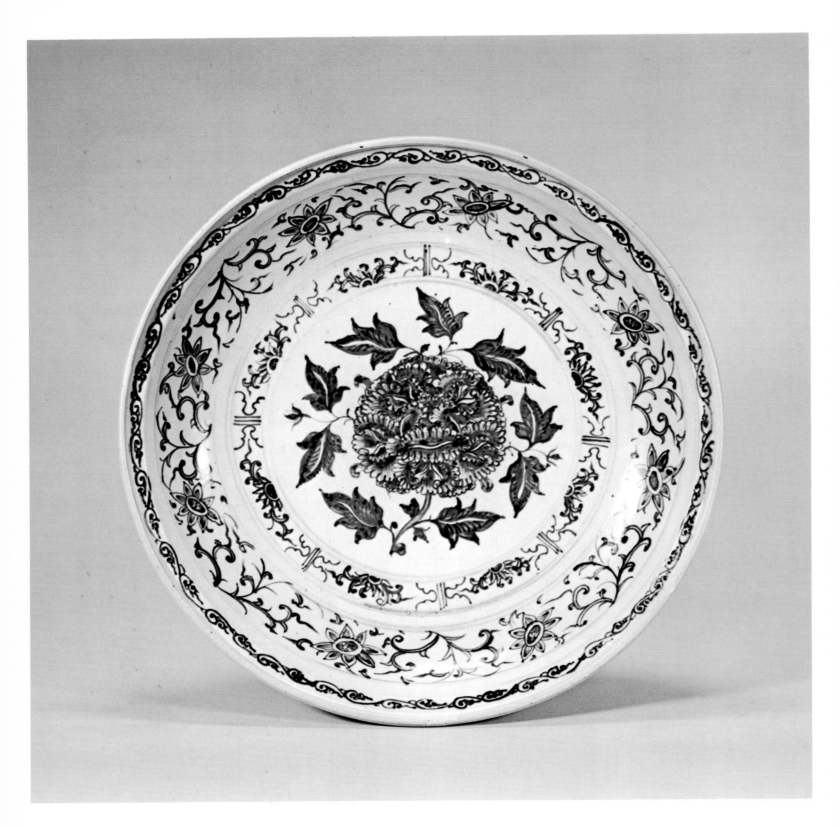

78. *Dish*. Vietnamese; 15th-16th century
Stoneware; Diam. 38.5 cm. (*opposite*)

80. *Dish*. Vietnamese; 15th-16th century
Stoneware; Diam. 36.5 cm. (*right*)

81. *Dish*. Vietnamese; 15th-16th century
Stoneware; Diam. 33.5 cm. (*below right*)

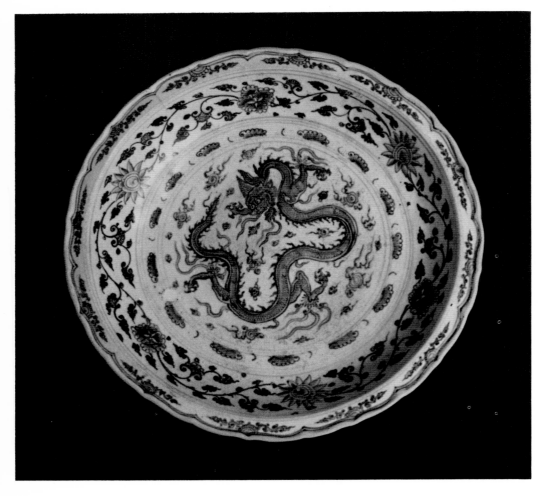

82. *Storage Jar*. Vietnamese; 15th-16th century
Stoneware; H. 53 cm. (*opposite*)

83. *Dish*. Vietnamese; 15th-16th century
Stoneware; Diam. 36.8 cm.

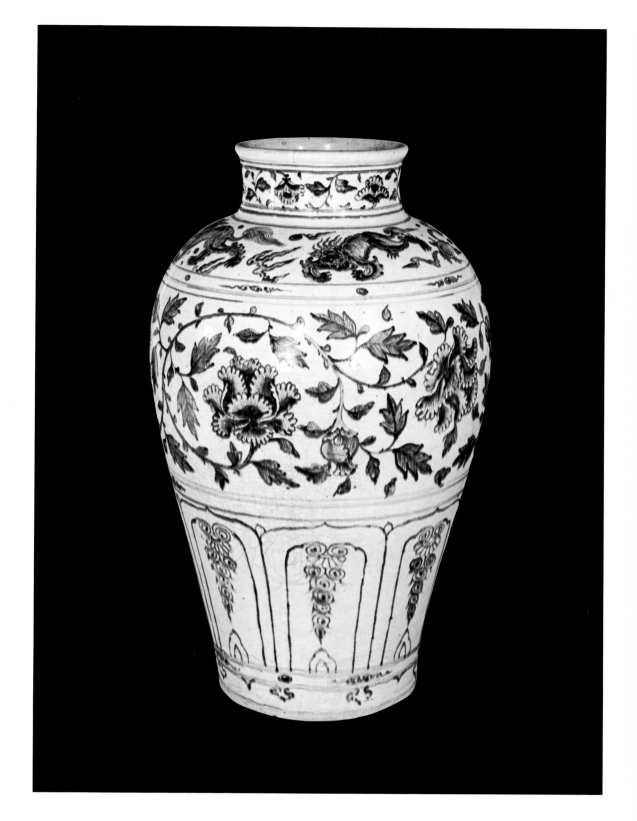

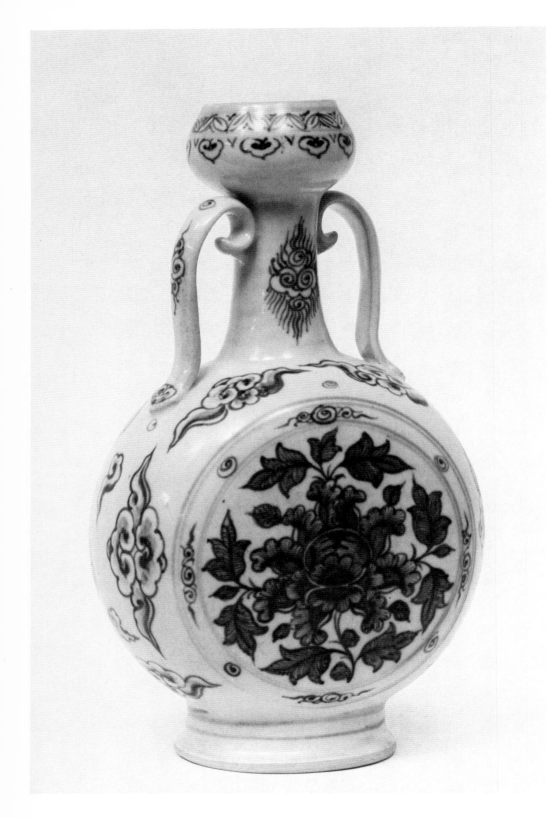

85. *Wine Bottle*. Vietnamese; 15th-16th century
Stoneware; H. 22.7 cm.

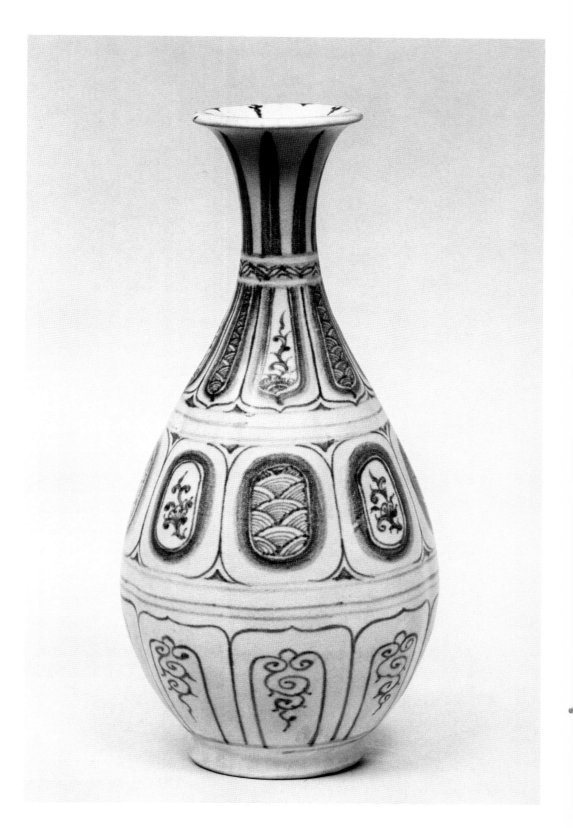

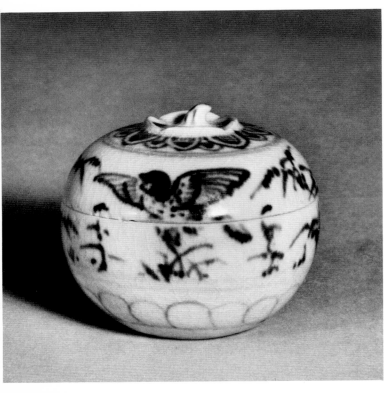

88. *Cosmetic Box With Cover*. Vietnamese;
 15th-16th century
Stoneware; Diam. 6.5 cm. *(left)*

91. *Water Pot*. Vietnamese; 15th-16th century
Stoneware; H. 6.6 cm. *(below left)*

92. *Dish on a High Foot*. Vietnamese;
 15th-16th century
Stoneware; Diam. 28.5 cm. *(opposite)*

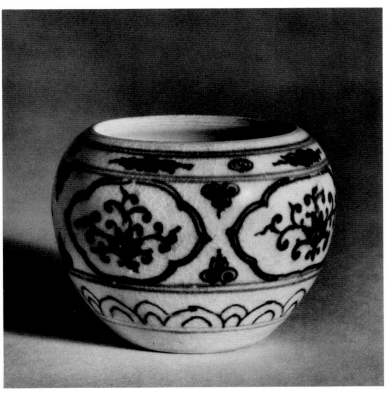

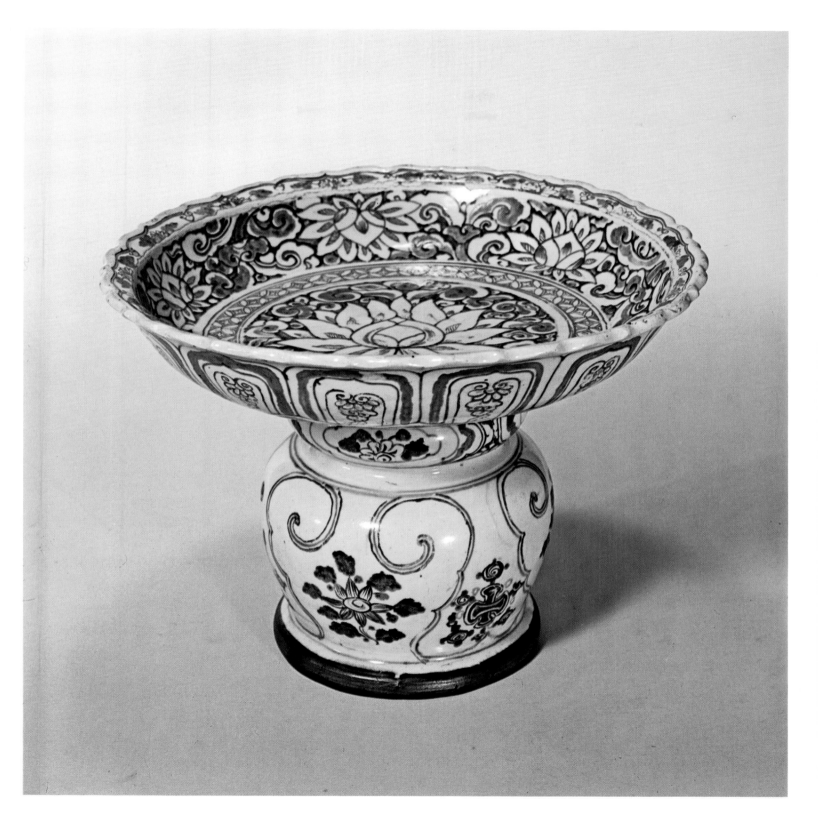

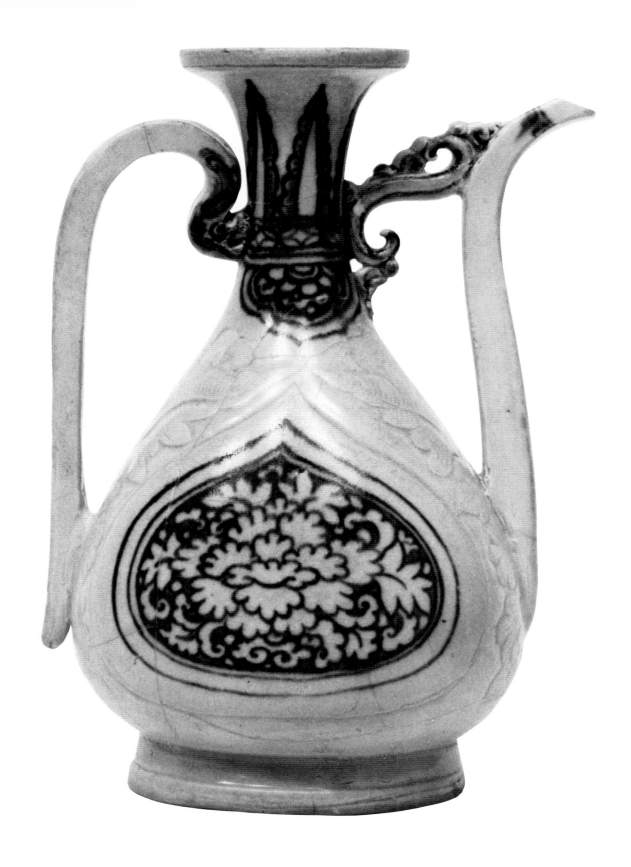

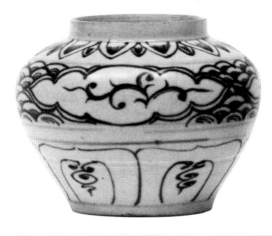

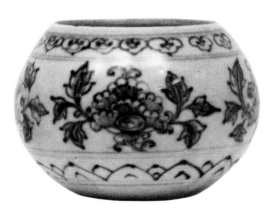

86. *Ewer*. Vietnamese; 15th-16th century
Stoneware; H. 20.3 cm. (*opposite*)

87. *Kendi*. Vietnamese; 15th-16th century
Stoneware; H. 12 cm. (*below*)

89. *Jar*. Vietnamese; 15th-16th century
Stoneware; H. 7.8 cm. (*upper left*)

90. *Water Pot*. Vietnamese; 15th-16th century
Stoneware; H. 6.7 cm. (*upper right*)

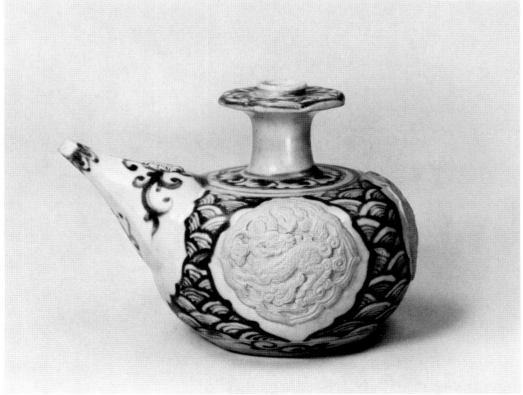

 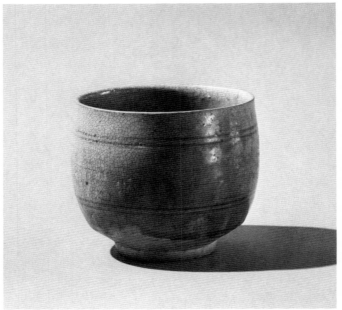

94. *Bowl*. Vietnamese; 15th-16th century
Stoneware; Diam. 17.8 cm. (*above left*)

95. *Beaker*. Vietnamese; 15th-16th century
Stoneware; H. 10.3 cm. (*above right*)

96. *Dish*. Vietnamese; 15th-16th century
Stoneware; Diam. 18.8 cm. (*opposite*)

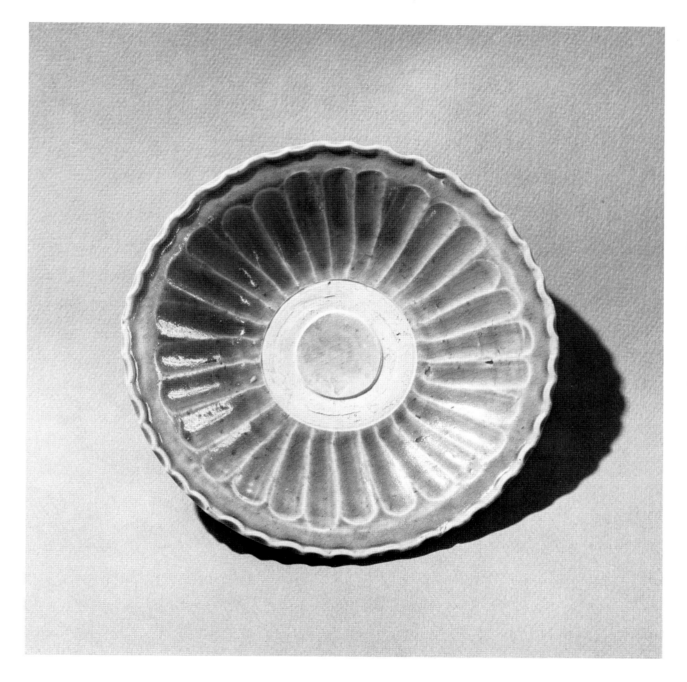

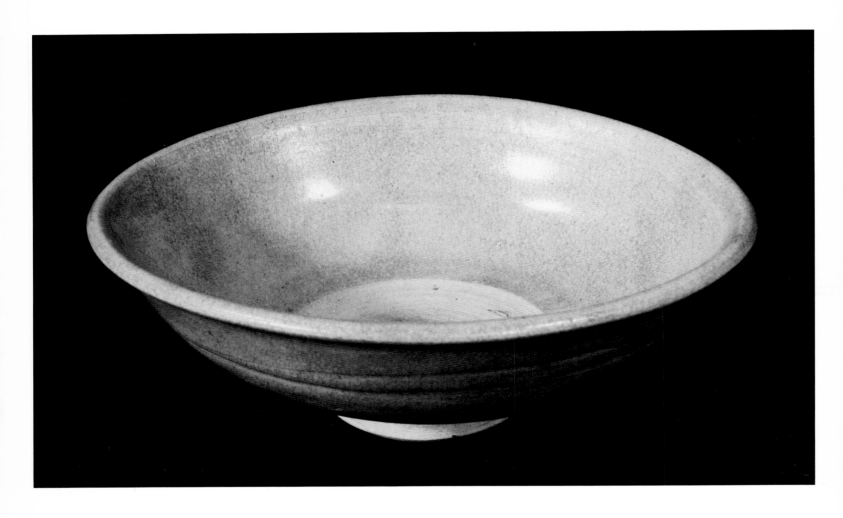

97. *Bowl*. Vietnamese; 16th century
Stoneware; Diam. 17 cm. (*opposite*)

98. *Wine Bottle*. Vietnamese; 16th century
Stoneware; H. 28.5 cm.

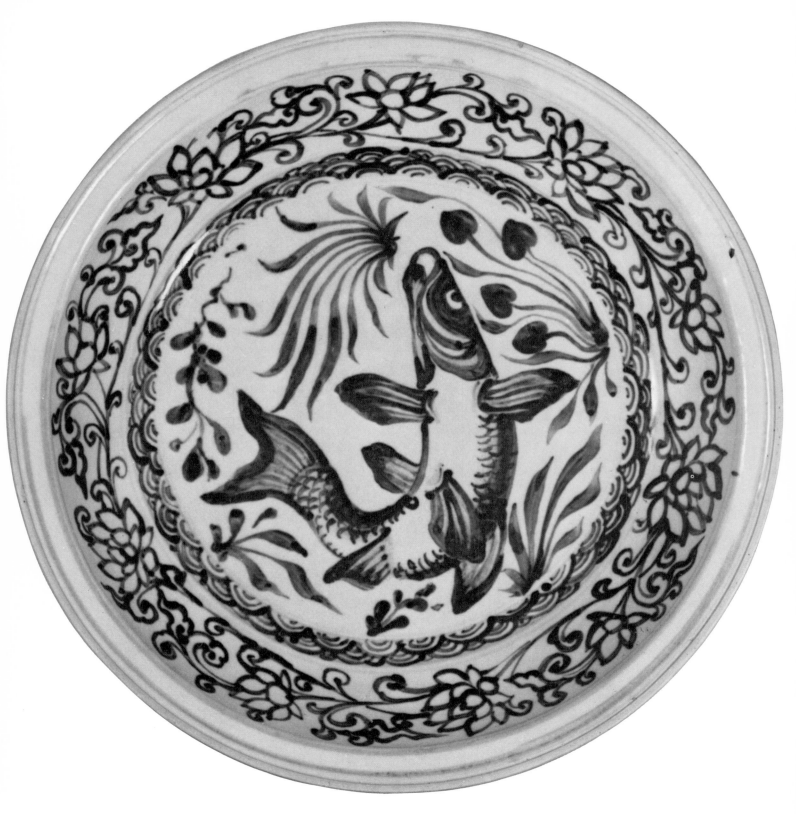

130

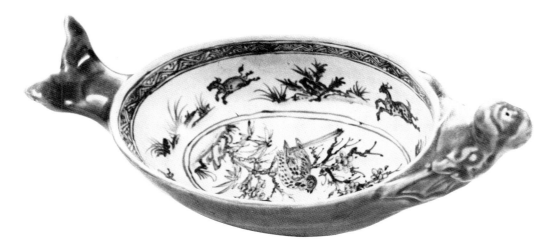

99. *Pouring Vessel*. Vietnamese; 16th century
Stoneware; H. 6.7 cm. (*right*)

100. *Serving Bowl*. Vietnamese; 16th century
Stoneware; L. 30 cm., W. 12 cm. (*above*)

101. *Dish*. Vietnamese; 16th century
Stoneware; Diam. 37 cm. (*opposite*)

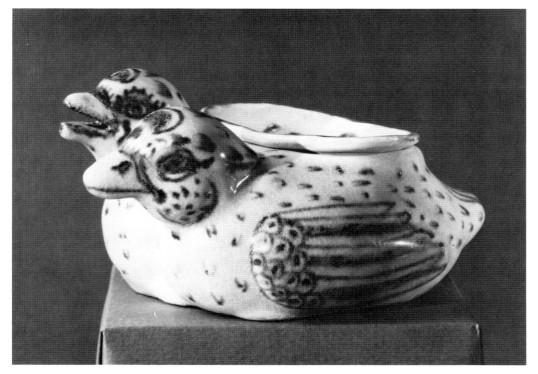

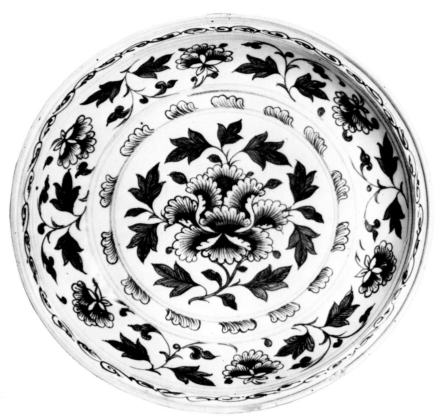

102. *Dish*. Vietnamese; 16th century
Stoneware; Diam. 35.5 cm. (*left*)

103. *Bowl*. Vietnamese; 16th century.
Stoneware; Diam. 34.3 cm. (*below left*)

104. *Dish*. Vietnamese; 16th century
Stoneware; Diam. 45.2 cm. (*opposite*)

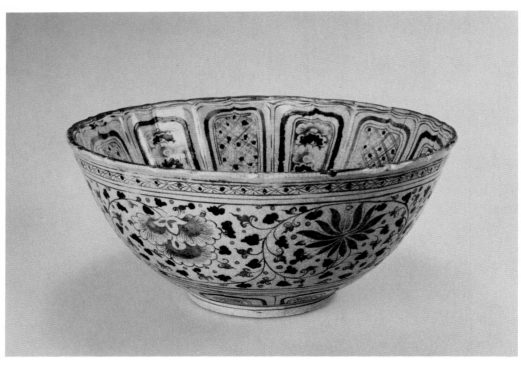

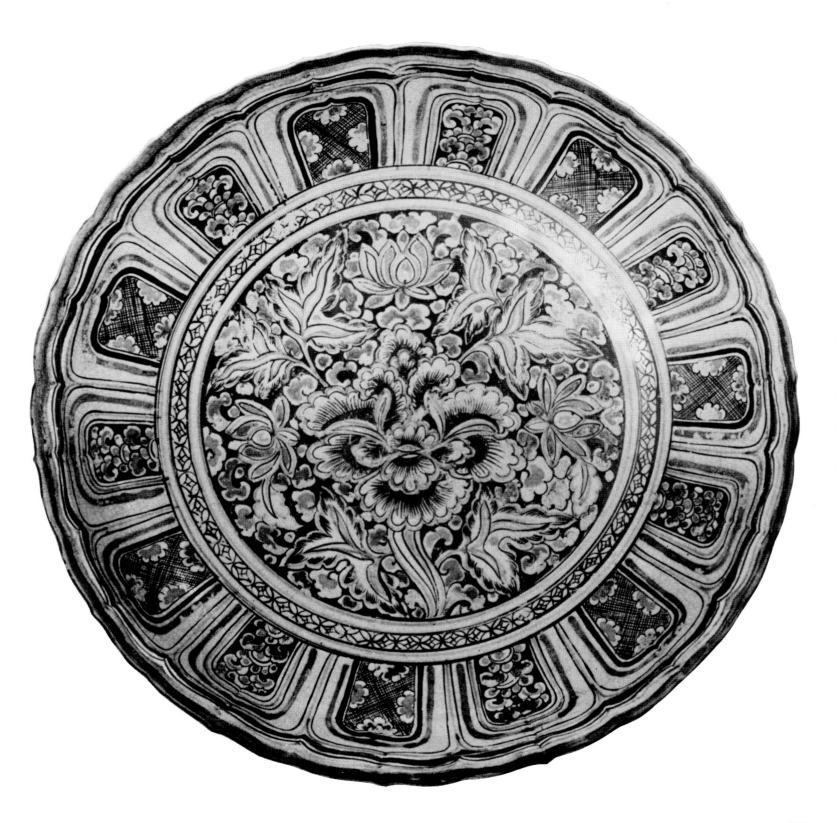

105. *Oil Bottle*. Vietnamese; 16th century
Stoneware; H. 12 cm.

106a. *Dish*. Vietnamese; 16th century
Stoneware; Diam. 18.5 cm. (*upper left*)

106b. *Dish*. Vietnamese; 16th century
Stoneware; Diam. 17.5 cm. (*upper right*)

107. *Wine Cup*. Vietnamese; 16th century
Stoneware; H. 3.7 cm., Diam. 7 cm. (*below*)

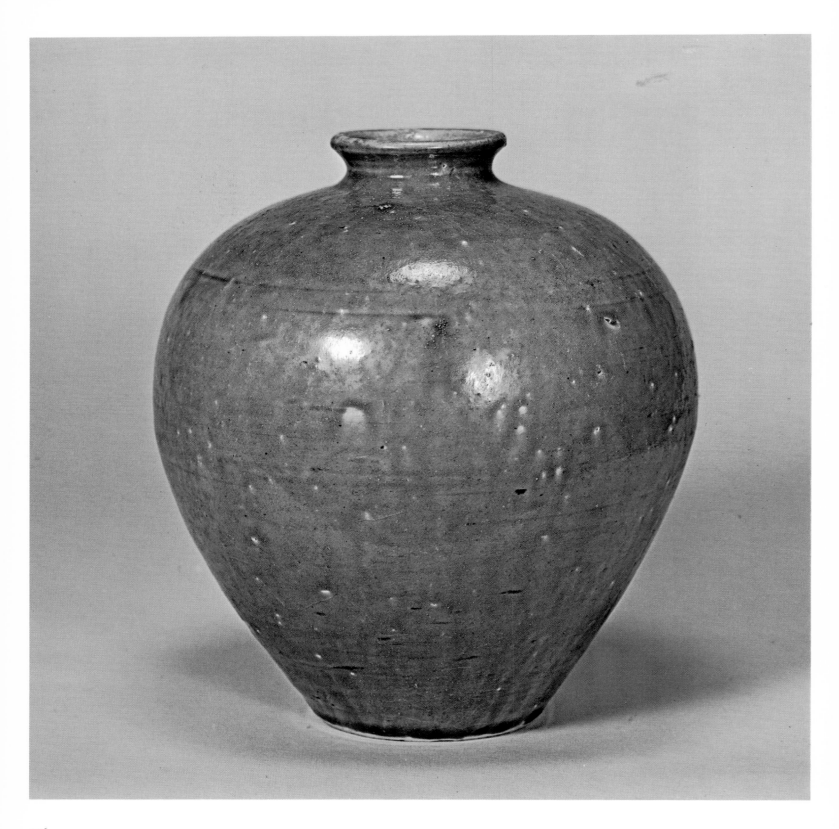

108. *Wine Jar.* Vietnamese; 16th-17th century
Stoneware; H. 22.3 cm. *(opposite)*

109. *Bowl.* Vietnamese; 16th-17th century
Stoneware; Diam. 9.5 cm.

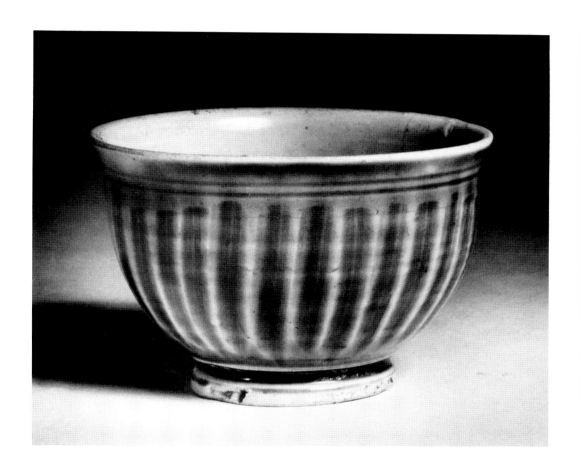

The Ceramics of Viet Nam

58. *Bowl.* Vietnamese; 10th-12th century
Stoneware; Diam. 35.8 cm.
Lent by the Musées Royaux d'Art et d'Histoire,
Brussels

Rosettes in relief and incised vines and leaves painted
in dark brown against a background of beige glaze
decorate the exterior of this deep bowl. The lip is
slightly beveled and the base is flat.

59. *Bowl.* Vietnamese; 11th-12th century
From Thanh Hoa
Celadon; Diam. 15.3 cm.
Lent by Mr. and Mrs. Adrian Zecha

Round-sided, with an everted lip and a splayed foot,
this green-glazed bowl has a stamped, convention-
alized flower design on the interior.

60. *Bowl.* Vietnamese; 11th-12th century
From Thanh Hoa
Stoneware; Diam. 10.5 cm.
Lent by the Musées Royaux d'Art et d'Histoire,
Brussels

The fluted bowl has a scalloped lip and a high foot.
A coarsely crackled greenish glaze covers the gray
beige paste.

61. *Bowl.* Vietnamese; 11th-12th century
From Thanh Hoa
Painted celadon; Diam. 13.5 cm.
Lent by the Musées Royaux d'Art et d'Histoire,
Brussels

A design of leaves and scrolling vines, between
borders of straight and wavy lines, is painted in gray
under the coarsely crackled green glaze that covers
this deep bowl. Of gray beige paste, the bowl has a
low, unglazed foot ring and a flat base.

62. *Grain Jar.* Vietnamese; 11th-12th century
From Thanh Hoa
Porcelaneous stoneware; H. 27.3 cm.
Lent by the Honolulu Academy of Arts

The jar, of ovoid shape, has a domed cover with an
everted edge and a perforated baluster base. The
body is decorated with panels of a stylized flower-
petal design incised and painted in brown under an
uneven, crackled, pale green glaze.

63. *Storage Jar.* Vietnamese; 11th-12th century
From Thanh Hoa
Stoneware; H. 21.5 cm.
Lent by The Denver Art Museum; Charles Bayly
Collection

The globular, dark brown glazed jar has six loop
handles attached at the shoulder. Lotus petals mod-
eled in relief decorate both the shoulder of the
vessel and the domed cover, which has a lotus bud
set in the center.

64. *Wine Pot.* Vietnamese; 11th-12th century
Stoneware; H. 19 cm.
Lent by the Museum of Asiatic Art, Rijksmuseum,
Amsterdam; Westendorp-Osieck bequest

The flat-shouldered, globular pot has a low neck and
an everted foot. The domed cover is decorated with
a molded pattern of lotus petals surrounding a lotus
bud; a second circle of lotus petals appears on the
shoulder. The pot is covered with a finely crackled,
honey colored glaze that leaves part of the foot ring
exposed.

65. *Bowl.* Vietnamese; 11th-12th century
From Thanh Hoa
Stoneware; Diam. 14.4 cm.
Lent by the Musées Royaux d'Art et d'Histoire,
Brussels

A half-spherical bowl with an everted lip is set on a
high, straight-sided foot ring. The cream slip is
covered with a crackled transparent glaze except at
the lower part of the foot.

66. *Cup.* Vietnamese; 11th-12th century
Stoneware; Diam. 11.1 cm.
Lent by the Musées Royaux d'Art et d'Histoire,
Brussels

This unusual drinking vessel has an everted rim and
a high, slightly splayed foot. It is decorated with a
flower motif in brown on off-white slip under a
crackled transparent glaze.

67. *Water Pot.* Vietnamese; 11th-12th century
From Thanh Hoa
Stoneware; H. 7 cm.
Lent by Mr. and Mrs. Adrian Zecha

The globular pot has a rolled lip and a slightly splayed
foot. Of beige paste, it is covered with a finely
crackled transparent glaze over a pale beige slip.
Wheel-cut flanges decorate the shoulder, the lowest
part of the body, and the foot.

68. *Miniature Box With Cover.* Vietnamese; 11th-
12th century
From Thanh Hoa
Stoneware; Diam. 5.5 cm.
Lent by Mr. and Mrs. Adrian Zecha

On the domed cover of this small round box two
unidentified lion-like animals molded in relief face
each other. The pale beige paste is covered with a
green glaze.

69. *Vase.* Vietnamese; 14th century
Stoneware; H. 18.5 cm.
Lent by Ambassador and Mrs. Jack W. Lydman

A globular vase with a high, cylindrical neck ending
in an everted lip is decorated in dark gray with bands
of trefoils around the neck, stylized lotus petals on
the shoulder, a wide peony scroll around the body,
and cloud scrolls above the foot. The vase is covered
with a finely crackled, pale beige glaze.

70. *Storage Jar.* Vietnamese; 14th-15th century
Stoneware; H. 33.5 cm.
Lent by Mr. and Mrs. John D. Rockefeller 3rd

Boldly and freely incised designs, spirals on the
shoulder and large chrysanthemum sprays on the
body, decorate this ovoid jar. Four small loops
attached just below the neck are also incised, with
combed lines. A thin, uneven, crackled, chocolate
brown glaze covers the beige paste. The flat base is
unglazed. *(p. 94)*

71. *Dish.* Vietnamese; 15th century
Stoneware; Diam. 28.8 cm.
Lent by Mr. and Mrs. Dale Keller

Decorated in underglaze blue, this shallow dish has
a narrow band of volutes on the flat rim and a border
of two concentric circles around a stylized flower at
the center. Except for a brown wash which covers
the shallowly recessed base, the exterior is un-
decorated. The wide, low, flat foot ring is unglazed
and six spur marks are clearly visible inside the
central medallion.

72. *Storage Jar.* Vietnamese; 15th century
Stoneware; H. 28.5 cm.
Lent by Mr. and Mrs. Leandro V. Locsin.

This globular jar is of gray beige paste decorated in
underglaze blue. The low, wide neck is encircled
with a diaper pattern; panels of lotus sprays sepa-
rated by a diamond pattern appear on the shoulder;
and large peony scrolls above a band of lotus panels
ornament the body of the jar. The flat base is
unglazed.

73. *Jar*. Vietnamese; 15th century
Stoneware; H. 25.4 cm.
Lent by Mr. and Mrs. Robert P. Griffing, Jr.

Fierce animal masks in relief alternating with four tiny loop handles on the shoulder are distinctive features of this ovoid jar, which is decorated in underglaze blue. The relief elements are enclosed in a painted band of cloud scrolls. Above them, and just below the rolled neck of the jar, is a ring of lotus petals. The main design is a large peony scroll bordered top and bottom with narrow bands of cloud scrolls. Near the base is a row of lotus panels. The paste is buff colored and there is a chocolate brown spiral on the base, inside the wide, flat foot ring. *(p. 112)*

74. *Wine Jar*. Vietnamese; 15th century
Stoneware; H. 46 cm.
Lent by Mr. and Mrs. Leandro V. Locsin

Four molded loop handles have been placed on the shoulder of this ovoid jar. The underglaze blue decoration includes a lotus scroll below the rolled lip of the narrow neck, lotus petal panels and a band of cloud scrolls on the shoulder, and a large, bold, peony scroll which ornaments the mid-section. A narrow band of classic scrolls and a band of stylized lotus petals appear above the flat base, which is unglazed, revealing the beige paste. *(p. 111)*

75. *Stem Bowl*. Vietnamese; 15th century
Stoneware; H. 16.5 cm.
Lent by Ambassador and Mrs. Jack W. Lydman

A heavily potted, globular bowl stands on a baluster foot, painted at the bottom with a dark brown iron oxide band. The underglaze blue decoration on the body includes a band of "Buddha's hand" (the inedible citron, or *citrus medica*) around the rim, a wide peony and lotus scroll around the waist, and lotus petals above the foot.

76. *Dish*. Vietnamese; 15th century
Stoneware; Diam. 45.5 cm.
Lent by Mr. and Mrs. Alphonse Cohen

Enameled designs in red, green, and yellow have been painted over a pale beige glaze on this large dish. A plump red fish, spotted in yellow and green, with a green eye and fins, swims in the center among green and yellow aquatic plants. Around the central medallion is a border of leaves and scalloped petals in green enamel. Yellow and green enamelled flowers and leaf scrolls encircle the cavetto and a narrow band of diaper pattern in green decorates the flat rim. The raised edge of the rim is also enamelled

in green. The exterior carries a pattern of lotus panels and the base has a wide, chocolate brown band inside the unglazed, rounded foot ring. The paste is beige.

77. *Dish*. Vietnamese; 15th century
Stoneware; Diam. 36.5 cm.
Lent by Mr. and Mrs. Robert P. Griffing, Jr.

The decoration of this dish, in underglaze blue, includes lotus scrolls on the cavetto and a border of scalloped petals encircling the central design of a single large peony and leaves. A narrow band of classic scrolls appears on the flat rim, which has a raised, unglazed edge, where the light gray paste is visible. The foot ring is slightly rounded and a thick transparent glaze covers the base.

78. *Dish*. Vietnamese; 15th-16th century
Stoneware; Diam. 38.5 cm.
Lent by Dr. Kyozo Yuasa

The underglaze blue decoration of this dish consists of a narrow scroll band on the flat rim, lotus scrolls on the cavetto, and a border of eight panels with lotus designs surrounding the central design of a large double-petaled peony encircled by leaves. The exterior of the dish is decorated with panels of a stylized lotus pattern, and a chocolate brown wash covers the base. Both the raised edge of the rim and the rounded foot ring are unglazed, revealing the beige paste. *(p. 116)*

79. *Storage Jar*. Vietnamese; 15th-16th century
Stoneware; H. 16.5 cm.
Lent by Mr. and Mrs. Robert P. Griffing, Jr.

Decorated in underglaze blue on a beige paste, this high-shouldered jar has a classic scroll pattern around the neck, lotus petals on the shoulder, and peony and lotus scrolls around the upper body. Stylized lotus panels surround the lower portion. The foot ring is flat and a chocolate brown wash has been applied to the base. *(p. 115)*

80. *Dish*. Vietnamese; 15th-16th century
Stoneware; Diam. 36.5 cm.
Lent by Mr. and Mrs. Robert P. Griffing, Jr.

Incised lotus scrolls encircle the cavetto of this cream colored dish, a border of scalloped petals surrounds the central lotus and leaf design, and on the exterior is an incised band of lotus panels. The flat rim has a raised, unglazed edge. A thin, white glaze overpainted with a brown spiral covers the flat base, but the rounded foot ring is also unglazed, showing the beige paste.

81. *Dish*. Vietnamese; 15th-16th century
Stoneware; Diam. 33.5 cm.
Lent by Mr. and Mrs. Robert P. Griffing, Jr.

Decorated in underglaze blue, this dish has a band of key-fret design on the flat rim and a border of scalloped petals surrounding a phoenix in flight among cloud scrolls in the center. The beige paste is visible at the raised, unglazed edge. The foot ring is rounded and has a brown wash on the upper portion of the exterior. A thick transparent glaze covers the base.

82. *Storage Jar*. Vietnamese; 15th-16th century
Stoneware; H. 53 cm.
Lent by the Rijksmuseum voor Volkenkunde, Leiden

This large ovoid jar has a short, wide neck with a rolled lip. The glaze, which stops short of the flat base, covers an underglaze blue decoration: a lotus scroll around the neck, lions (?) and flaming pearls on the shoulder, large peony scrolls on the mid-section, and stylized lotus panels above a band of roughly sketched cloud patterns and pendant trefoils near the base. The paste is gray beige.

83. *Dish*. Vietnamese; 15th-16th century
Stoneware; Diam. 36.8 cm.
Lent by Mr. and Mrs. Leandro V. Locsin

Surrounded by a border of scalloped petals, a four-clawed dragon twists among flaming pearls in the center of this underglaze blue decorated dish. On the cavetto are peony and lotus scrolls; a peony scroll band ornaments the foliate rim, whose raised edge is unglazed, revealing the gray beige paste.

84. *Pilgrim Bottle*. Vietnamese; 15th-16th century
Stoneware; H. 26.6 cm.
Lent by Mr. and Mrs. Robert P. Griffing, Jr.

This distinctively shaped pilgrim bottle, of light buff paste, has a high neck topped with a cup finial, two loop handles on the shoulder, and a slightly splayed foot. A circle of cloud scrolls around a peony with leaves forms a medallion on each of the flat sides of the bottle; cloud scrolls appear on the neck, handles, and rounded sides; and the cup finial is banded with flower (?) and trefoil designs. All are painted in underglaze blue. The base is covered with a thick transparent glaze and the rounded foot ring has a chocolate brown wash on the upper portion of the exterior.

85. *Wine Bottle*. Vietnamese; 15th-16th century
Stoneware; H. 22.7 cm.
Lent by Mr. and Mrs. Robert P. Griffing, Jr.

The bands of underglaze blue decoration on this pear-shaped wine bottle include a design of plantain leaves below the everted lip, followed by stylized lotus panels alternately filled with wave and vine (?) patterns, oval panels containing alternate flower sprays and wave patterns, and another row of lotus panels above the foot. Of light buff paste, the bottle has a flat foot ring and chocolate brown wash on the base.

86. *Ewer*. Vietnamese; 15th-16th century
Stoneware; H. 20.3 cm.
Lent by Mr. and Mrs. Robert P. Griffing, Jr.

The shape of this ewer recalls earlier Persian ceramic forms. On each side of the vessel a relief decoration of leaf sprays runs from the shoulder to the oval base, surrounding a tear-drop medallion which contains a peony and leaves in reserve against an underglaze blue background. An underglaze blue design of narrow leaves rises from a floral band that ornaments the neck and continues onto the handles and the curving bracket that supports the spout. Inside the wide, flat foot ring there is a broad spiral of chocolate brown wash on the base. The paste is beige. (*p. 124*)

87. *Kendi*. Vietnamese; 15th-16th century
Stoneware; H. 12 cm.
Lent by the Idemitsu Art Gallery, Tokyo

Three molded medallions in unglazed biscuit, each showing a kylin among flaming pearls, are distinctive features of this drinking vessel. Also unglazed is a small rosette on the tapering, octagonal spout. Framing the medallions is a wave pattern in underglaze blue; sprays are painted on the spout and flower petals appear on the octagonal flange and around the base of the short neck.

88. *Cosmetic Box With Cover*. Vietnamese; 15th-16th century
Stoneware; Diam. 6.5 cm.
Lent anonymously

This round box, of beige paste, has the stem and petals of a mangosteen molded in relief on the cover. Encircling these elements is a ring of overlapping lotus petals in underglaze blue. Two birds in flight among bamboo are the principal decorative motif, and a band of flower petals appears above the low, unglazed foot ring. (*p. 122*)

89. *Jar*. Vietnamese; 15th-16th century
Stoneware; H. 7.8 cm.
Lent by Mr. and Mrs. Robert P. Griffing, Jr.

A container for condiments, this ovoid jar is decorated in underglaze blue with lotus petals around the shoulder, a band of three flower (?) medallions interspersed with wave patterns at the waist, and a band of lotus panels above the foot. Inside the flat foot ring the base is unglazed, showing the buff paste.

90. *Water Pot*. Vietnamese; 15th-16th century
Stoneware; H. 6.7 cm.
Lent by Mr. and Mrs. Robert P. Griffing, Jr.

Painted with underglaze blue designs, this small, globular pot has a band of trefoils below the lip, peonies surrounded by leaves encircling the mid-section, and a band of lotus petals above the flat, unglazed base. The paste is a light buff color.

91. *Water Pot*. Vietnamese; 15th-16th century
Stoneware; H. 6.6 cm.
Lent by Mrs. Lauriston Sharp

Cloud scrolls fill the upper band of underglaze blue decoration on this miniature bowl. Below the scrolls, four medallions framing leaf sprays are interspersed with trefoils, and a ring of lotus petals is painted above the base. (*p. 122*)

92. *Dish on a High Foot*. Vietnamese; 15th-16th century
Stoneware; Diam. 28.5 cm.
Lent by the Idemitsu Art Gallery, Tokyo

On this unusual dish, red and green enamels and gold applied over the colorless glaze have been used to embellish the underglaze blue design. Encircling the everted rim, with its raised, foliate edge, is a narrow band of red and green flowers and leaves, and stylized lotus flowers in red and white with green leaves appear on the cavetto. The central design of a large white lotus outlined in blue and red against a green, red, and blue ground, is surrounded by a border of diaper pattern in red. The outside of the bowl is decorated with a row of enamelled lotus panels. On the high, bulbous foot, red lotuses amid green leaves alternate with a motif representing two crossed silver ingots in red, blue, and green, above a chocolate brown band on the rounded foot rim. The paste is a pale buff color.

93. *Dish*. Vietnamese; 15th-16th century
Stoneware; Diam. 25 cm.
Lent by the Rijksmuseum voor Volkenkunde, Leiden

This deep dish is decorated in red and green enamels on a crackled cream glaze over underglaze blue designs. A border of scalloped petals surrounds the central design of a bird in flight among cloud scrolls

holding a peach branch in its beak; the cavetto has twelve stylized lotus panels filled with flowers, leaves, and cloud scrolls; and a narrow band of cloud scrolls ornaments the foliate, flattened rim with a raised edge. On the exterior is a row of enamelled lotus panels. A large area of the base is covered with a chocolate brown wash, but the rounded, unglazed foot ring reveals the buff paste. (*p. 12*)

94. *Bowl*. Vietnamese; 15th-16th century
Stoneware; Diam. 17.8 cm.
Lent by Ambassador and Mrs. Jack W. Lydman

This bowl with an everted rim and a high, partially unglazed foot ring is covered with a dark chocolate brown glaze on the exterior and a cream glaze on the interior. The paste, clearly visible on the foot ring, is gray beige.

95. *Beaker*. Vietnamese; 15th-16th century
Stoneware; H. 10.3 cm.
Lent by Ambassador and Mrs. Jack W. Lydman

The deep body with gently bowed sides has a very slightly everted lip and a sharply cut foot ring. Of beige paste, the beaker is decorated with four incised, horizontal bands under a thick, glossy, crackled, almond green glaze that stops short of the foot. A ring on the interior bottom is also unglazed.

96. *Dish*. Vietnamese; 15th-16th century
Stoneware; Diam. 18.8 cm.
Lent by Ambassador and Mrs. Jack W. Lydman

Molded in the shape of a chrysanthemum, with a raised, scalloped edge, the dish is covered with almond green glaze except for a ring in the center of the interior and the flat base where the beige paste is exposed.

97. *Bowl*. Vietnamese; 16th century
Stoneware; Diam. 17 cm.
Lent by the Rijksmuseum voor Volkenkunde, Leiden

From the splayed foot rim, the sides of the bowl curve out to the everted, beveled lip. Except for a wide unglazed ring in the bottom of the bowl, the beige paste is covered with a crackled cream glaze.

98. *Wine Bottle*. Vietnamese; 16th century
Stoneware; H. 28.5 cm.
Lent by Mr. and Mrs. Robert P. Griffing, Jr.

A grayish white glaze covers this pear-shaped bottle with a narrow, flaring neck and a slightly splayed, flat foot ring. No glaze or wash has been applied to the base, where the white paste is visible.

99. *Pouring Vessel*. Vietnamese; 16th century
Stoneware; H. 6.7 cm.
Lent by Mr. and Mrs. Severance A. Millikin

The vessel is modeled in the form of two ducks, with the open beak of one serving as a spout. It has retained its circular, concave cover. The feathers and other markings are freely drawn in underglaze blue, tipped with yellow, and covered with a finely crackled glaze. The base is flat and unglazed, revealing the pale gray paste.

100. *Serving Bowl*. Vietnamese; 16th century
Stoneware; L. 30 cm., W. 12 cm.
Lent by the Museum Pusat, Jakarta

The rather whimsical head and tail of a dugong, modeled in relief and perhaps intended to serve as handles, are distinctive features of this oval bowl decorated in underglaze dark blue. Below a band of trellis pattern, goat-like animals chase each other around the cavetto, while a long-tailed, spotted bird perches on a prunus branch in the center. Underglaze blue completely covers the exterior except for the flat base where the putty-colored biscuit is visible.

101. *Dish*. Vietnamese; 16th century
Stoneware; Diam. 37 cm.
Lent by the Idemitsu Art Gallery, Tokyo

A large carp among aquatic plants, surrounded by a border of wave patterns, is the bold central design of this flat-rimmed dish decorated in underglaze blue. The cavetto is ornamented with very freely drawn lotus scrolls and a band of lotus panels is painted on the exterior. The raised edge of the dish is unglazed, showing the gray beige paste.

102. *Dish*. Vietnamese; 16th century
Stoneware; Diam. 35.5 cm.
Lent by Mr. and Mrs. Dale Keller

A single large peony surrounded by leaves and then by a band of scalloped petals is the central motif on this dish decorated in underglaze blue. Peony scrolls cover the cavetto and a narrow border of scrolls appears on the rim. The flat rim has a raised, unglazed edge and the base is covered with a brown wash.

103. *Bowl*. Vietnamese; 16th century
Stoneware; Diam. 34.3 cm.
Lent by Mr. and Mrs. Alphonse Cohen

This deep bowl with foliate rim and low foot is decorated in red, green, and yellow enamels on a coarsely crackled, pale beige glaze. Inside, twelve stylized lotus panels framing alternate flower and diaper patterns surround a worn circle of leaf (?) sprays. Outside are a narrow band in diaper pattern, a wide band of peony and lotus scrolls, and a row of stylized lotus panels rising from the foot. There are patches of chocolate brown wash on the flat, unglazed base, where the light buff paste is also visible.

104. *Dish*. Vietnamese; 16th century
Stoneware; Diam. 45.2 cm.
Lent by the Museum Pusat, Jakarta

This unusually large dish is decorated in underglaze blue and overglaze red, green, and gold enamels. Leaf and flower patterns alternate in the panels on the cavetto and a diaper pattern borders the central design of a large peony and three lotus flowers reserved in white on a red ground. On the exterior, above the high, carved foot, is a band of stylized lotus panels. The foot ring is unglazed and the slightly convex base is covered with a light brown wash.

105. *Oil Bottle*. Vietnamese; 16th century
Stoneware; H. 12 cm.
Lent by Mr. and Mrs. Adrian Zecha

Three prominent wheel cuts mark the high neck of this oil bottle, whose narrow mouth opens out into a wide, slightly convex lip. From the low, sharply curved shoulder, the straight sides of the body slope inward to the flat, unglazed base. A crackled cream glaze decorated with splashes of green glaze covers the pale beige paste. Also evident are several clusters of five small depressions that were originally filled with enamel.

106a. *Dish*. Vietnamese; 16th century
Stoneware; Diam. 18.5 cm.
Lent by Mr. and Mrs. Dale Keller

An uneven, chocolate brown glaze has been applied to this flat-rimmed dish with a raised edge. A ring in the center and the carved foot and base are unglazed. The paste is a cream color.

106b. *Dish*. Vietnamese; 16th century
Stoneware; Diam. 17.5 cm.
Lent by Mr. and Mrs. Dale Keller

The shallow dish with a flat rim and a raised edge is covered with finely crackled off-white glaze, except for a wide ring in the center and the carved foot where the cream colored paste is exposed.

107. *Wine Cup*. Vietnamese; 16th century
Stoneware; H. 3.7 cm., Diam. 7 cm.
Lent anonymously

The cup has steep sides with subtle fluting above the foot and is covered with a crackled transparent glaze over beige slip, except at the lip, where the beige paste is exposed.

108. *Wine Jar*. Vietnamese; 16th-17th century
Stoneware; H. 22.3 cm.
Lent by Mr. Kimiyuki Hasegawa

The ovoid jar has a short neck, a flared, rounded lip, and a flat, unglazed foot ring. A thin, almond green glaze over the beige paste reaches almost to the foot and the recessed base is covered with a chocolate brown wash.

109. *Bowl*. Vietnamese; 16th-17th century
Stoneware; Diam. 9.5 cm.
Lent by Mrs. Lauriston Sharp

This bowl, with slightly flaring lip and fluted sides, is coated with cream glaze on the interior and a thin, almond green glaze on the outside. The paste is beige. Two parallel, wheel-cut lines circle the exterior below the rim, and there is a deep groove above the foot.

Selected Bibliography

Aga-Oglu, Kamer. "Five Examples of Annamese Pottery." *Bulletin of the University of Michigan Museum of Art* 5 (May 1954): 6-11.

Aymonier, E. *Le Cambodge*. Vol. 2. Paris: Ernest Leroux, 1901.

Azuma, Y. "Sukotai no Yakimono" [Pottery of Sukhothai]. *Tosetsu* (October 1968). English translation by John Tsuchyia in the writer's possession.

_____. *Toki Koza* [Lectures on Ceramics]. Third series, vol. 13 (Annamese, Khmer, Thai). Tokyo, 1973.

Barbotin, H. "La poterie indigène au Tonkin." *Bulletin Economique de l'Indochine* 15 (1912): 659-661.

Beyer, H. O. "A Preliminary Catalogue of the Pre-Spanish Ceramic Wares Found in the Philippine Islands." Unpublished manuscript, 1930.

Bezacier, L. *L'art vietnamien*. Paris: Editions de L'Union Française, 1955.

Blackmore, M. "The Rise of Nan-Chao in Yunnan." *Journal of Southeast Asian History* 1 (1960): 47-61.

Boisselier, J. *Manuel d'archéologie d'Extrême-Orient*, vol. 1: *Le Cambodge*. Paris: Editions A. et J. Picard, 1966.

_____. "Travaux de la Mission Archéologique Française en Thailande." *Arts Asiatiques* 25 (1972): 27-90.

Bowie, T., ed. *The Arts of Thailand*. Bloomington: Indiana University, 1960.

Briggs, L. P. "Dvaravati, Most Ancient Kingdom of Siam." *Journal of the American Oriental Society* 65 (1945): 98-107.

_____. "The Ancient Khmer Empire." *Transactions of the American Philosophical Society* n.s. 41, part 1 (1951).

Brodrick, A. H. *Little China : The Annamese Lands*. London: Oxford University Press, 1942.

Brown, R. "The History of Ceramic Finds in Sulawesi." *Transactions of the Southeast Asian Ceramic Society* 5 (1975).

Brown, R., Childress, V., and Gluckman, M. "A Khmer Kiln Site—Surin Province." *Journal of the Siam Society* 62, 2 (July 1974): 239-252.

Cady, J. F. *Southeast Asia : Its Historical Development*. New York: McGraw-Hill, 1964.

Cheng Te-k'un. "The Study of Ceramic Wares in Southeast Asia." *The Journal of the Institute of Chinese Studies* 5, 2 (December 1972): 1-40.

Chou Ta-kuan. *Notes on the Customs of Cambodia*. Translated from the French version of Paul Pelliot by J. Gilman d'Arcy Paul. Bangkok: Social Science Association Press, 1967.

Coedès, G. "Les collections archéologiques du Musée National de Bangkok." *Ars Asiatica* 12 (1928).

_____. "Les statuettes décapitées de Savank'alok." *Bulletin et Travaux de l'Institut Indochinois Pour l'Etude de l'Homme* 2 (1939): 189-190.

_____. *Angkor*. Hong Kong: Oxford University Press, 1963.

_____. *The Making of South East Asia*. Translated by H. M. Wright. Berkeley and Los Angeles: University of California Press, 1966.

_____. *The Indianized States of Southeast Asia*. Translated by S. B. Cowing and edited by W. F. Vella. Honolulu: East-West Center Press, 1968.

Collis, M. S. "Fresh Light on the Route Taken by Export Porcelains From China to India and the Near East During the Ming Period." *Transactions of the Oriental Ceramic Society* 13 (1935-1936): 9-29.

Damrong Rajanubhab, Prince. *A History of Porcelain Altar Pieces and Dinnerware*. Cremation Ceremony Volume for Prince Prida (in Thai). Bangkok, 1917.

d'Argencé, R.-Y. L. "Les céramiques à base chocolatée." *Publications de l'Ecole Française d'Extrême-Orient* 44 (1958).

_____. "Annamese Pottery: What is It?" Manila Trade Porcelain Seminar, 1968.

de Pouvourville, A. *L'Art Indochinois*. Brussels: Librairie Vanderlinden, 1894.

Dufour, H., and Carpeaux, G. *Le Bayon d'Angkor Thom*. 2 vols. Paris: Ernest Leroux, 1913.

Dumoutier, G. "Letter to the Director." *Bulletin de l'Ecole Française d'Extrême-Orient* 3, 3 (1903): 365-367.

_____. "Essais sur les Tonkinois." *Revue Indochinoise* (1908): 77-82.

Dupont, P. "Art de Dvaravati et art khmer: Le buddha debout de l'époque du Bayon." *Revue des Arts Asiatiques* 9 (1935): 63-75.

Finot, L. "Dharmaçâlâs au Cambodge." *Bulletin de l'Ecole Française d'Extrême-Orient* 25 (1925): 417-422.

_____. "Hindu Kingdoms in Indochina." *Indian Historical Quarterly* 2 (1925): 599-622.

Fisher, C. A. *South East Asia*. London: Methuen & Co., 1971.

Fitzgerald, C. P., *A Concise History of East Asia*. Middlesex: Pelican Books, 1974.

Fournereau, L. *Les ruines khmères : Cambodge et Siam*. Paris: Berthaud, 1890.

_____. "La céramique des Thais." *Le Siam Ancien, Annales du Musée Guimet* 31, 2 (1908): 129-138.

Fox, R. B. "The Calatagan Excavations." *Philippine Studies* 7, 3 (August 1959): 325-390.

Gerini, G. E. "Siam's Intercourse With China (Seventh to Nineteenth Centuries)." *The Imperial and Asiatic Quarterly Review* 13 (April 1902): 119-147 and 14 (October 1902): 391-407.

Gluckman, M. "A Visit to the Phan Kilns in Northern Thailand." *Transactions of the Southeast Asian Ceramic Society* 4 (1974).

Goloubew, V. "La province de Thanh-Hoa et sa céramique." *Revue des Arts Asiatiques, Annales du Musée Guimet* 7, 2 (1921): 112-114.

_____. *India and the Art of Indochina*. London: India Society, 1923.

Gompertz, G. St. G. M. *Celadon Wares*. London: Faber and Faber, 1968.

Gourdon, H. *L'Art de l'Annam*. Paris: E. Boccard, 1933.

Griffing, R. P., Jr. "Blue and White of Annam." *Orientations* (May 1970): 60-63.

Graham, W. A. "Pottery in Siam." *Journal of the Siam Society* 16, 1 (1922): 1-27.

Griswold, A. B. "New Evidence for the Dating of Sukhothai Art." *Artibus Asiae* 19, 3-4 (1956): 240-250.

Groslier, B. P. *Indochina : Art in the Melting Pot of Races*. London: Methuen & Co., 1962.

_____. *Indochina*. Cleveland and New York: The World Publishing Company, 1966.

Groslier, B. P., and Arthaud, J. *Angkor*. Singapore: Donald Moore Press, 1966.

Groslier, G. "Objets anciens trouvés au Cambodge." *Revue Archéologique* 4 (1916): 129-139.

_____. *Recherches sur les Cambodgiens*. Paris: A. Challamel, 1921.

_____. "Les collections khmères du Musée Albert Sarraut à Phnom Penh." *Ars Asiatica* 16 (1927): 123-126.

Hall, D. G. E. *A History of South-East Asia*. 3rd ed. New York: St. Martin's Press, 1968.

Harrisson, T. "Some Borneo Ceramic Objects." *The Sarawak Museum Journal* n.s. 5, 2 (September 1950): 270-273.

_____. "Ceramics Penetrating Central Borneo." *The Sarawak Museum Journal* n.s. 6, 6 (December 1955): 549-560.

Hejzlar, J. *The Art of Vietnam*. London: Hamlyn, 1973.

Hobson, R. L. "Chinese Porcelains at Constantinople." *Transactions of the Oriental Ceramic Society* (1933-1934): 13.

Honey, W. B. *The Ceramic Art of China and Other Countries of the Far East*. London: Faber and Faber, 1945.

Huard, P., and Durand, M. *Connaissance du Vietnam*. Hanoi, 1954.

Huet, C. "Les pots à chaux, les pipes à eau." *Bulletin des Musées Royaux d'Art et d'Histoire* 4 (July-August 1941): 74-84.

———. "Les terres cuites de Tho-ha, les brule-parfums de Bat-trang." *Bulletin des Musées Royaux d'Art et d'Histoire* 1 (January-February 1942): 1-9.

———. "Terres cuites architecturales de Dai-la." *Bulletin des Musées Royaux d'Art et d'Histoire* 3 (May-June 1942): 50-61.

Jabouille, P., and Peyssonaux, J.-H. *Céramiques de l'époque "Song."* Hué: Le Musée Khai-Dinh, 1931.

Janse, O. "A Source of Ancient Chinese Pottery Revealed in Indo-China." *The Illustrated London News* (November 12, 1938): 894.

Jenyns, S. *Ming Pottery and Porcelain*. London: Faber and Faber, 1953.

Joseph, A. *Chinese and Annamese Ceramics Found in the Philippines and Indonesia*. London: Hugh Moss Publishing, 1973.

Koyama, F., and Figgess, J. *Two Thousand Years of Oriental Ceramics*. New York: Harry N. Abrams, 1960.

Krom, N. J., and van Erp, T. *Beschrijving van Barabudur*. 2 vols. The Hague: Martinus Nijhoff, 1920.

Kuakul, P. *The Ceramics and Kilns of Sankampaeng* (in Thai). Bangkok: The Fine Arts Department, 1972.

Kuo Tsung-fei. "A Brief History of the Trade Routes Between Burma, Indochina and Yunnan." *T'ien-hsia Monthly* 12, 1 (August-September 1941): 9-32.

Lammers, C. *Annamese Ceramics in the Museum Pusat Jakarta*. Jakarta: Himpunan Keramik Indonesia, 1974.

Leach, B. *A Potter's Book*. Hollywood-by-the-Sea, Florida: Transatlantic Arts, 1953.

Lee, S. E., and Ho, W. *Chinese Art Under the Mongols: The Yüan Dynasty (1279-1368)*. Cleveland: The Cleveland Museum of Art, 1968.

Le May, R. S. "The Ceramic Wares of North-Central Siam." *The Burlington Magazine* 63 (1933): 156ff.

———. "On Tai Pottery." *Journal of the Siam Society* 31, 1 (March 1939): 57-67.

Locsin, L. and C. *Oriental Ceramics Discovered in the Philippines*. Rutland, Vermont, and Tokyo: Charles E. Tuttle Co., 1967.

Louis-Frédéric. *Art of Southeast Asia*. New York: Harry N. Abrams, 1965.

Lunet de Lajonquière, E. *Le Siam et les Siamois*. Paris: A. Colin, 1906.

———. "Essai d'inventaire archéologique de Siam." *Bulletin de la Commission Archéologique de l'Indochine* (1912): 19-181.

Lyle, T. H. "Siam: Celadon Ware." *Man* 41-42 (1901): 54-56.

———. "Notes on the Ancient Pottery Kilns at Sawankalok, Siam." *Journal of the Anthropological Institute* 33 (July-December 1903): 238-245.

Macintosh, D. "Introduction to Blue and White." *Orientations* 4, 11 (November 1973): 27-41.

Malleret, L. "Notes sur les fabrications actuelles ou anciennes de poteries dans le delta du Mekong." *Bulletin de la Société des Etudes Indochinois* n.s. 32, 1 (1957): 31-38.

Marchal, H. "La collection khmère, Musée Louis Finot." *Bulletin de l'Ecole Française d'Extrême-Orient* (1939): 145-160.

Medley, M. "A Fourteenth-Century Blue and White Chinese Box." *Oriental Art* n.s. 19 (1973): 433-437.

Minh Kim, H. "Viengchan et son ancien site." *Bulletin des Amis du Royaume Lao* 3 (October-December 1970): 100-120.

Nakon Prah Ram, Praya. "Thai Pottery." *Journal of the Siam Society* 29, 1 (August 1937): 13-36.

Nimmanahaeminda, K. *Sankampaeng Glazed Pottery*. Chiang Mai: The Konmaung Publishing Co., 1960.

Okuda, S. *Annam Toji Zukan* [Illustrated Catalogue of Annamese Ceramics]. Tokyo, 1954.

Pope, J. A. "The Princessehof Museum in Leeuwarden." *Archives of the Chinese Art Society of America* 5 (1951): 23-37.

———. *Fourteenth-Century Blue-and-White: A Group of Chinese Porcelains in the Topkapu Sarayi Müzesi, Istanbul*. Washington: Smithsonian Institution, 1952.

———. *Chinese Porcelains From the Ardebil Shrine*. Washington: Smithsonian Institution, 1956.

Robb, W. "New Data on Chinese and Siamese Ceramic Wares of the 14th and 15th Centuries." *Philippines Magazine* 27, 3-4 (August-September 1930): 150 ff.

Schafer, E. H. *The Vermilion Bird: T'ang Images of the South*. Berkeley and Los Angeles: University of California Press, 1967.

Silice, A., and Groslier, G. "La céramique dans l'ancien Cambodge." *Arts et Archéologie Khmers* 2 (1924-1926): 31-64.

Sivaramamurti, C. *Le stupa de Barabudur*. Paris: Musée Guimet, 1961.

Smithsonian Institution. *Art and Archeology of Vietnam: Asian Crossroad of Cultures*. Washington, D.C., 1961.

Spinks, C. N. "Siam and the Pottery Trade of Asia." *Journal of the Siam Society* 44, 2 (August 1956): 61-111.

———. *Siamese Pottery in Indonesia*. Bangkok: The Siam Society, 1959.

———. *The Ceramic Wares of Siam*. Bangkok: The Siam Society, 1965.

Stern, P. "Un nouveau style khmer au Phnom Kulen." *Academie des Inscriptions et Belles Lettres: Comptes Rendus des Séances* (1937): 333-339.

Stott, W. "The Expansion of the Nan-Chao Kingdom." *T'oung Pao* 50 (1963): 190-220.

Sullivan, M. "Kendi." *Archives of the Chinese Art Society of America* 11 (1957): 40-58.

Thompson, V. *French Indo-China*. New York: Macmillan, 1937.

Vallibhotama, S. "The Khmer Ceramic Kilns of Ban Kruat and Their Preservation." *Our Future* 2, 7 (January 1947): 30-33.

van Orsoy de Flines, E. W. *Guide to the Ceramic Collection (Foreign Ceramics)*. Jakarta: Museum Pusat, 1969.

Velder, C. "La poterie du Wat Si Satthanet, Vientiane (Laos)." *Journal of the Siam Society: Felicitation Volumes of Southeast Asian Studies* 2 (1965): 199-204.

Vlekke, B. H. M. *Nusantara: A History of Indonesia*. The Hague: W. van Hoeve, 1965.

Volker, T. *Porcelain and The Dutch East India Company*. Leiden: E. J. Brill, 1954.

Wales, H. G. Q. "The Origins of Sukhodaya Art." *Journal of the Siam Society* 44, 2 (August 1956): 113-124.

Wang Gung-wu. "The Nanhai Trade—A Study of the Early History of Chinese Trade in the South China Sea." *Journal of the Malaysian Branch of the Royal Asiatic Society* 31, 2 (June 1958): 53, 62-72.

Watt, J. C. Y. "Southeast Asian Pottery—Thai, in Particular." *The Art Gallery of Southern Australia Bulletin* 32, 4 (April 1971).

Westendorp, H. K. "Ceramik van Sawankhalok." *Maandblad voor Beeldende Kunsten* (September 1932): 270-276.

Wiens, H. J. *Han Chinese Expansion in South China*. Hamden, Conn.: The Shoe String Press, 1967.

Willetts, W. *Ceramic Art of Southeast Asia*. Singapore: The Southeast Asian Ceramic Society, 1971.

Zimmer, H. *The Art of Indian Asia*. 2 vols. New York: Bollingen Foundation, 1955.

Credits

Maps
The maps were prepared by Joseph del Gaudio
Design Group Inc. and based on earlier versions by
Carmen Maddalena.

Figures
(Fig. 1) H. Dufour and G. Carpeaux, *Le Bayon
d'Angkor Thom*, Paris, 1913, vol. II. (Figs. 2, 5, 6)
N. Krom and T. van Erp, *Beschrijving van Barabadur*,
The Hague, 1920, plate vol. I; (Fig. 8) plate vol. II;
(Fig. 7) plate vol. III. (Figs. 4, 10) Dean F. Frasché.
(Fig. 3, on page 6) Yves Coffin. (Fig. 11) Otto E.
Nelson. (Fig. 14) Gemeentelijk Museum Het
Princessehof, Leeuwarden. (Fig. 15) Topkapu Sarayi
Müzesi, Istanbul.

The following figures were redrawn by Gary Tong
from existing illustrations. (Fig. 9) from B. Leach,
A Potter's Book, Hollywood-by-the-Sea, Fla., 1953,
p. 212. (Fig. 12) from Y. Azuma, ''Sukotai no
Yakimono,'' *Tosetsu* (October 1968), p. 18, fig. 7.
(Fig. 13) from Y. Azuma, *Toki Koza*, Tokyo, 1973,
p. 271, fig. 73.

Photographs
Otto E. Nelson: 2, 5, 12, 13, 16, 17, 18, 19, 20,
21 (color), 23 (color), 24, 29, 32, 33, 35, 36, 37,
43, 48 (color), 49, 52, 53, 54, 55, 56, 57, 70
(color), 71, 88, 91, 102, 106a & b, 107, 109.
Eugene Mantie: 3, 4, 6, 8, 69, 75, 94, 95, 96.
A. J. Wyatt: 9 (color), 11, 14, 15, 25, 26, 27, 28,
38, 40, 50, 51. Other photographs by courtesy of
the lenders.

SOUTHEAST ASIAN CERAMICS has been designed by
Joseph del Gaudio and printed at the Press of
A. Colish in Mount Vernon, New York. It was
composed in Monotype Perpetua and printed on
Warren's Lustro Dull. The binding was by
Publishers Book Bindery.

First printing, 1976: 4750 copies.